The Great Escape

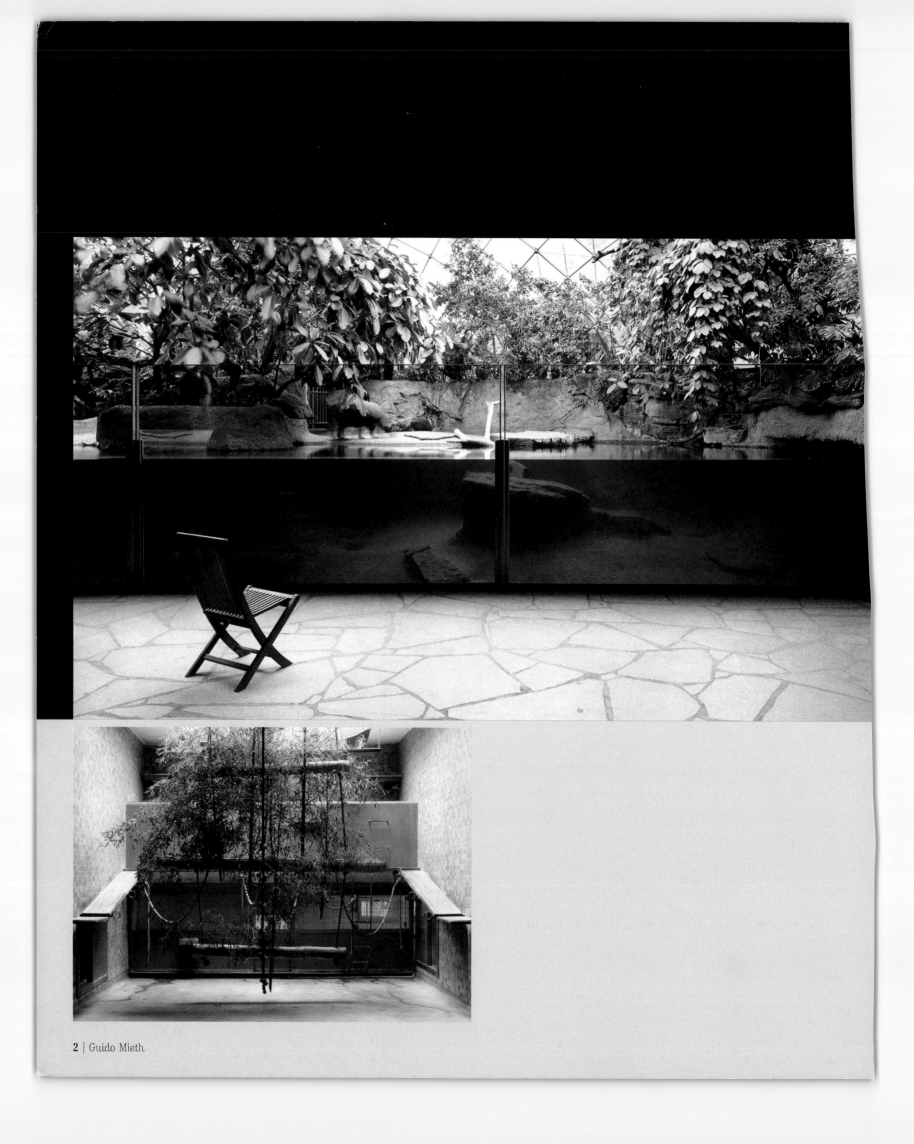

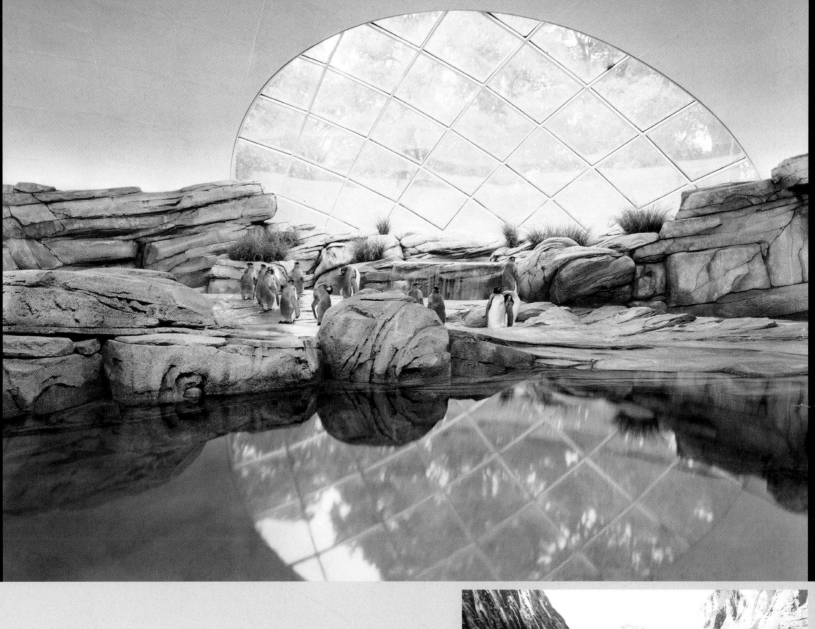

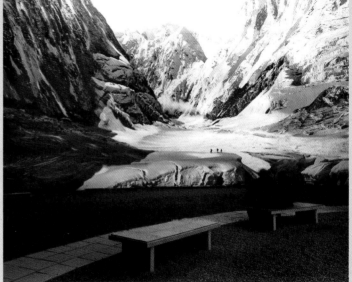

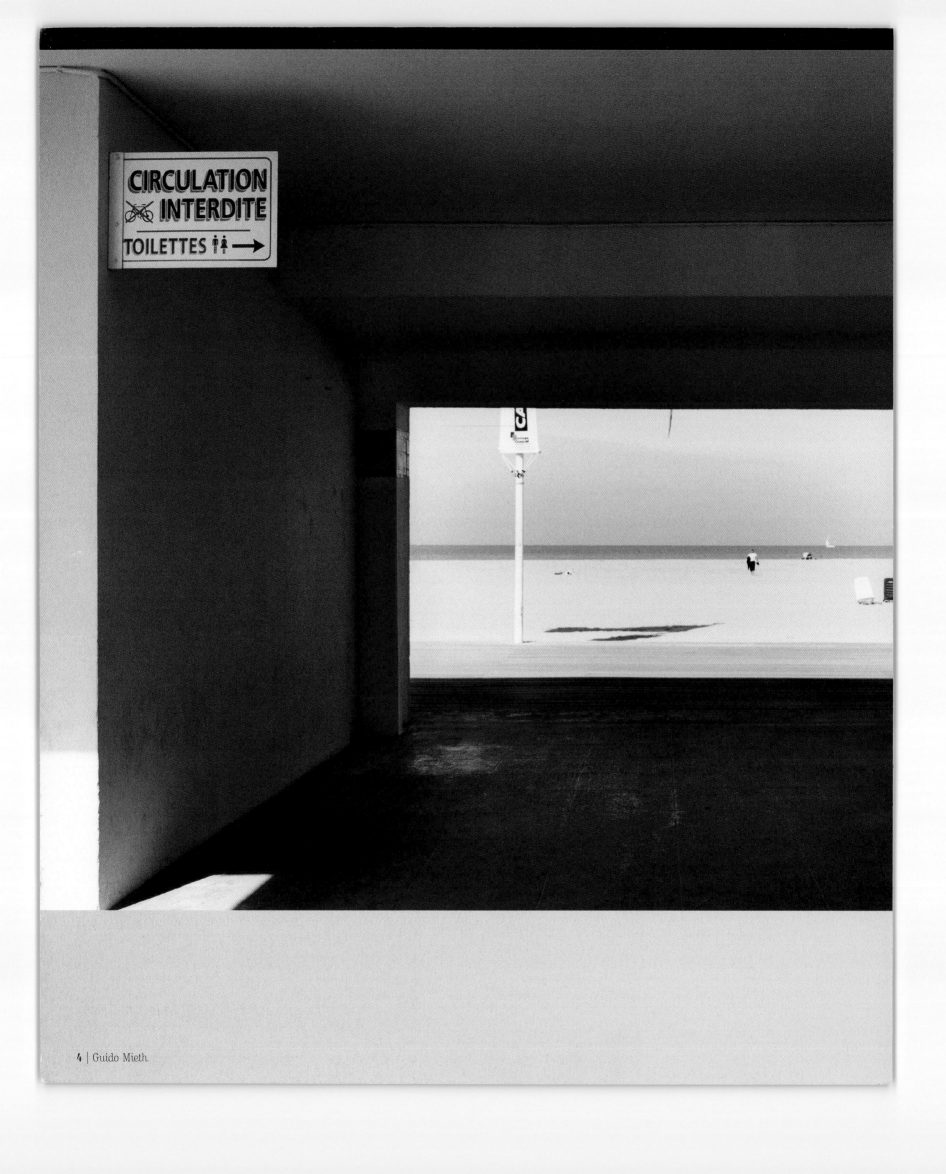

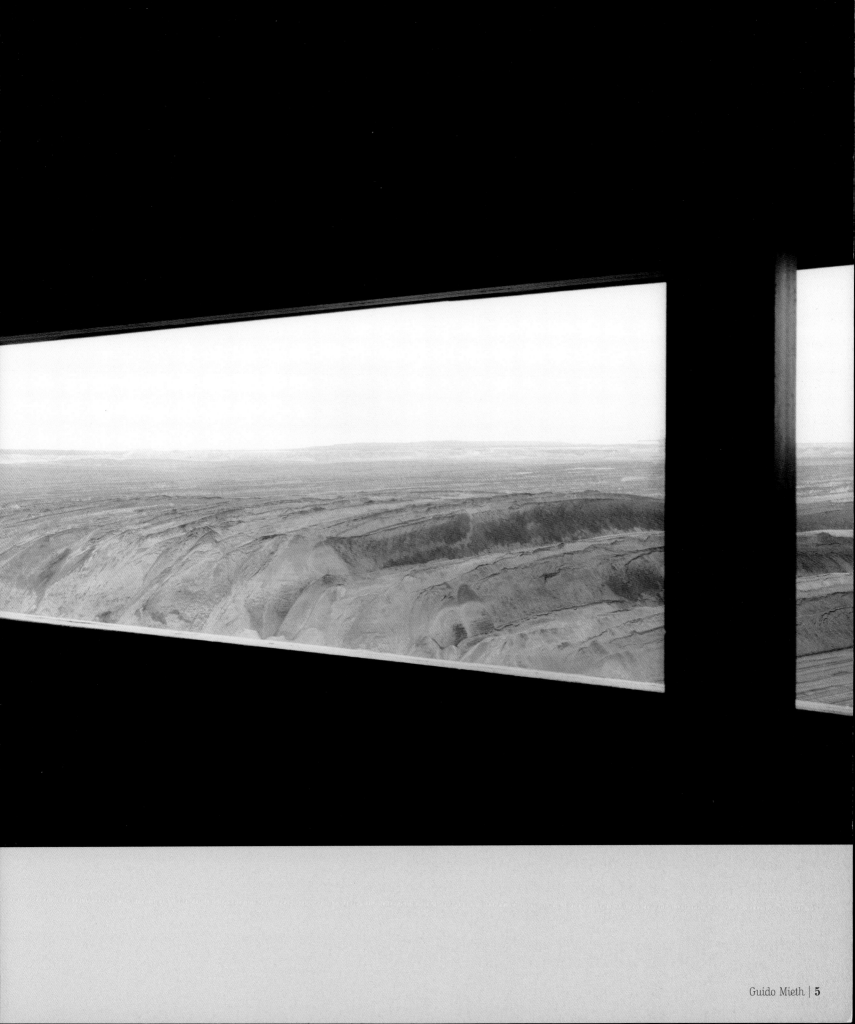

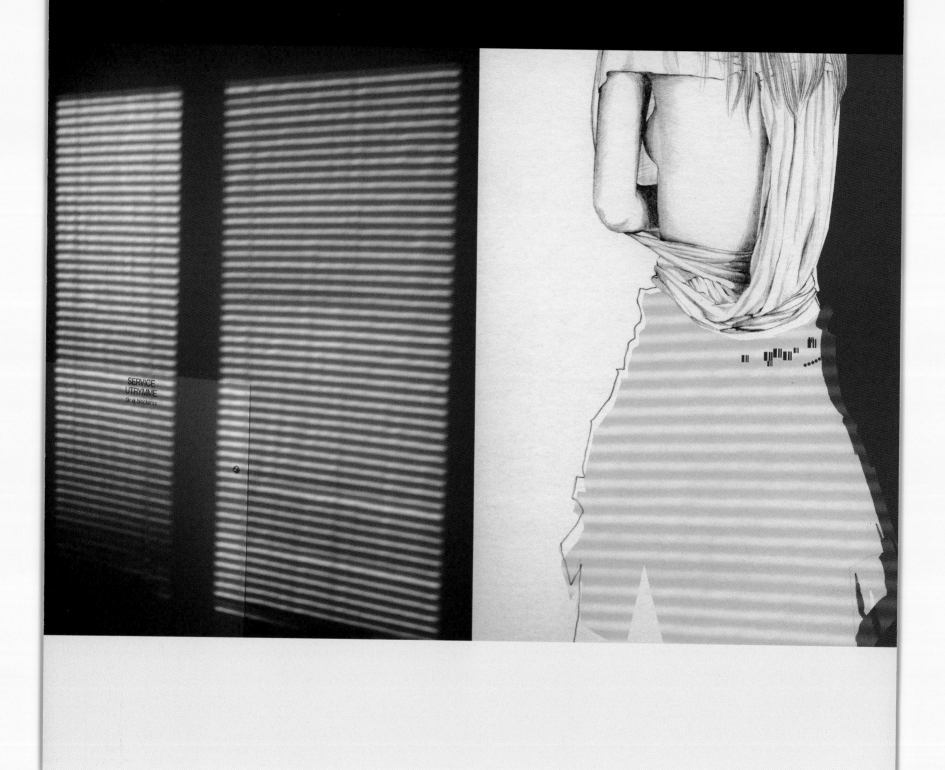

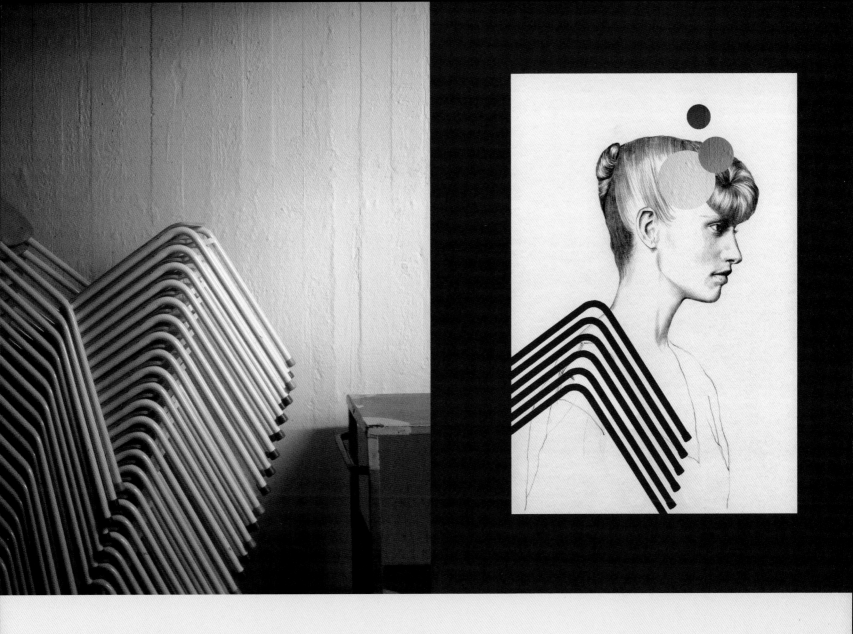

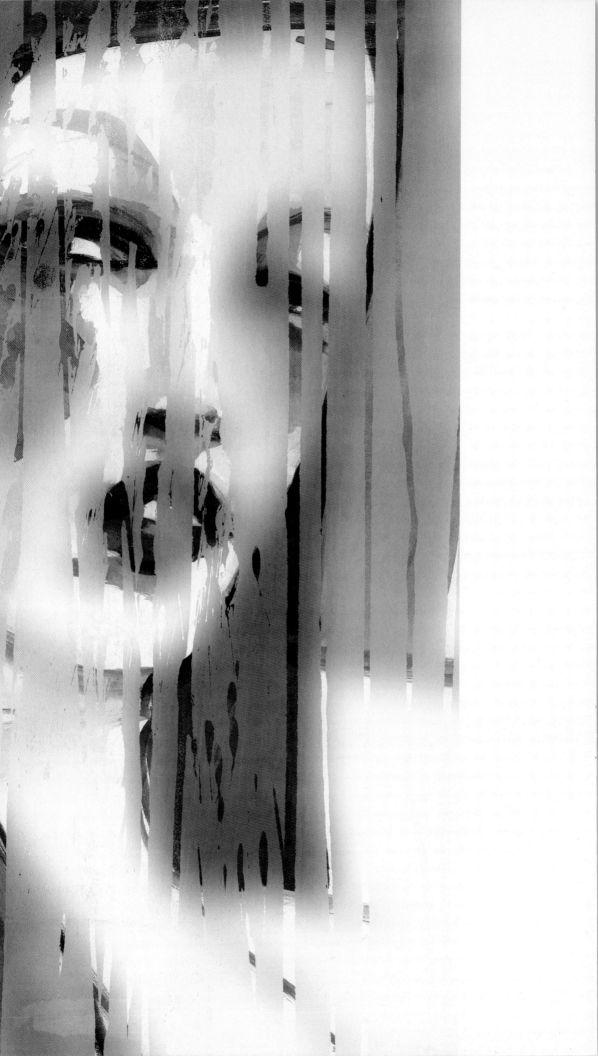

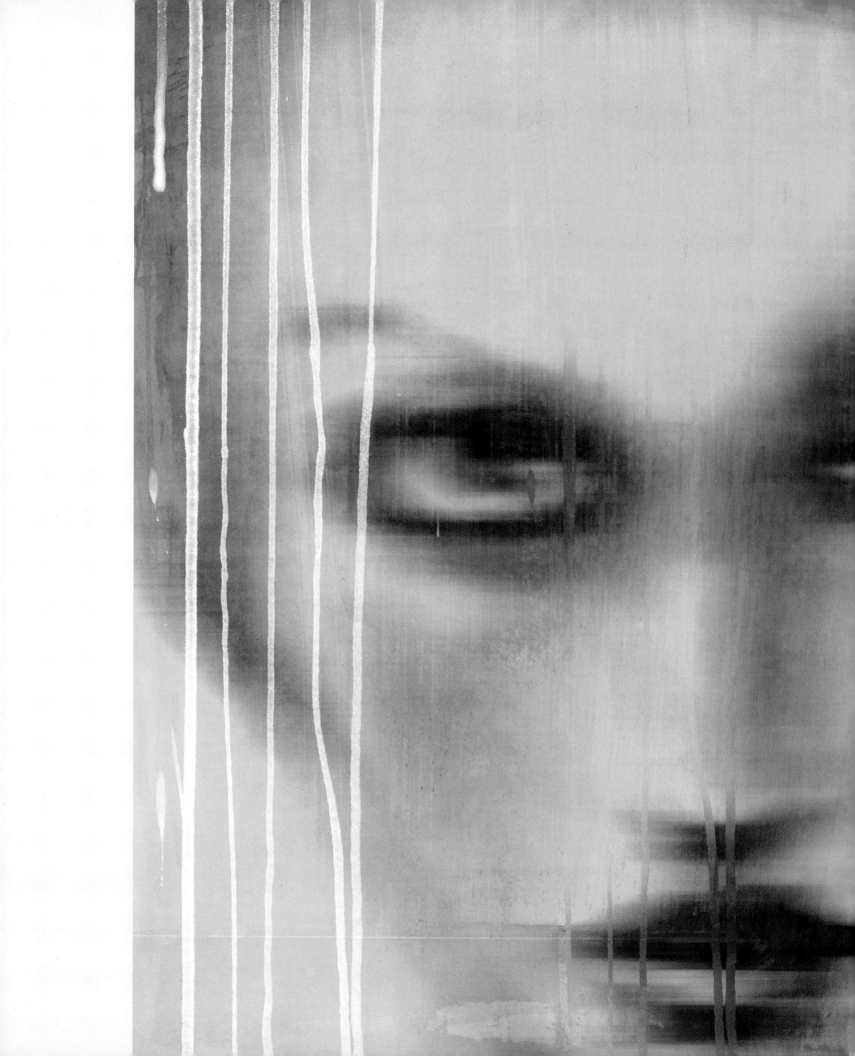

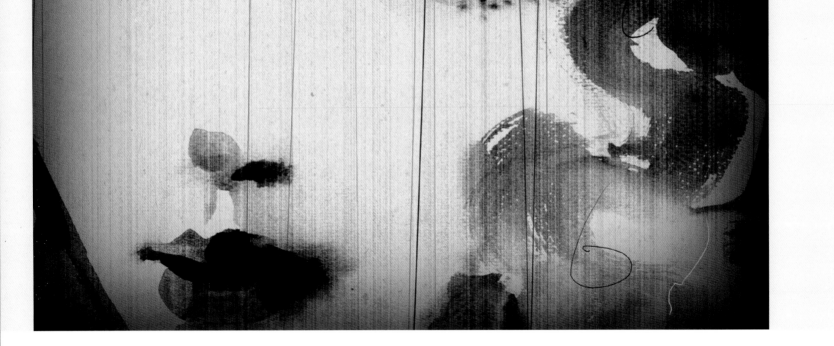

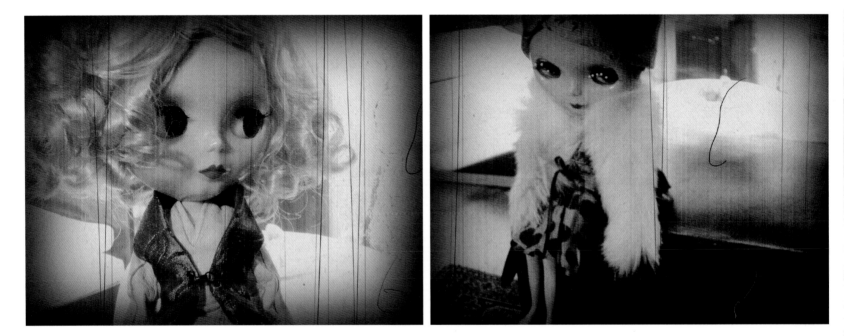

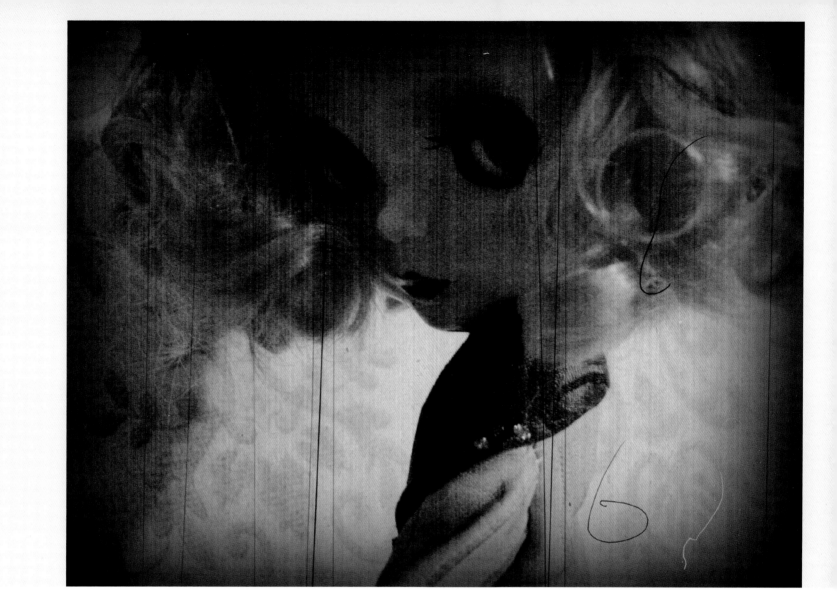

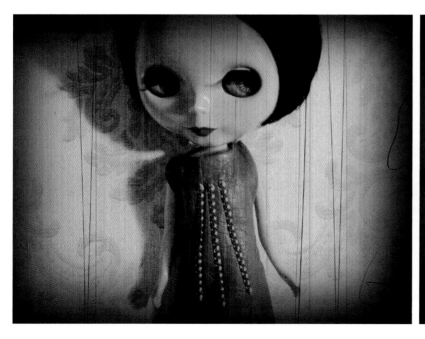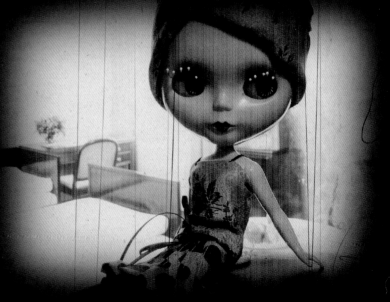

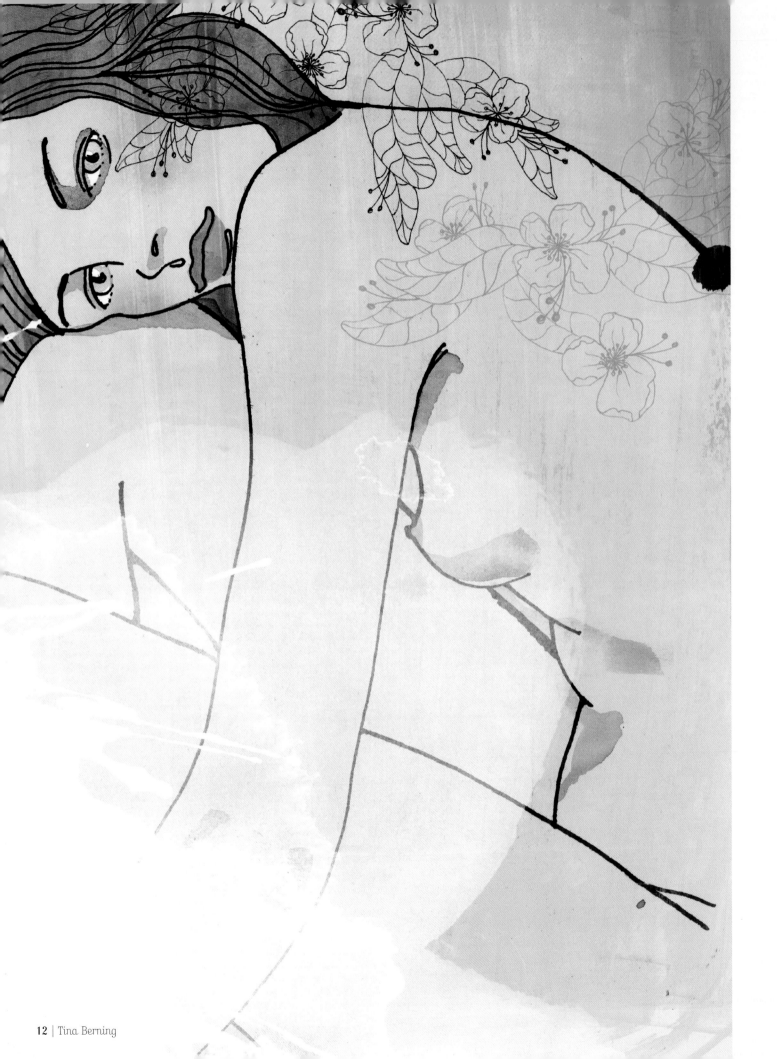

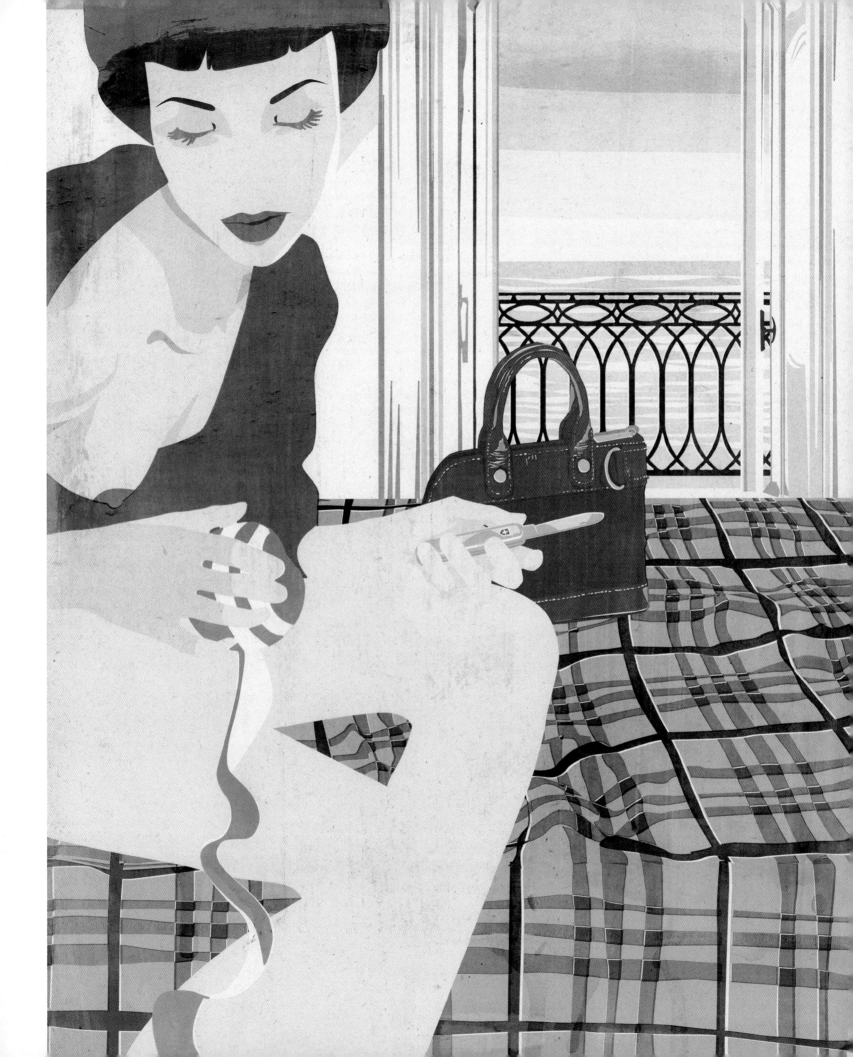

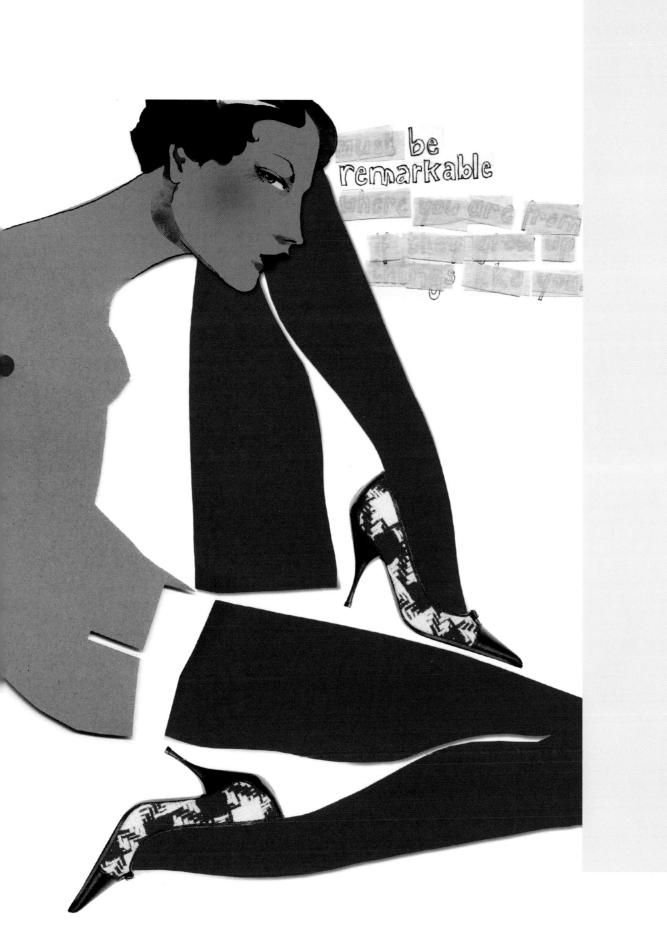

be
remarkable

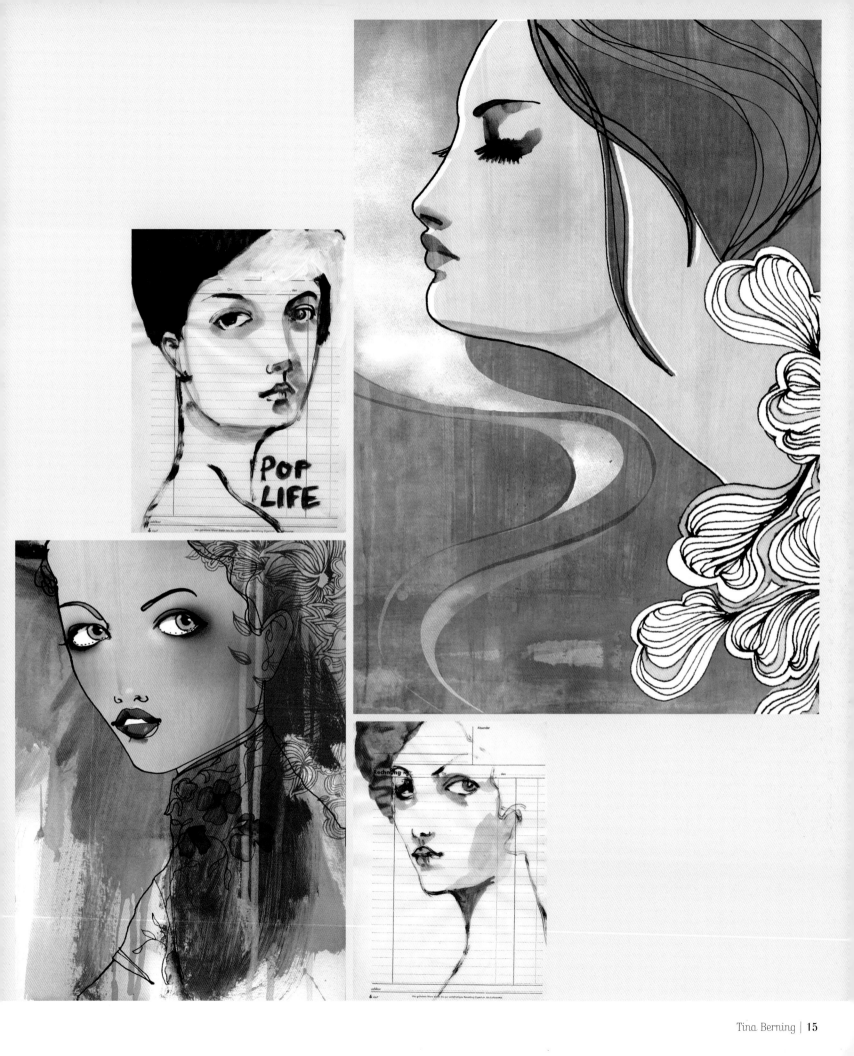

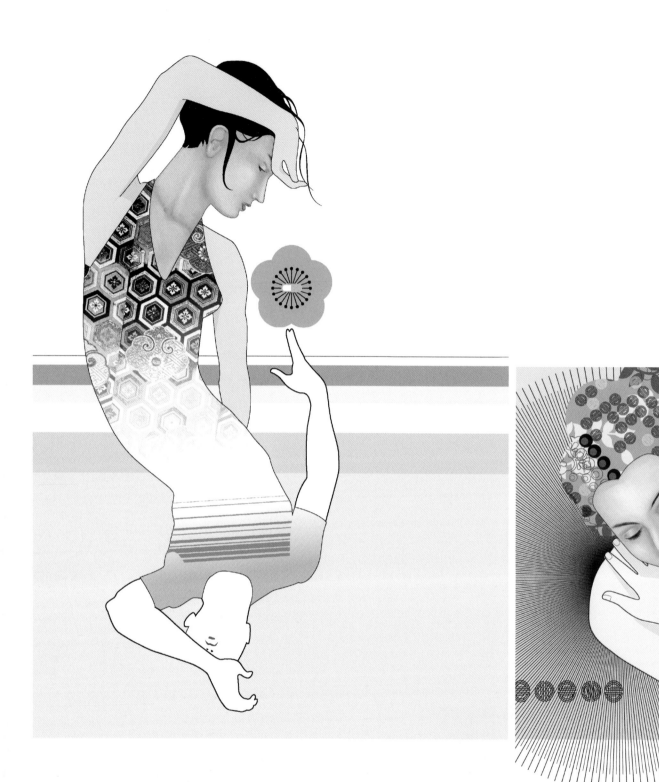

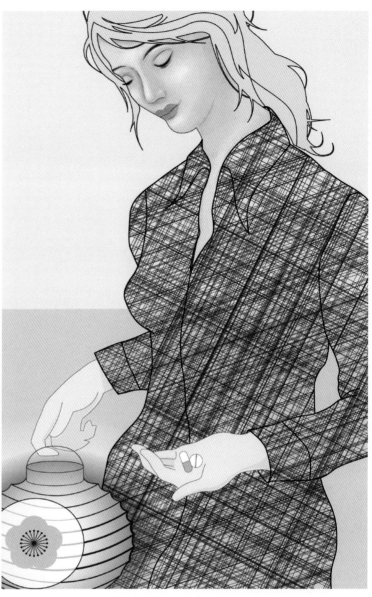

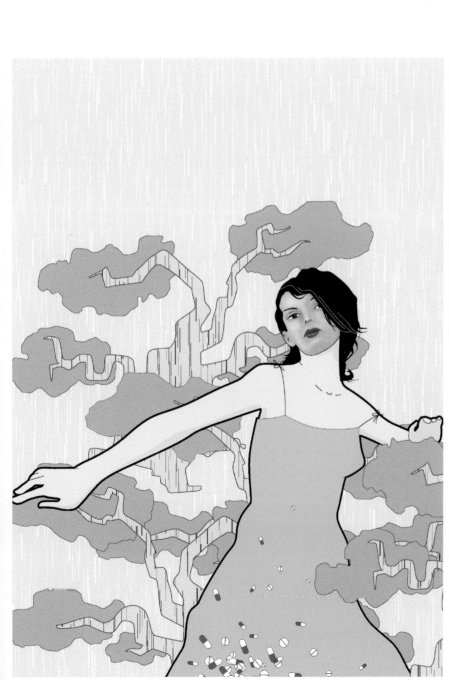

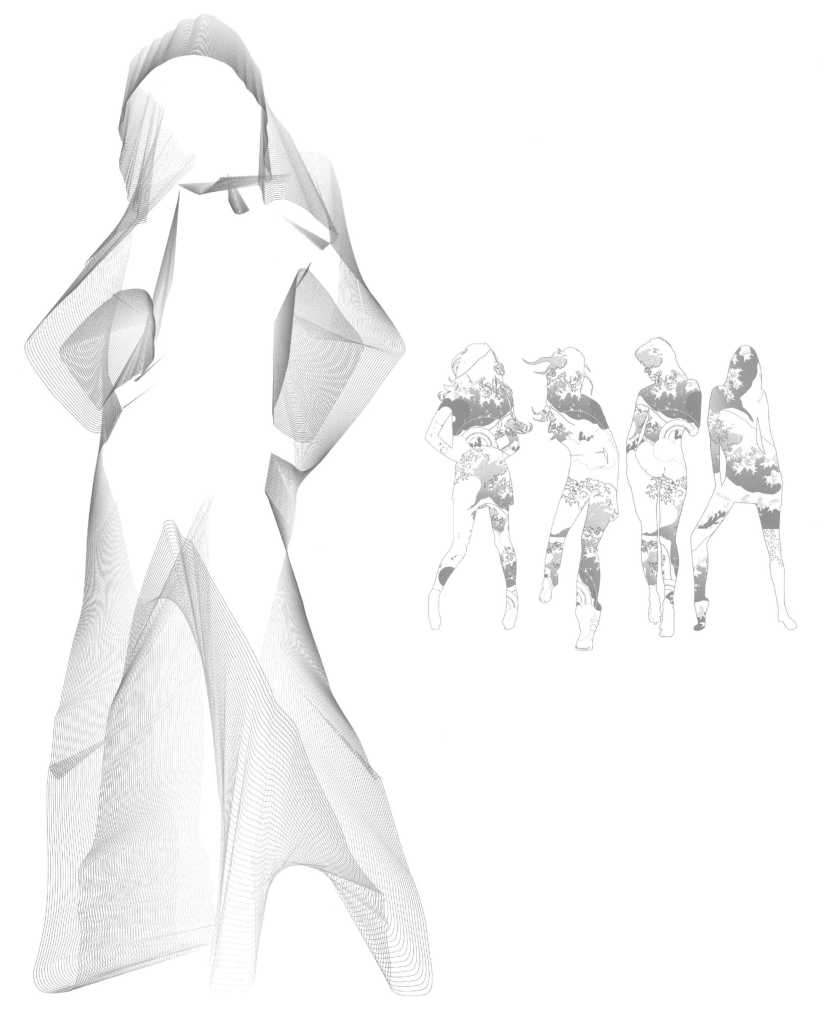

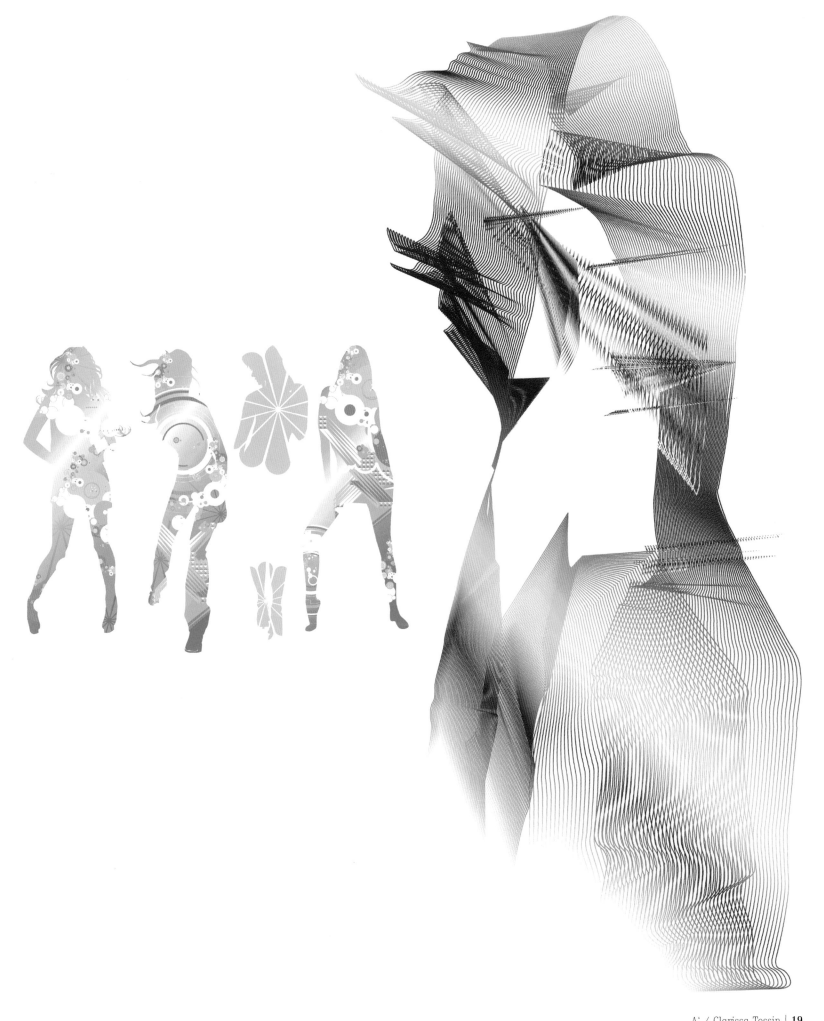

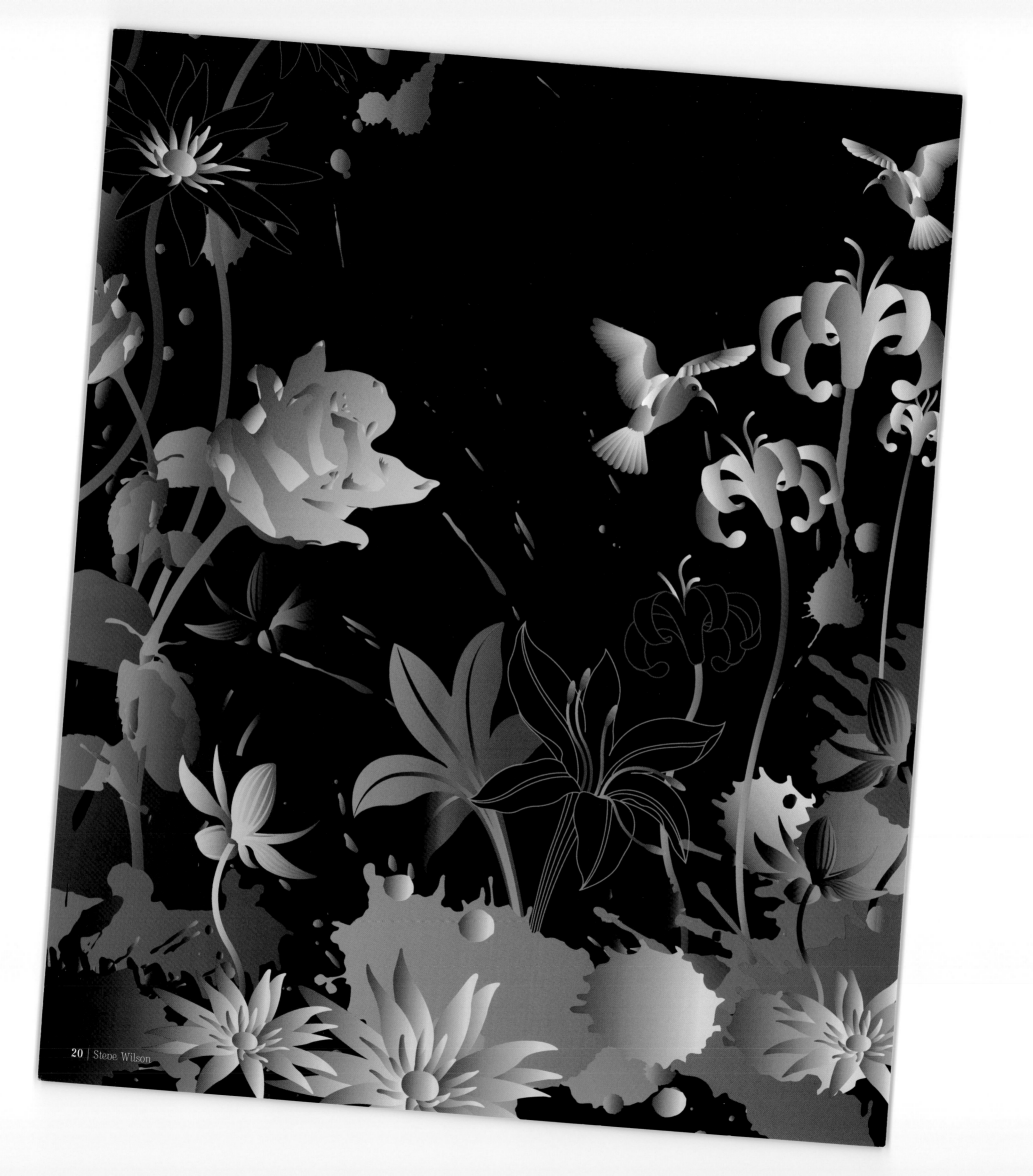

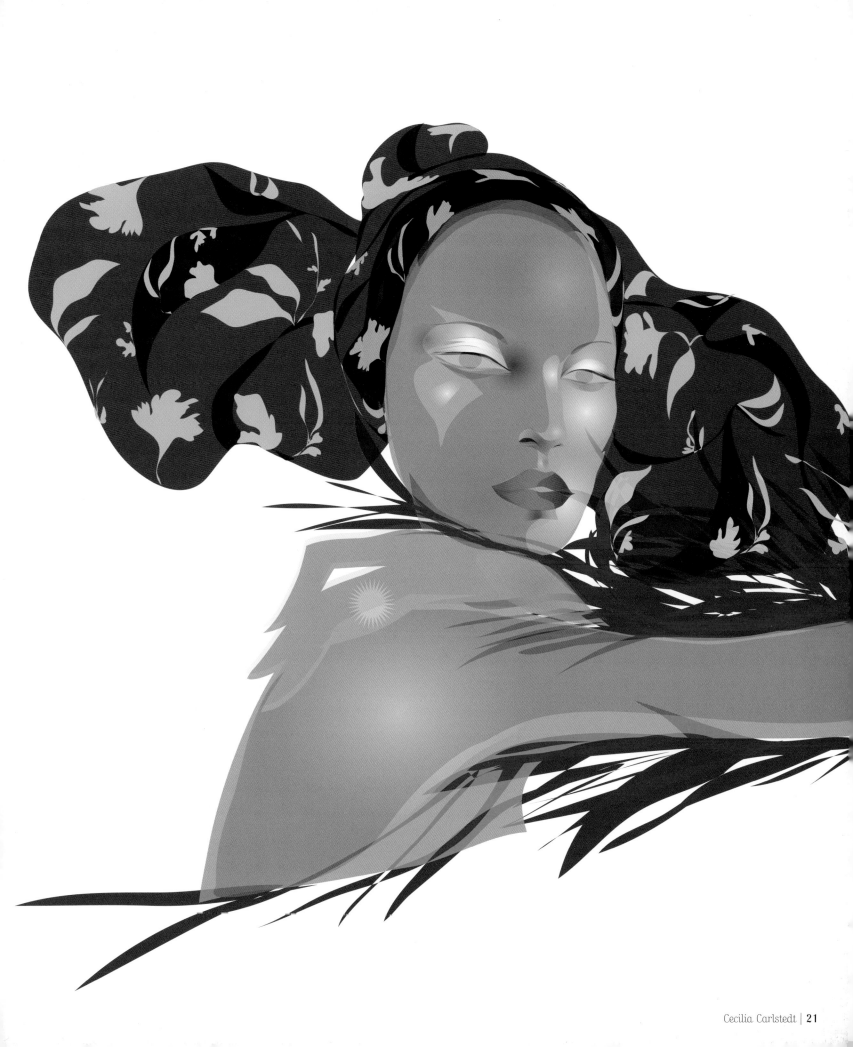

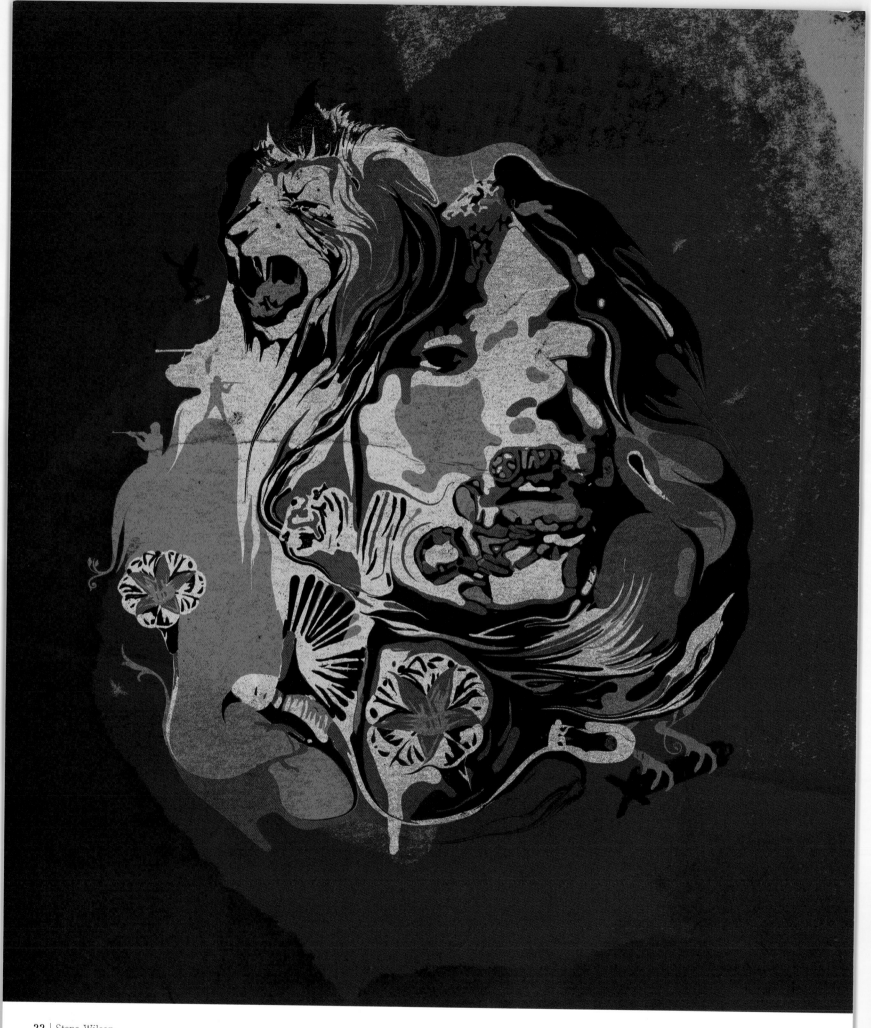

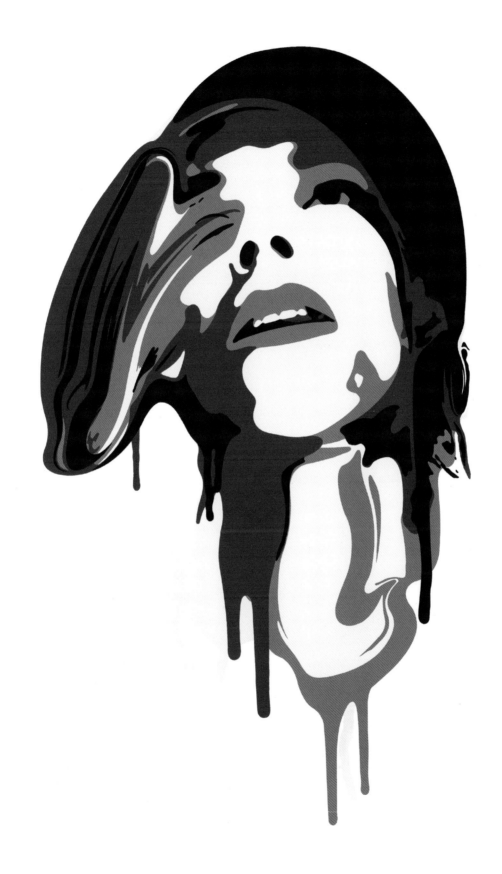

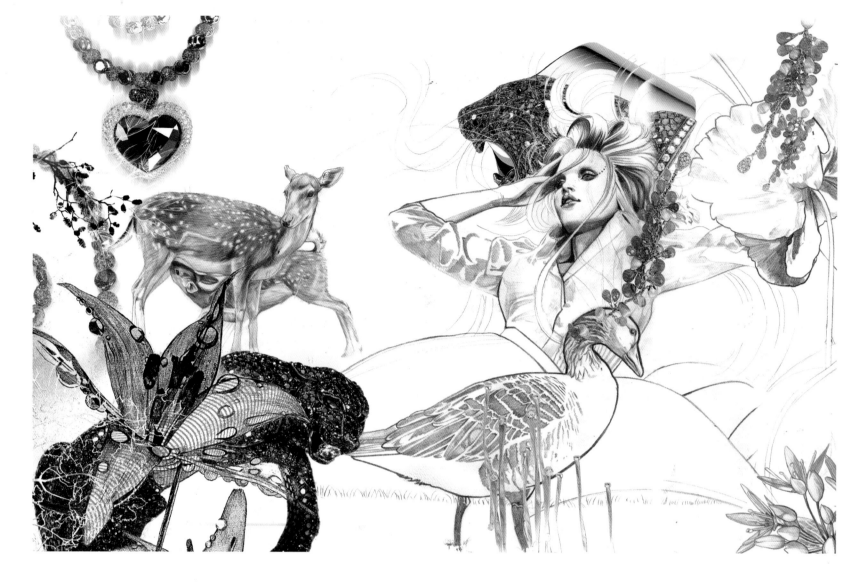

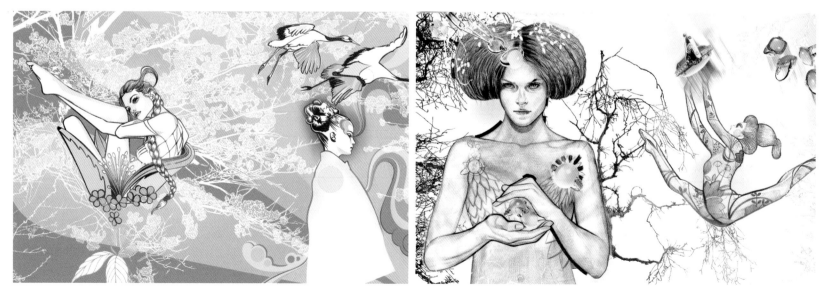

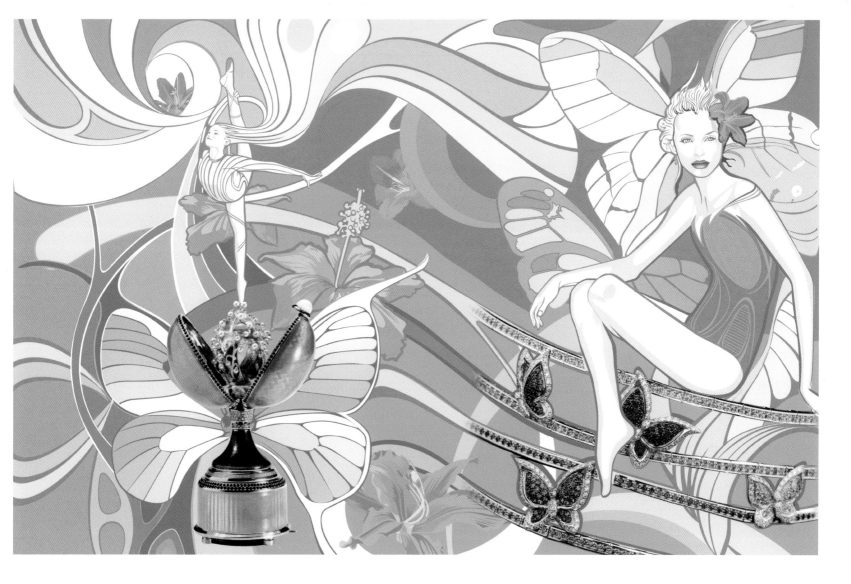

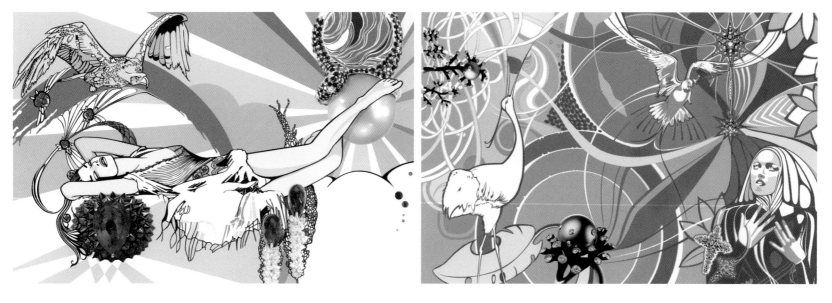

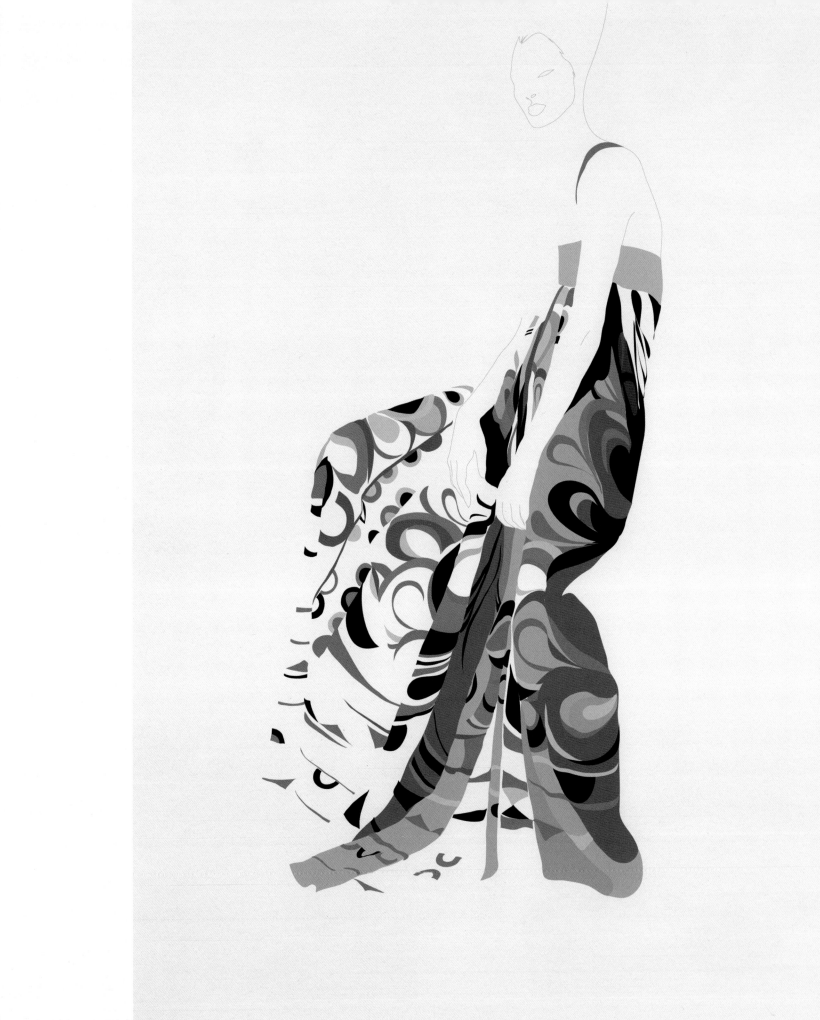

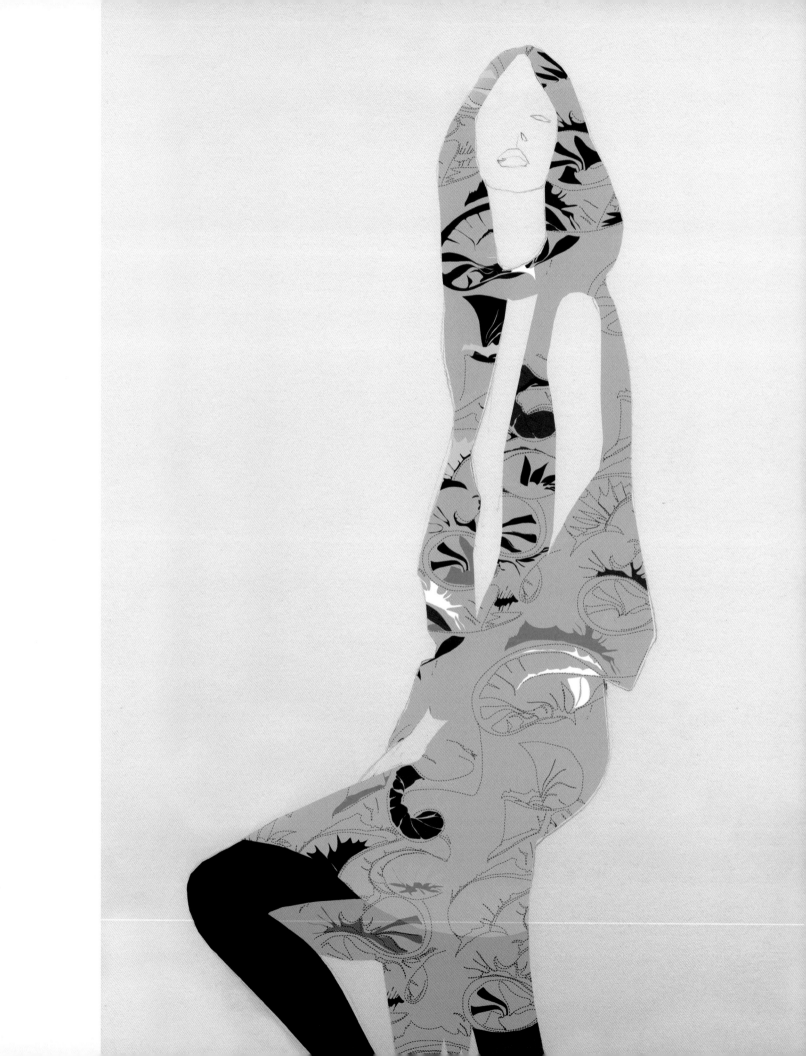

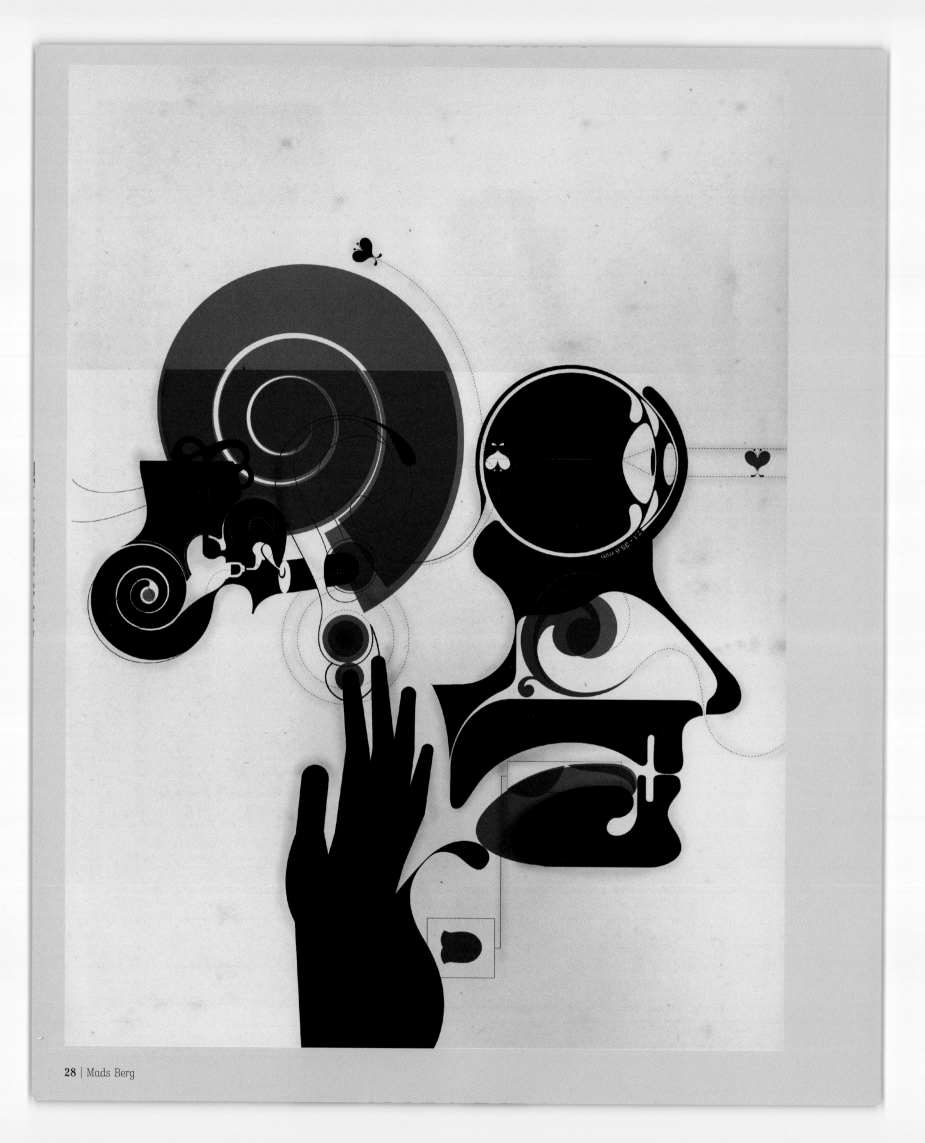

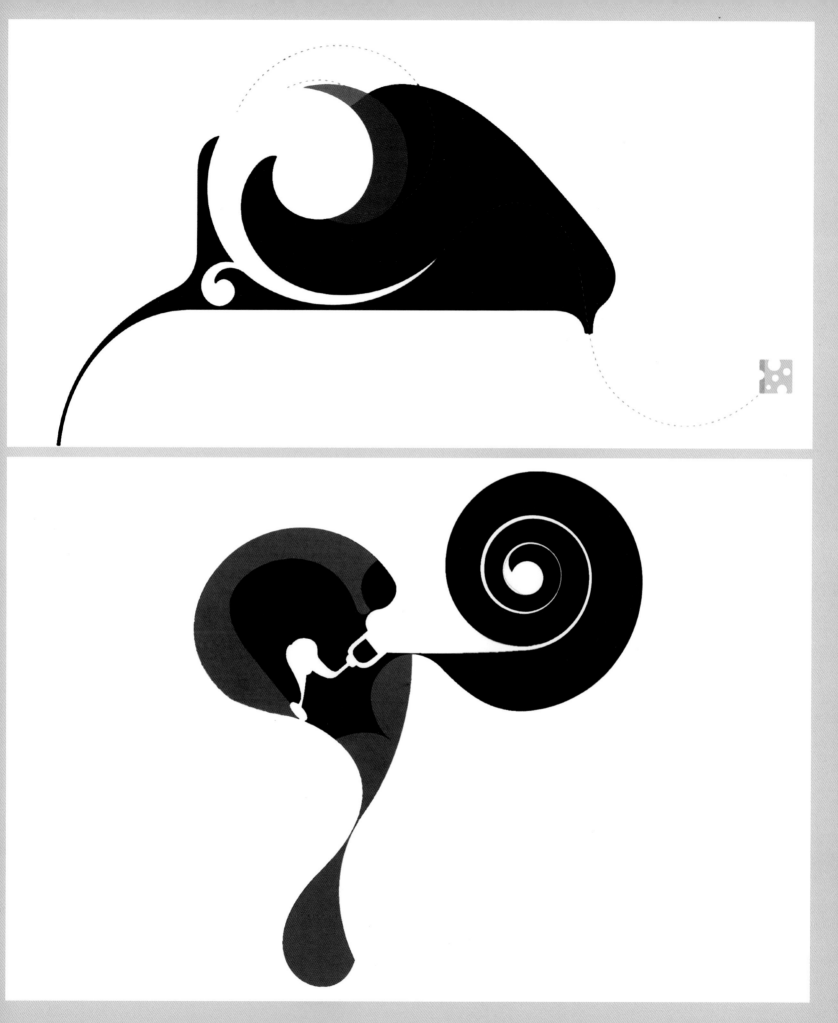

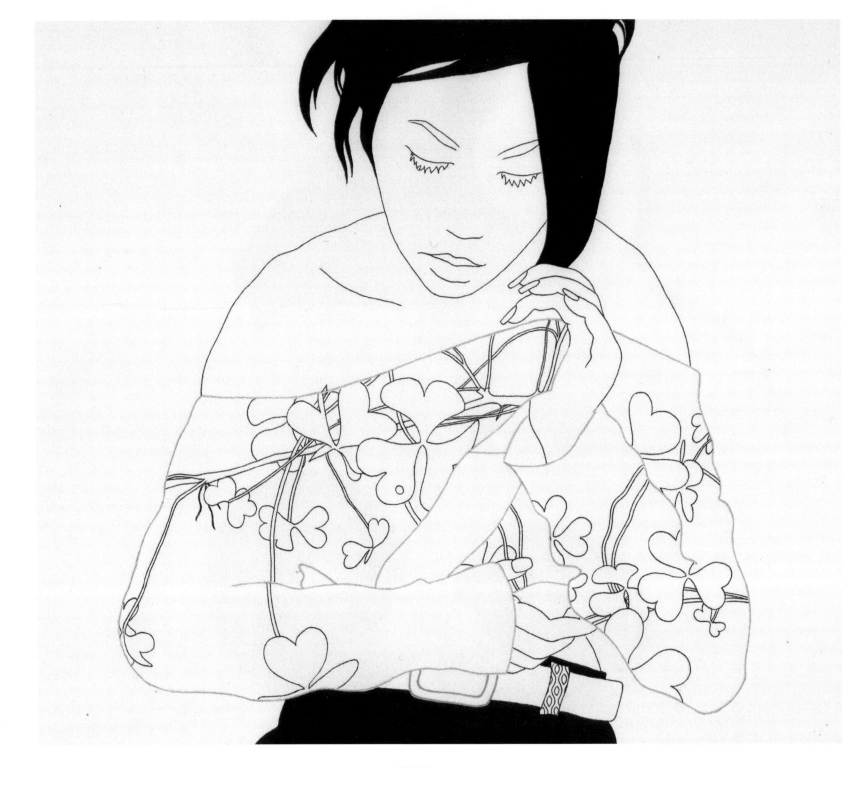

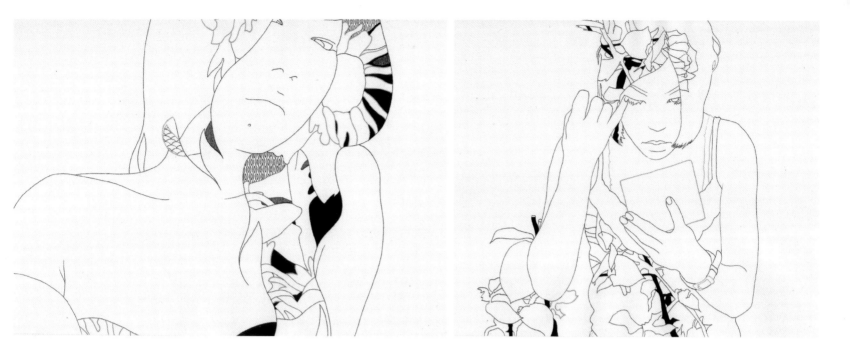

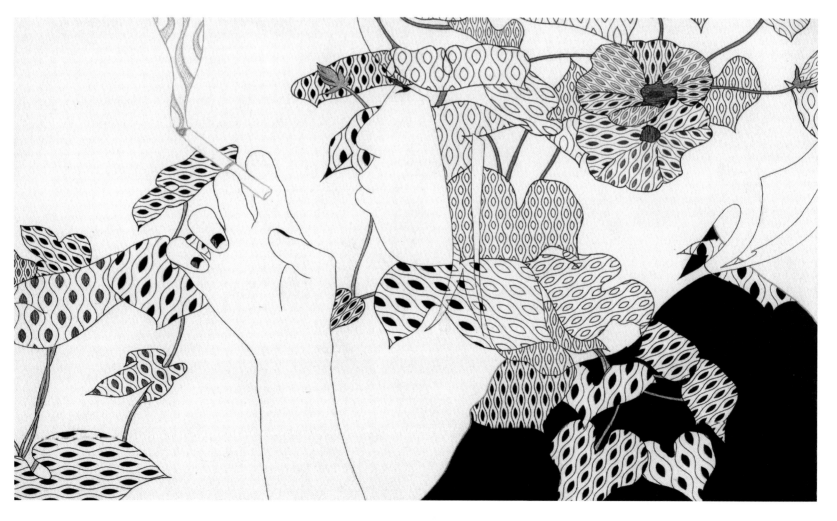

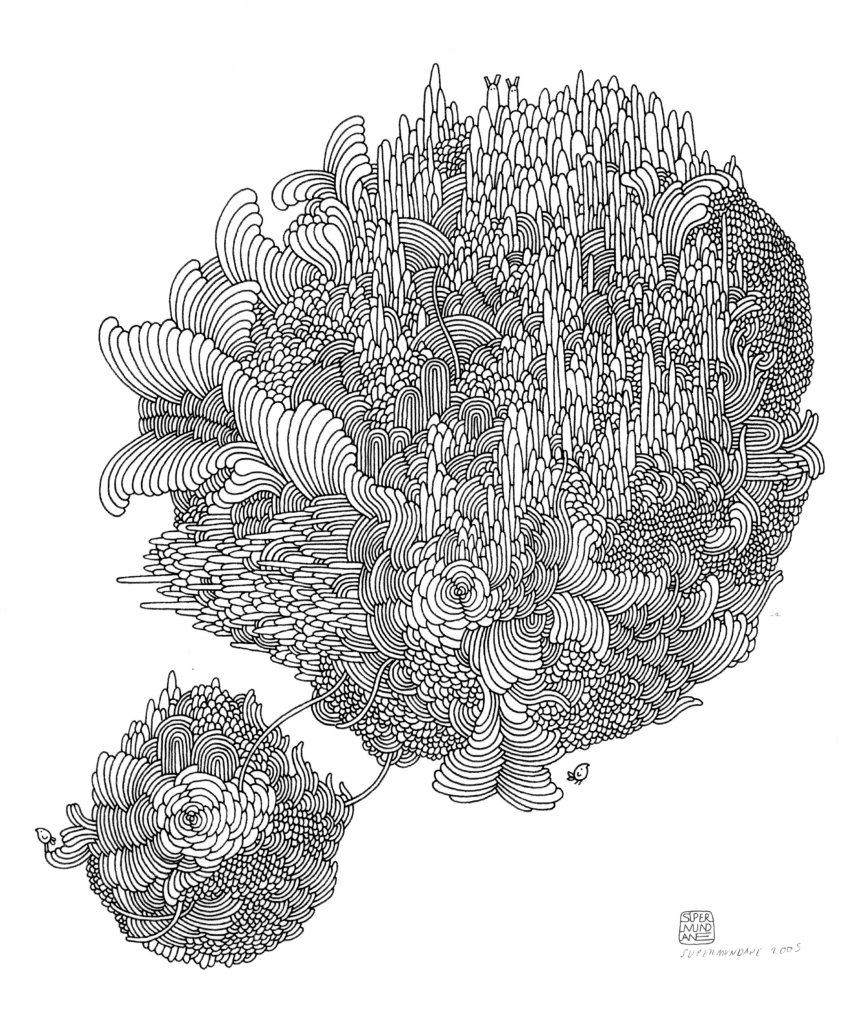

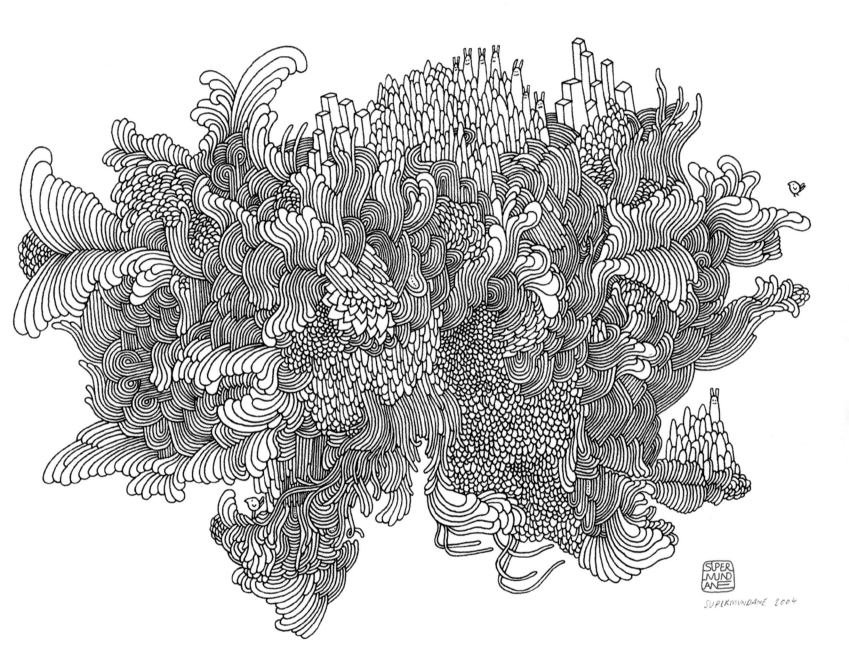

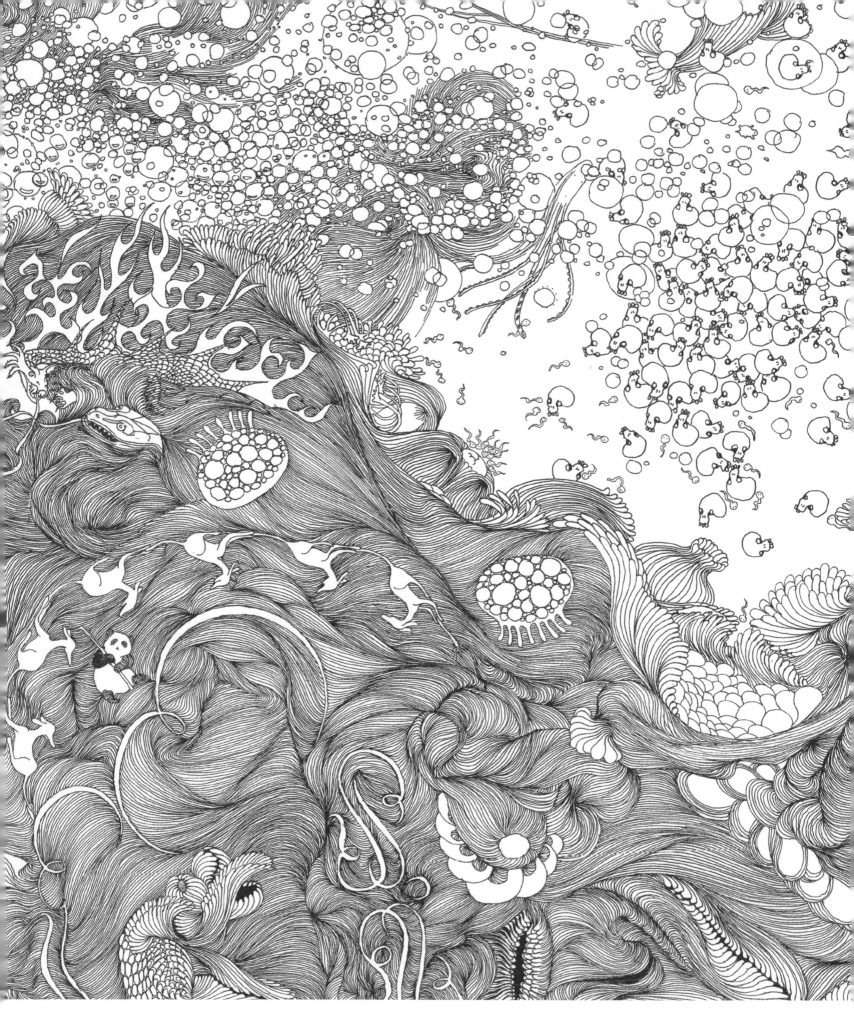

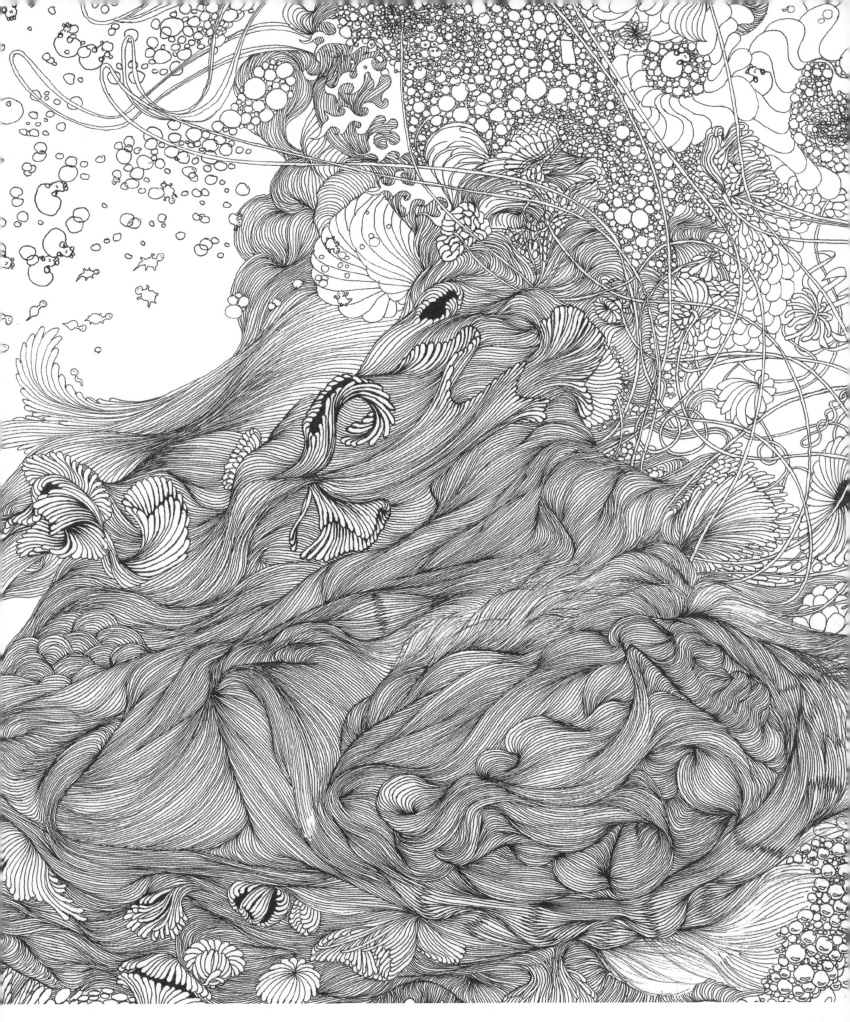

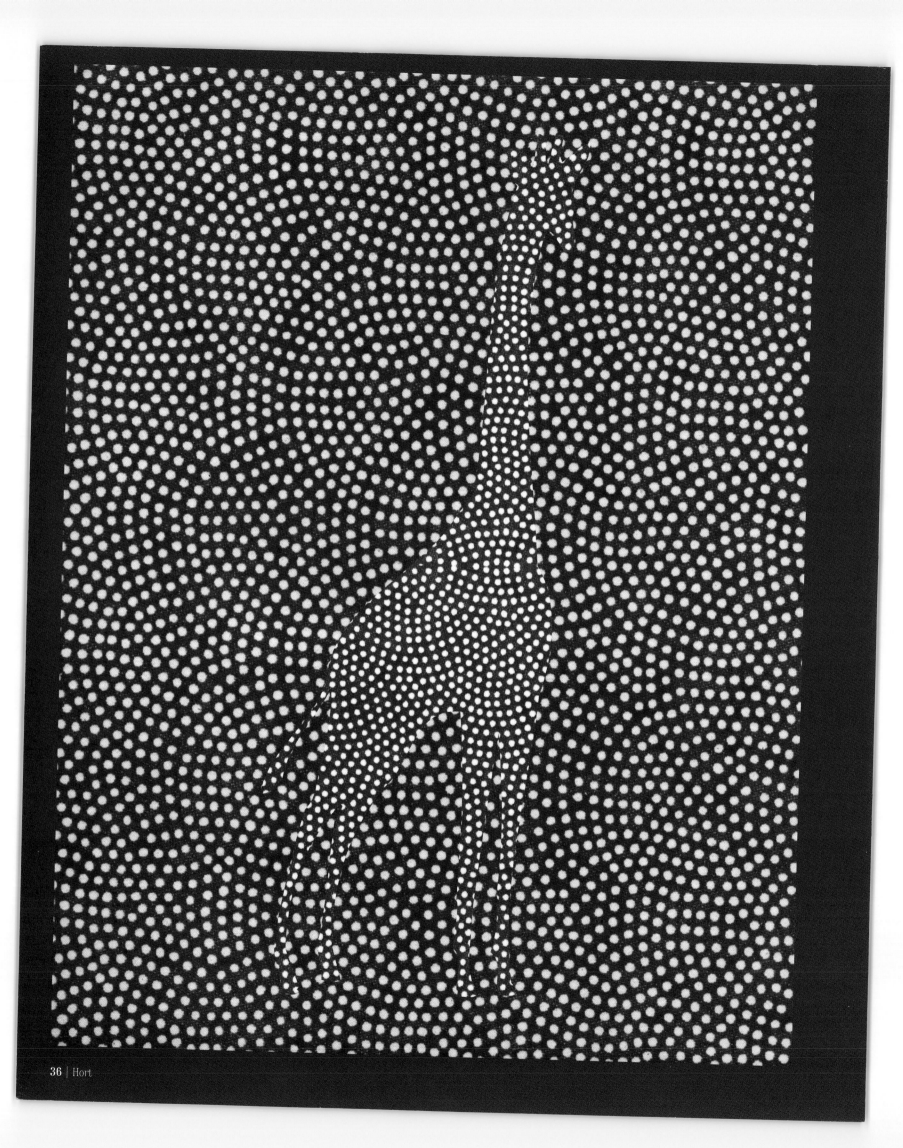

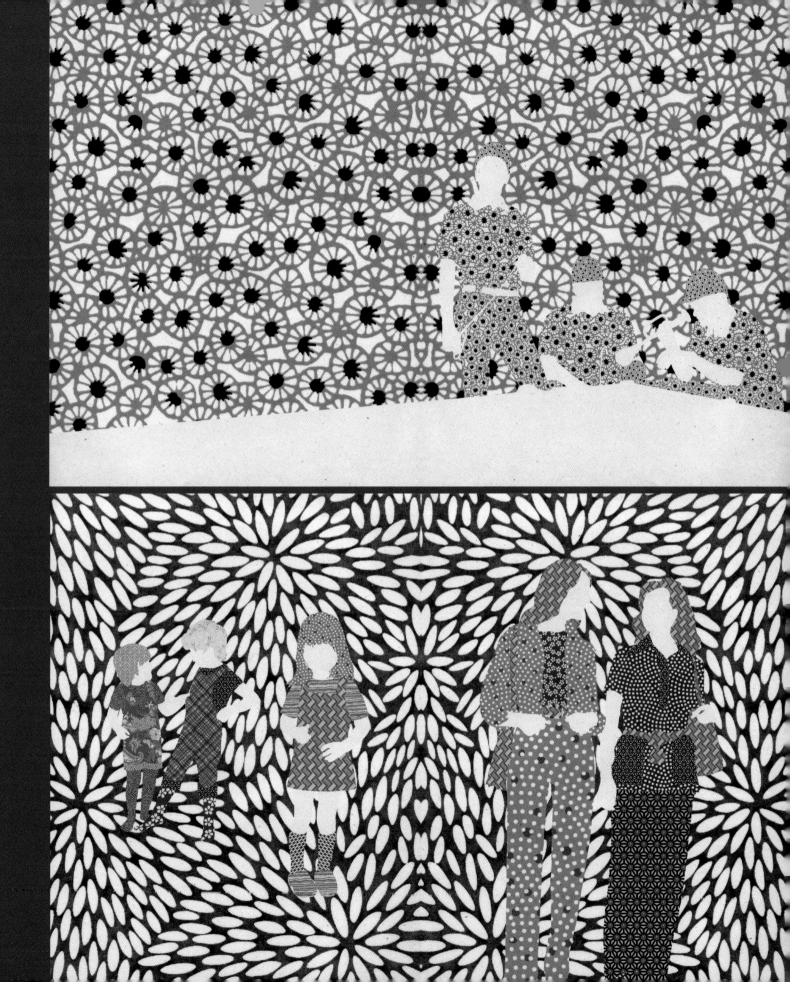

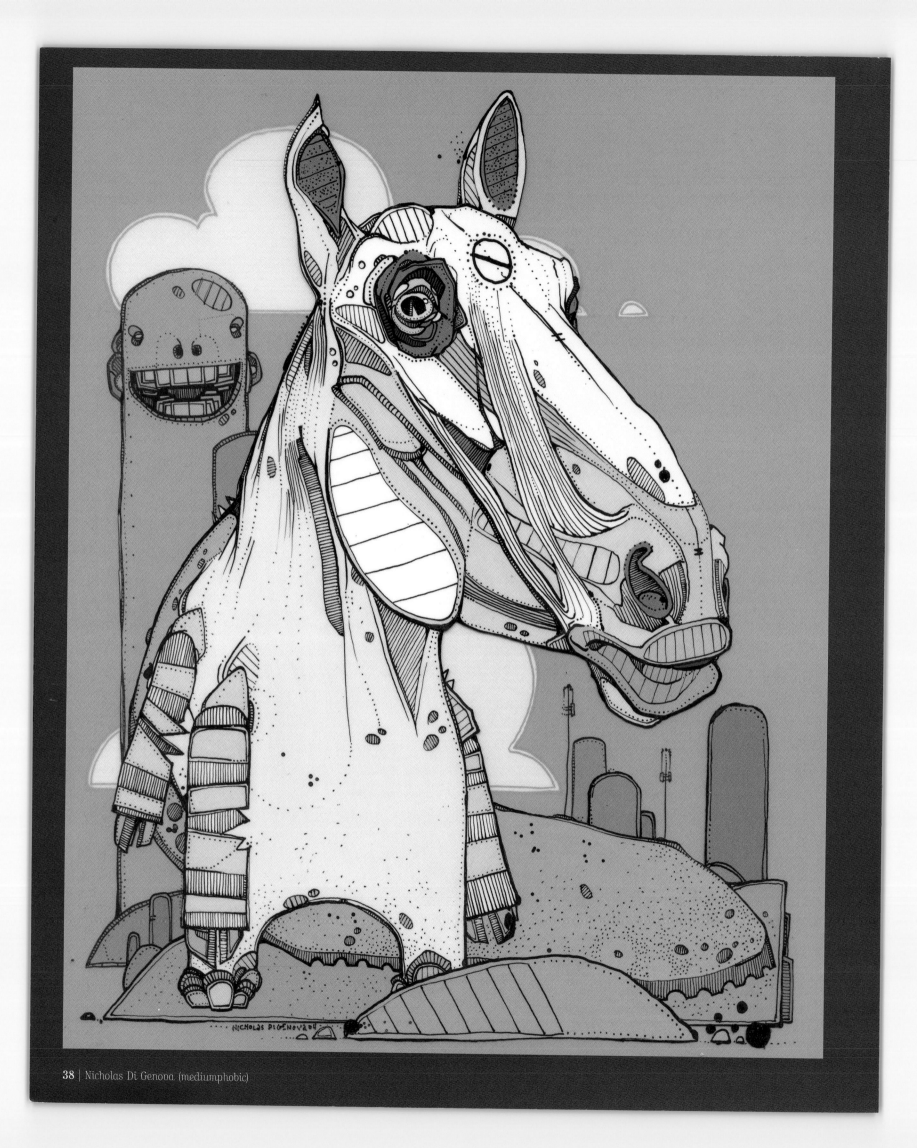

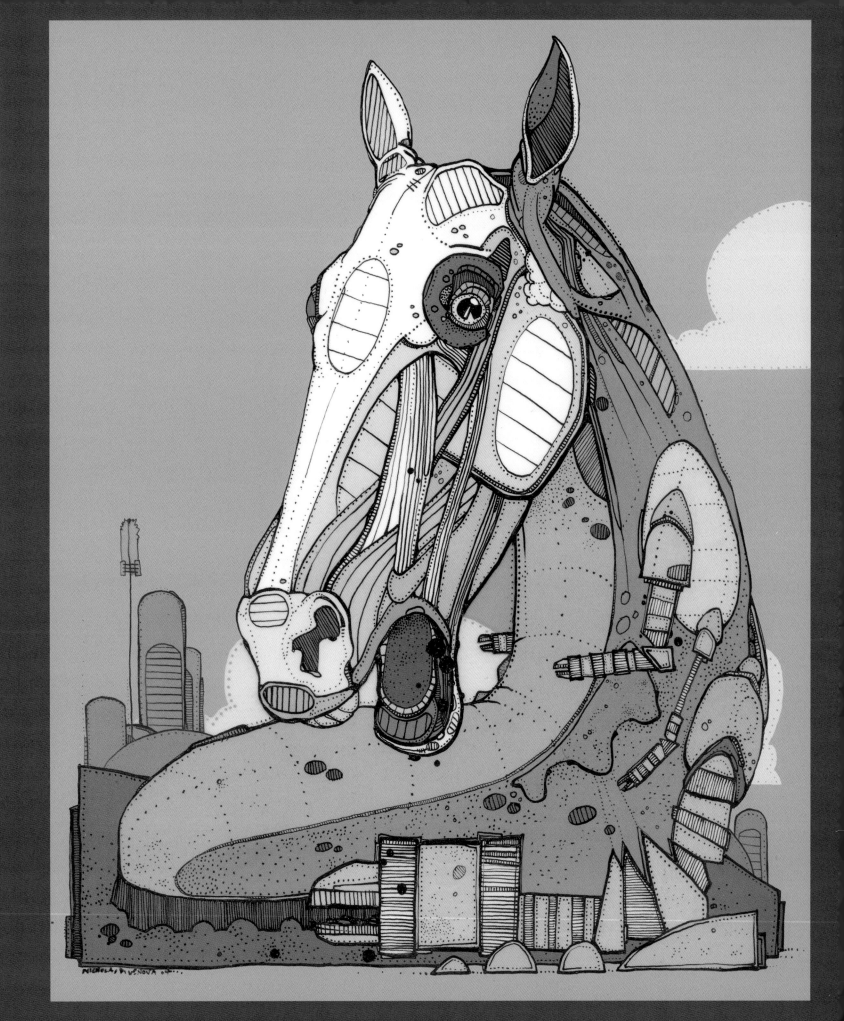

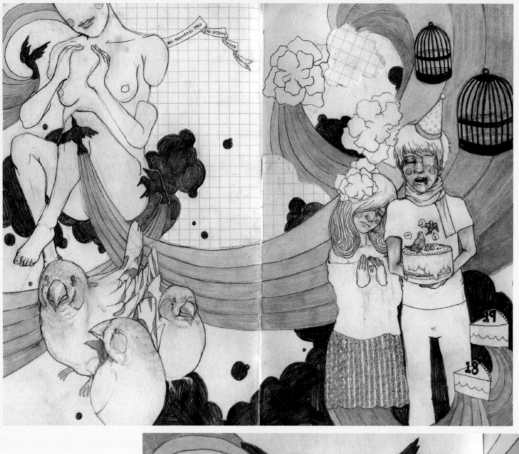

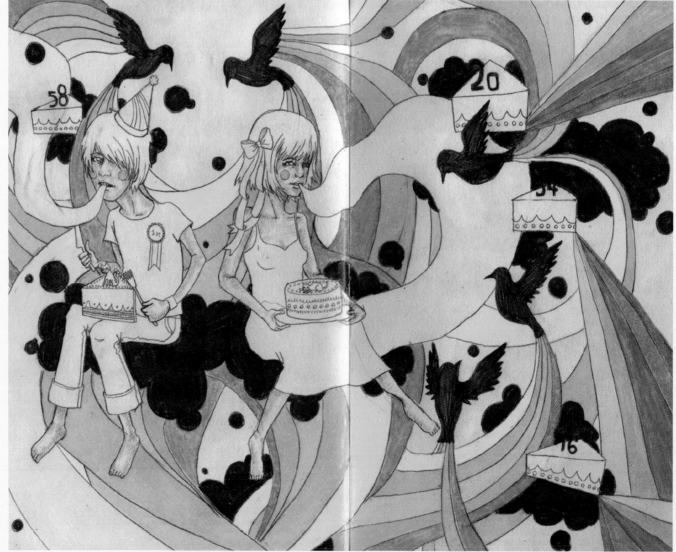

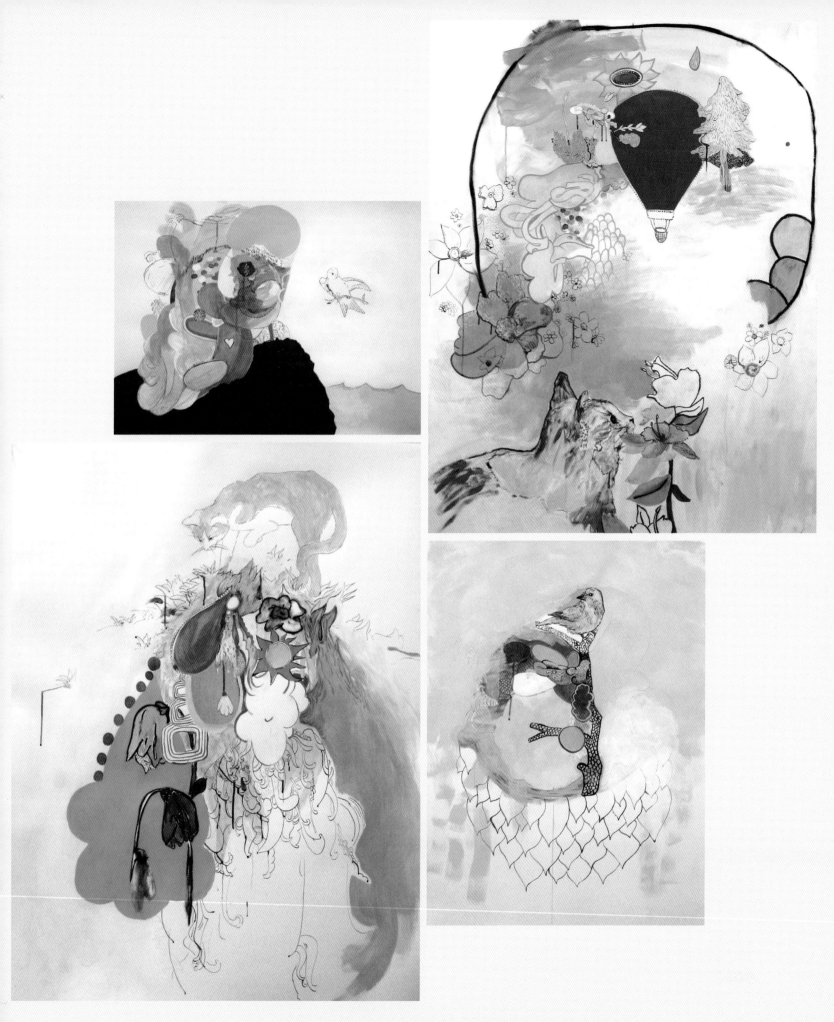

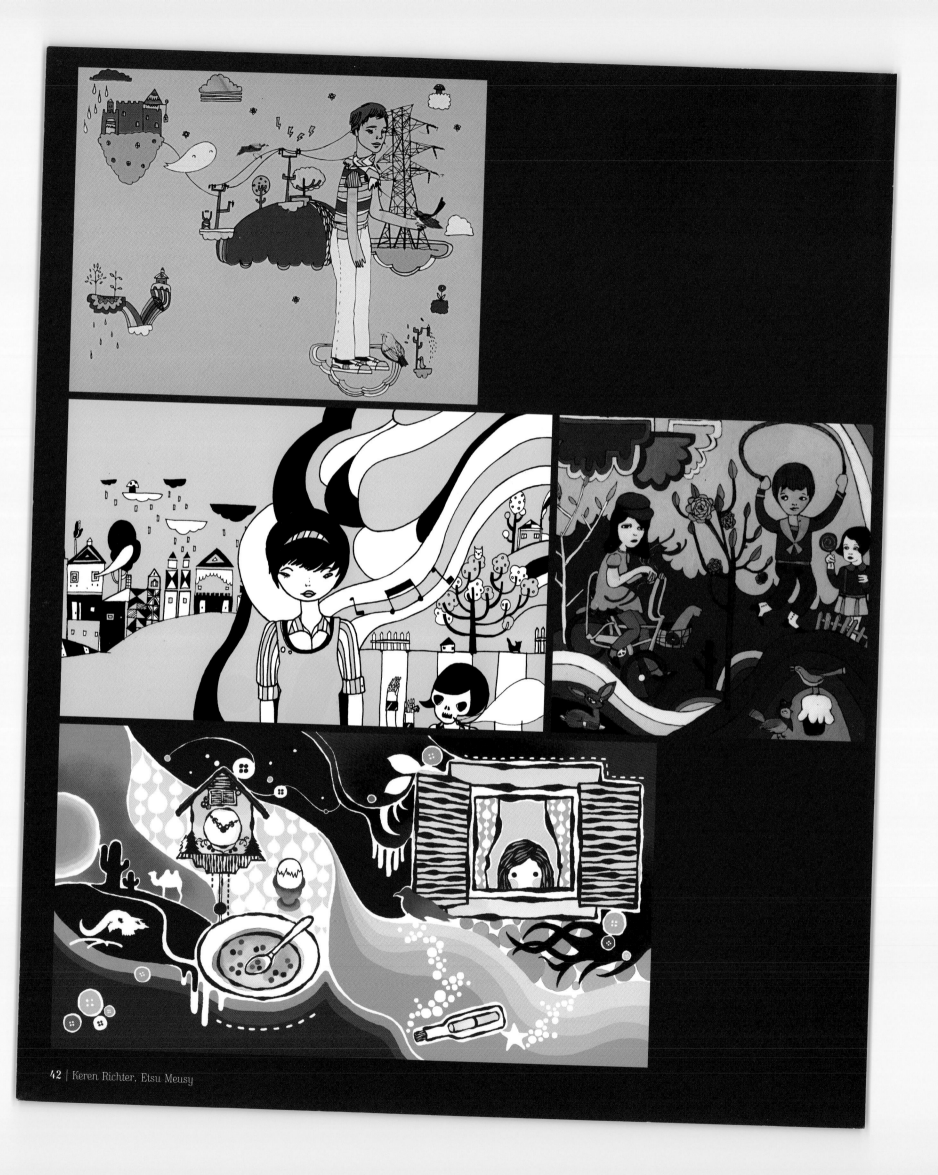

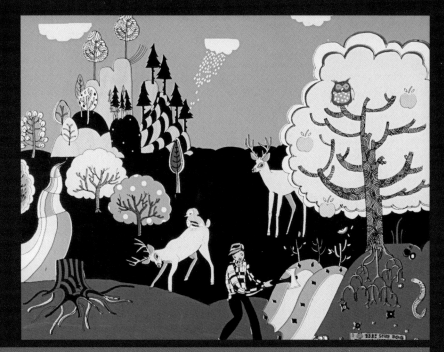

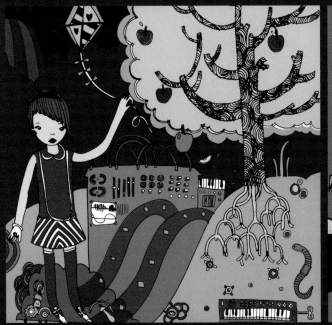

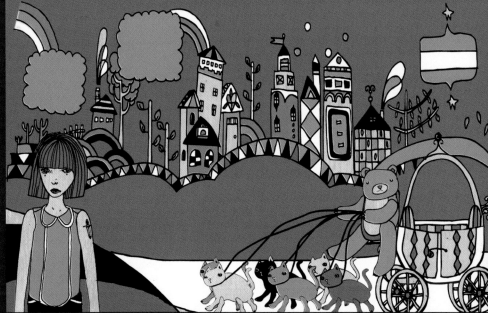

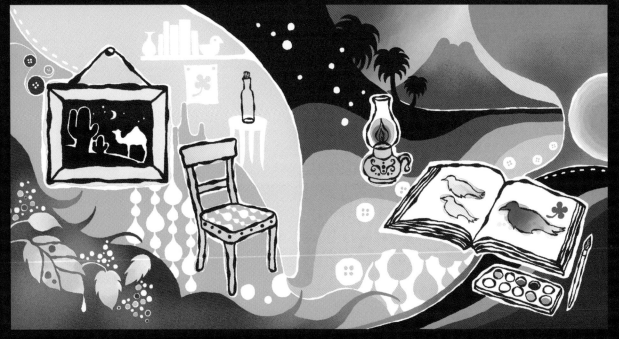

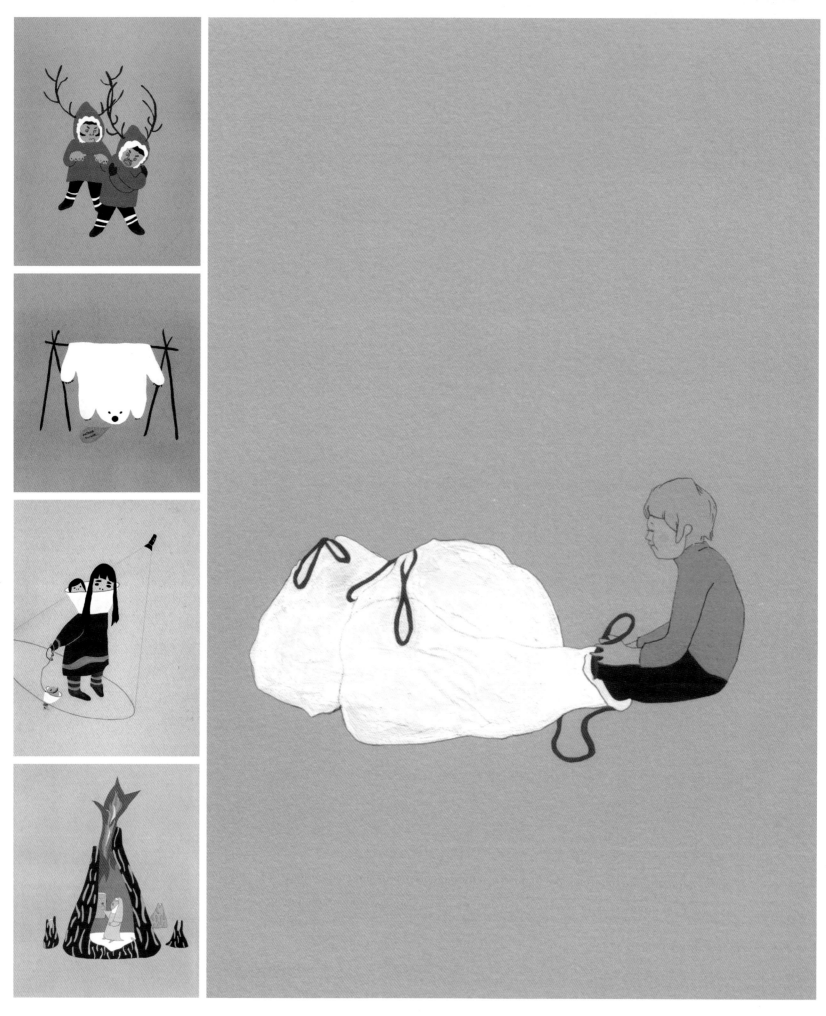

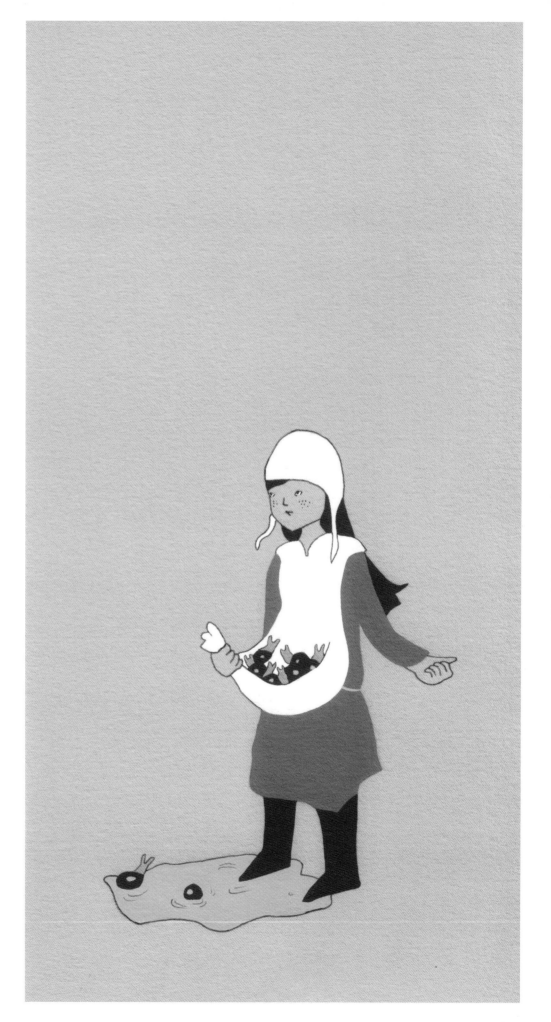

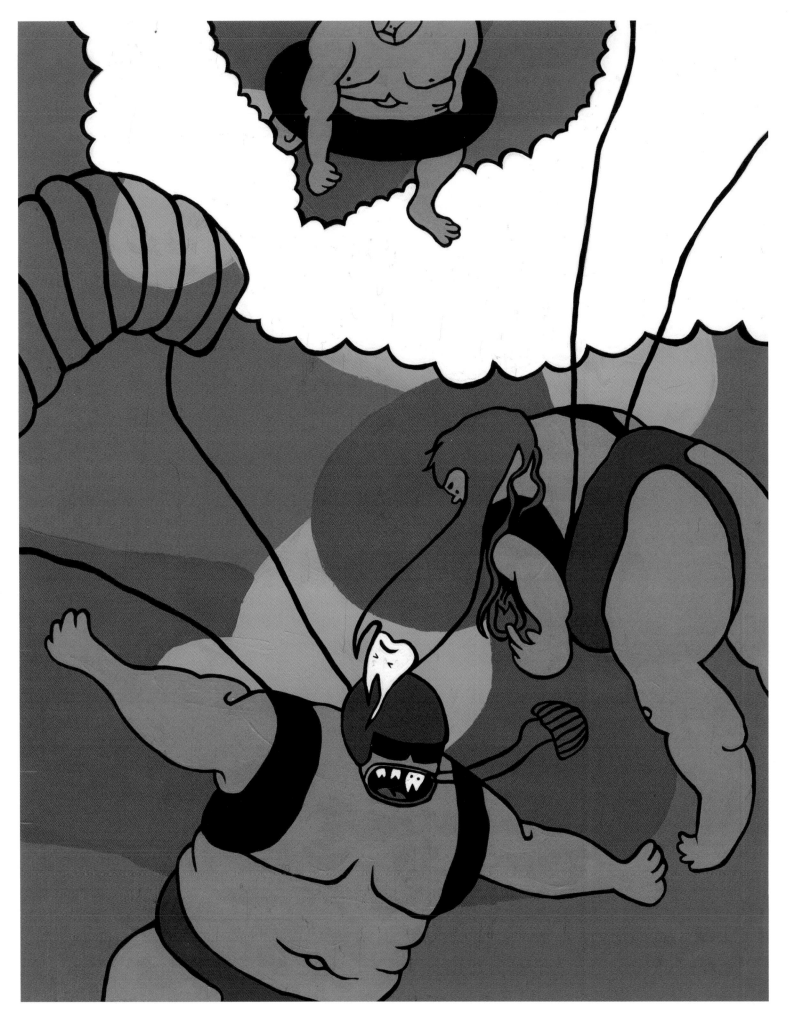

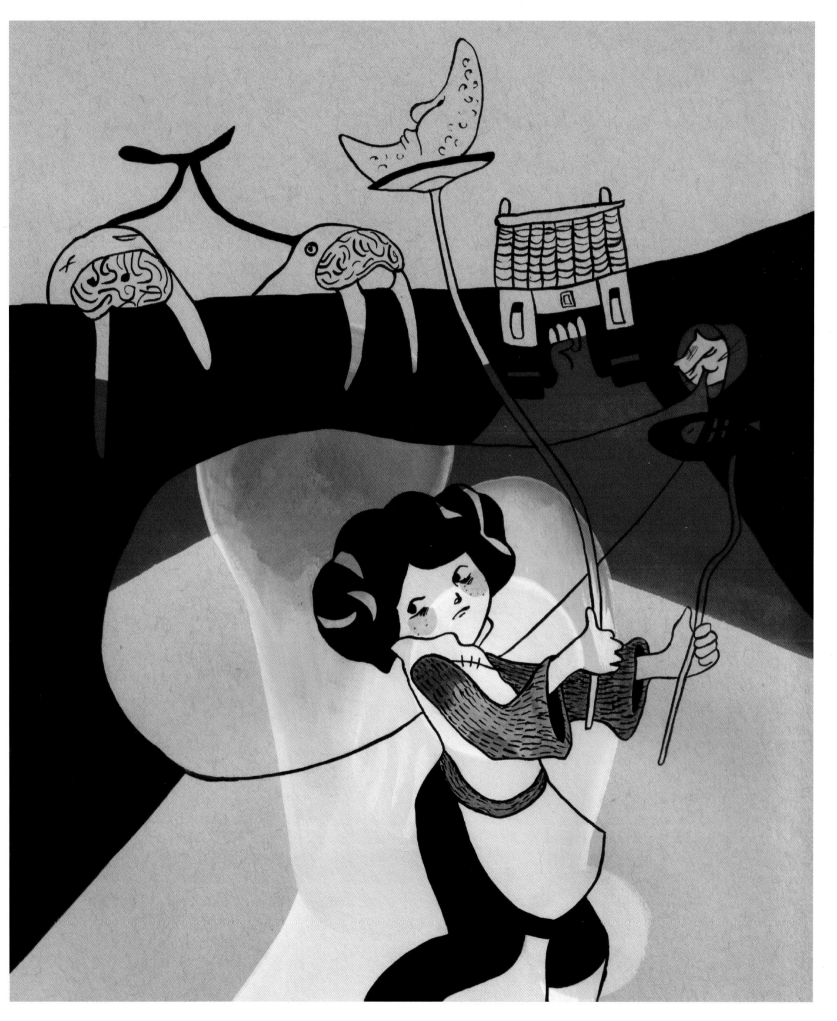

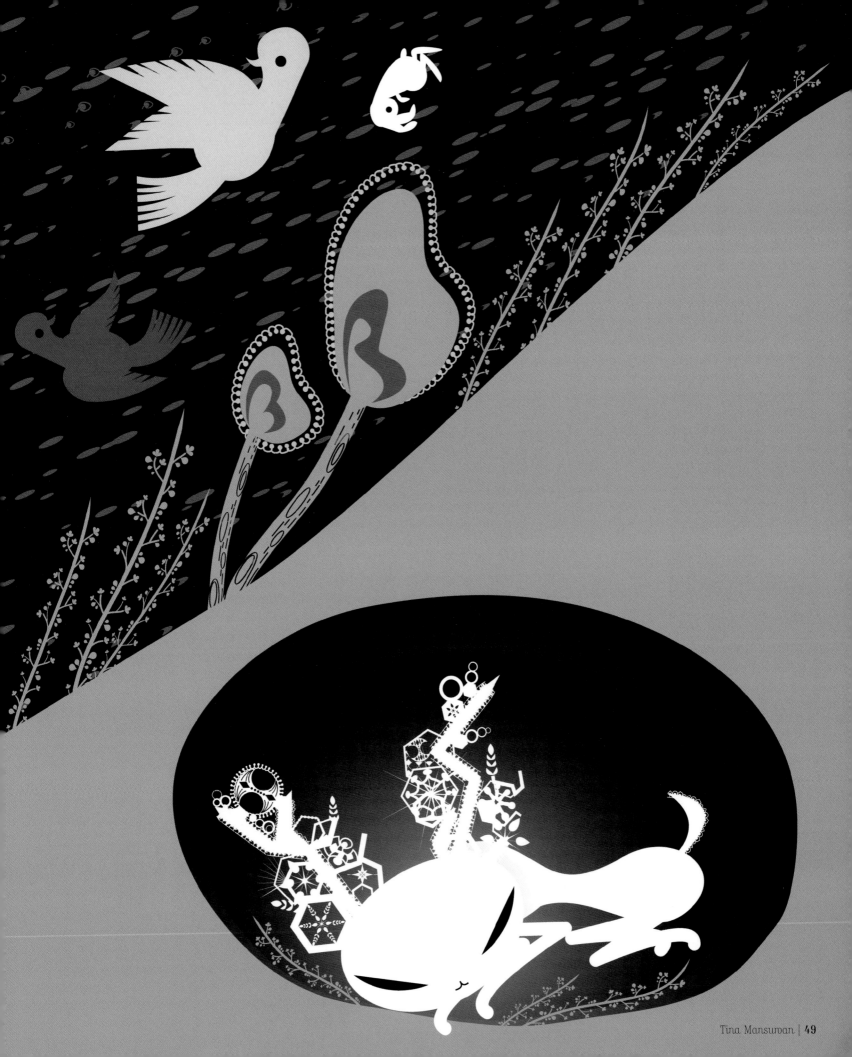

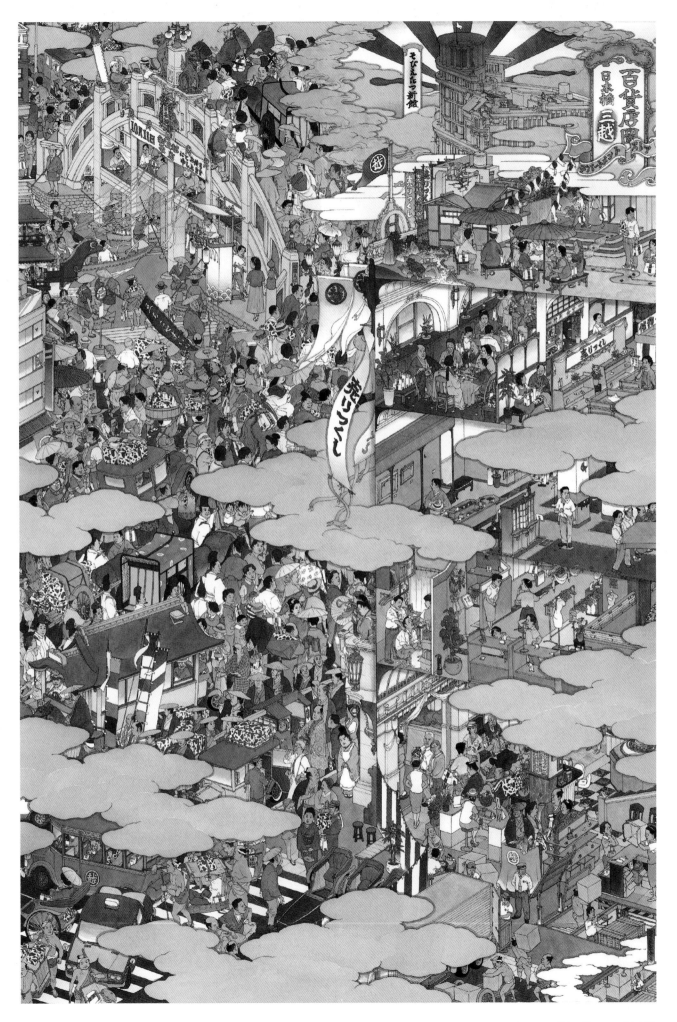

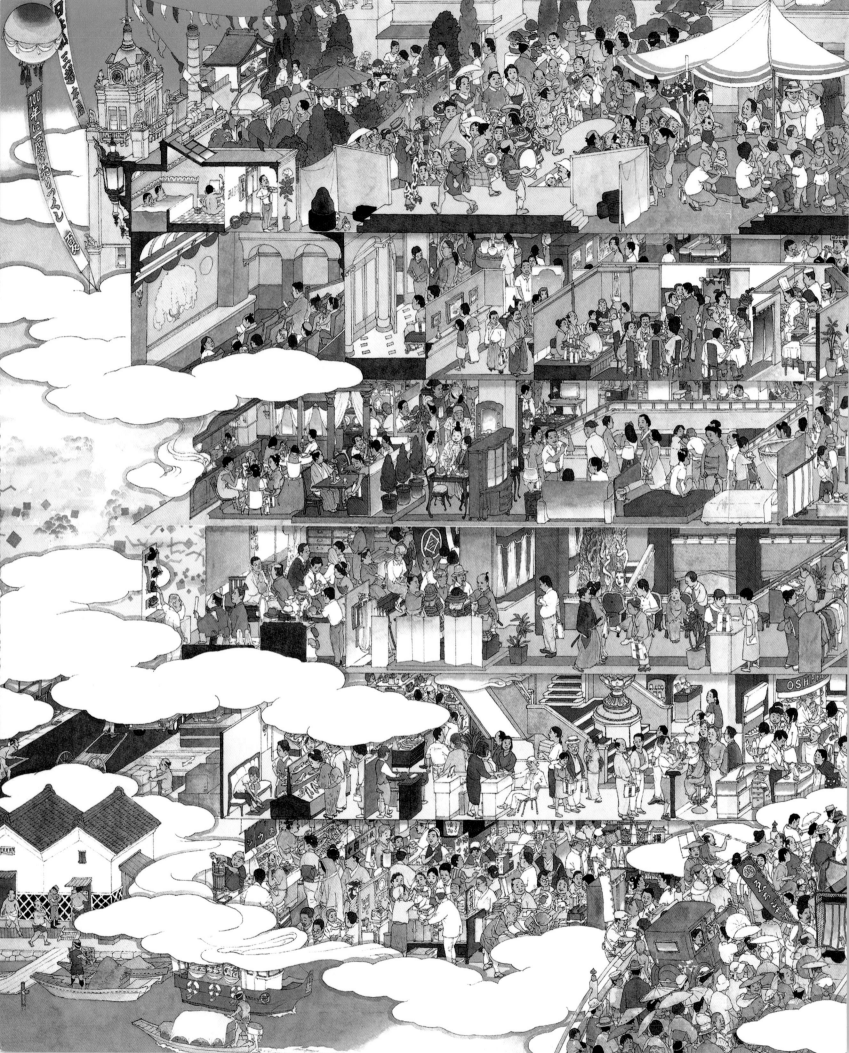

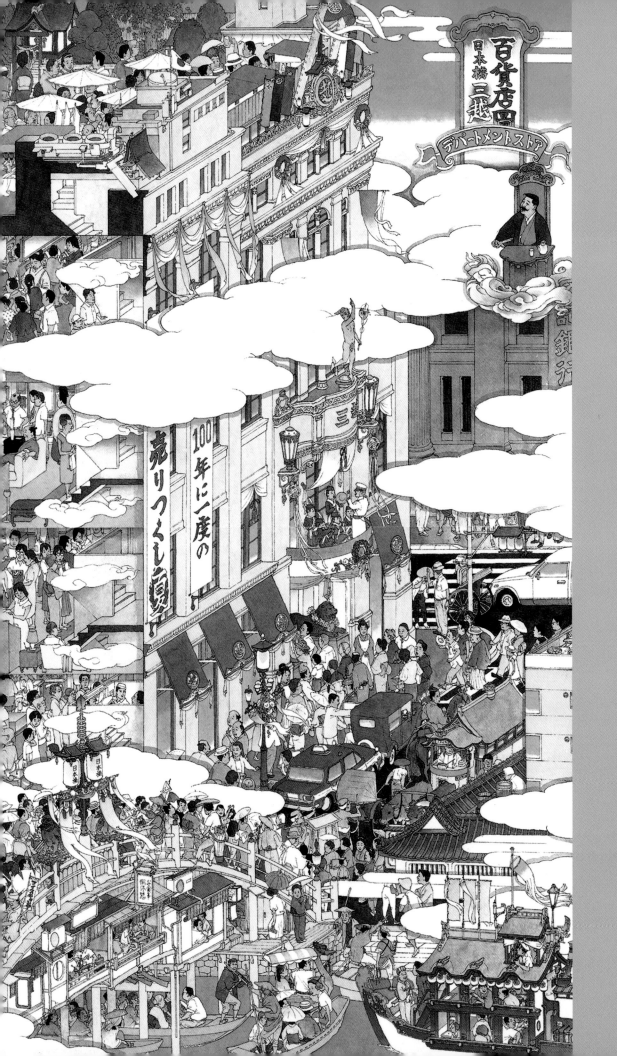

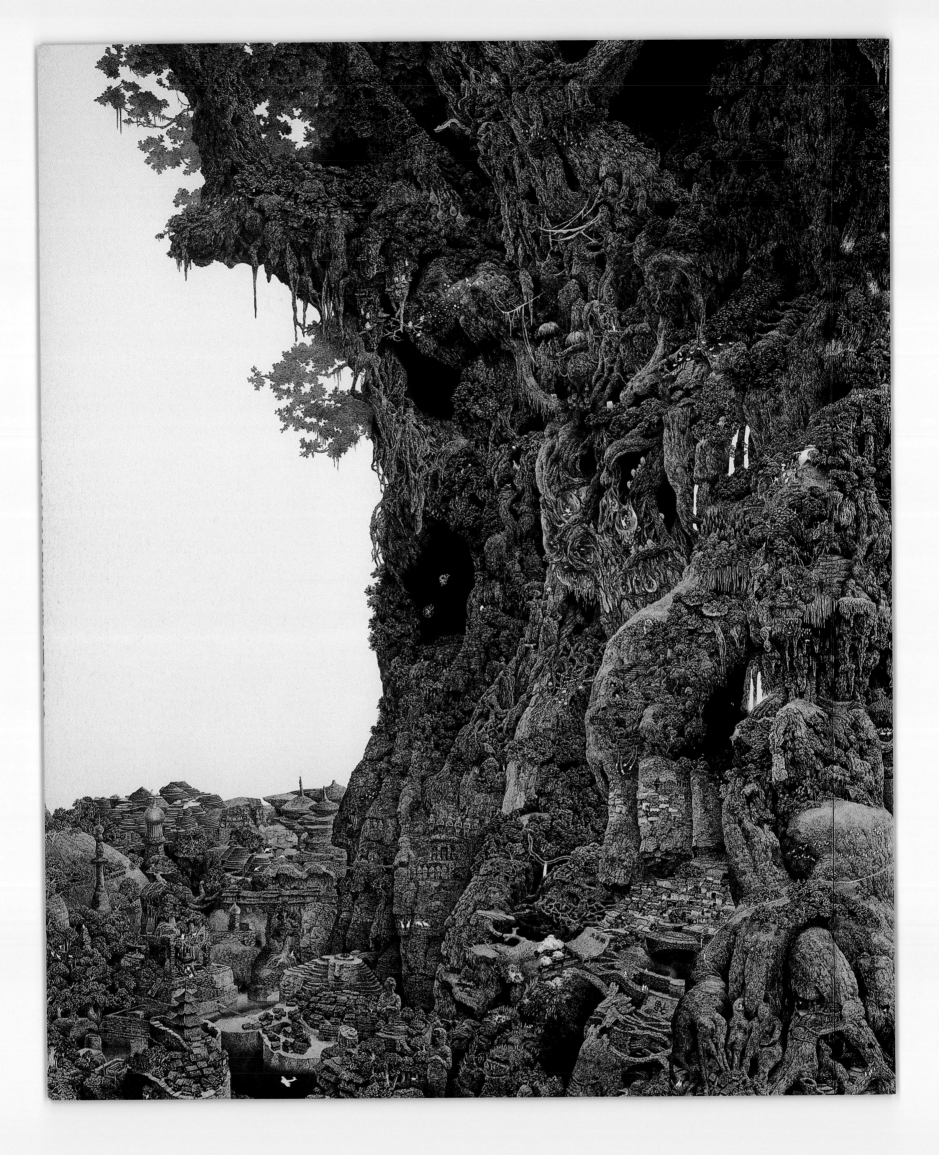

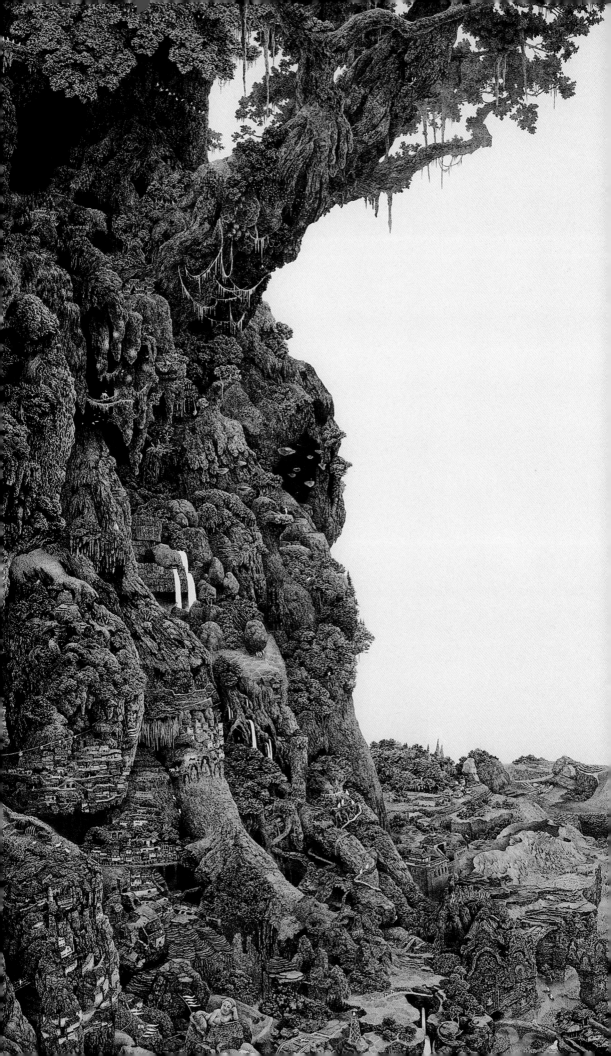

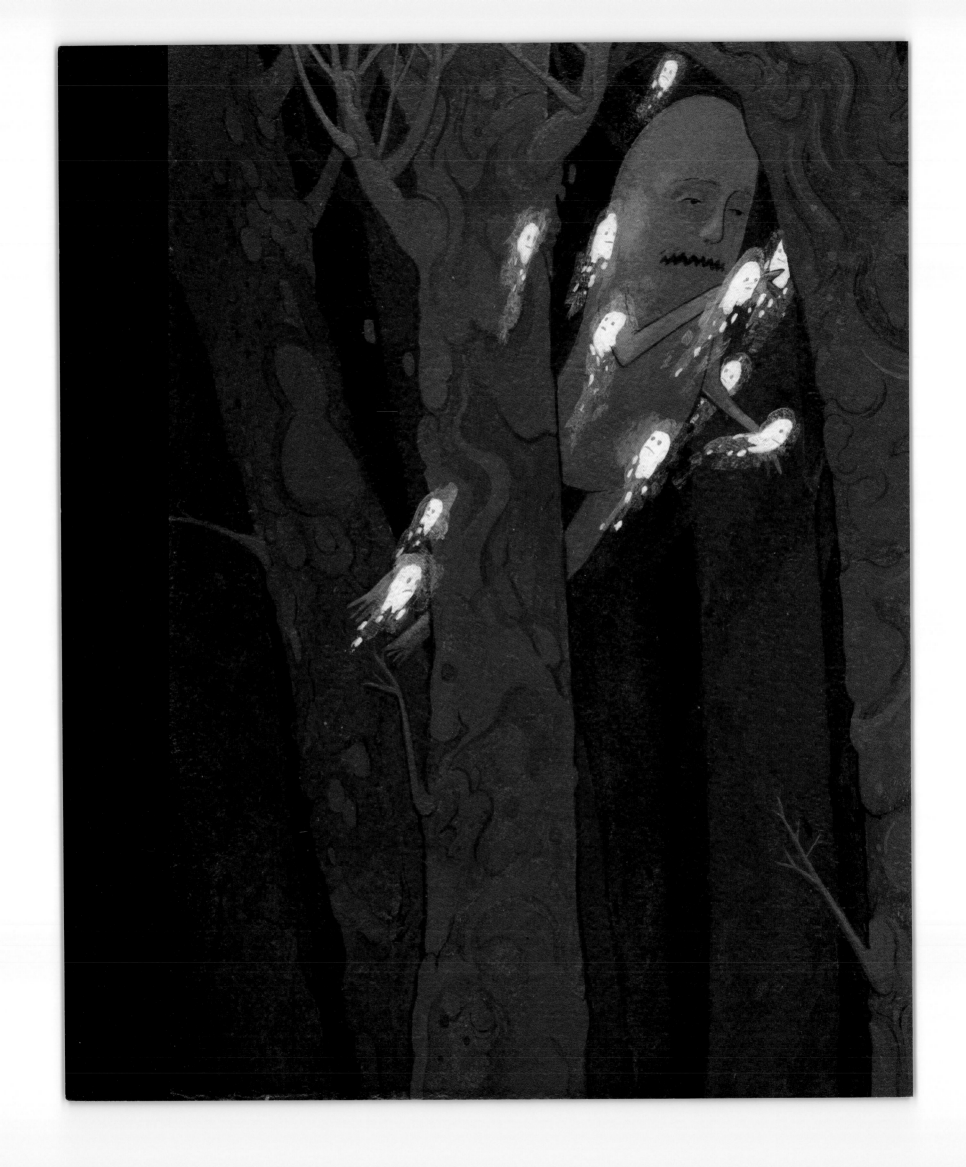

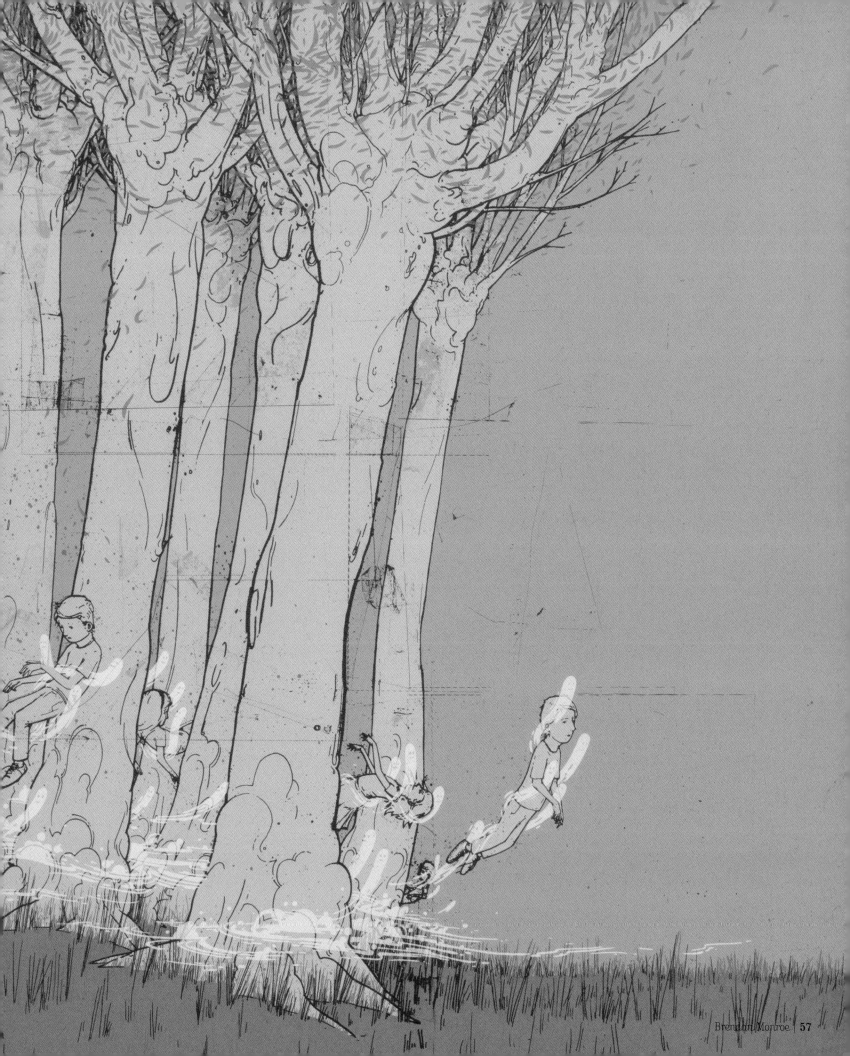

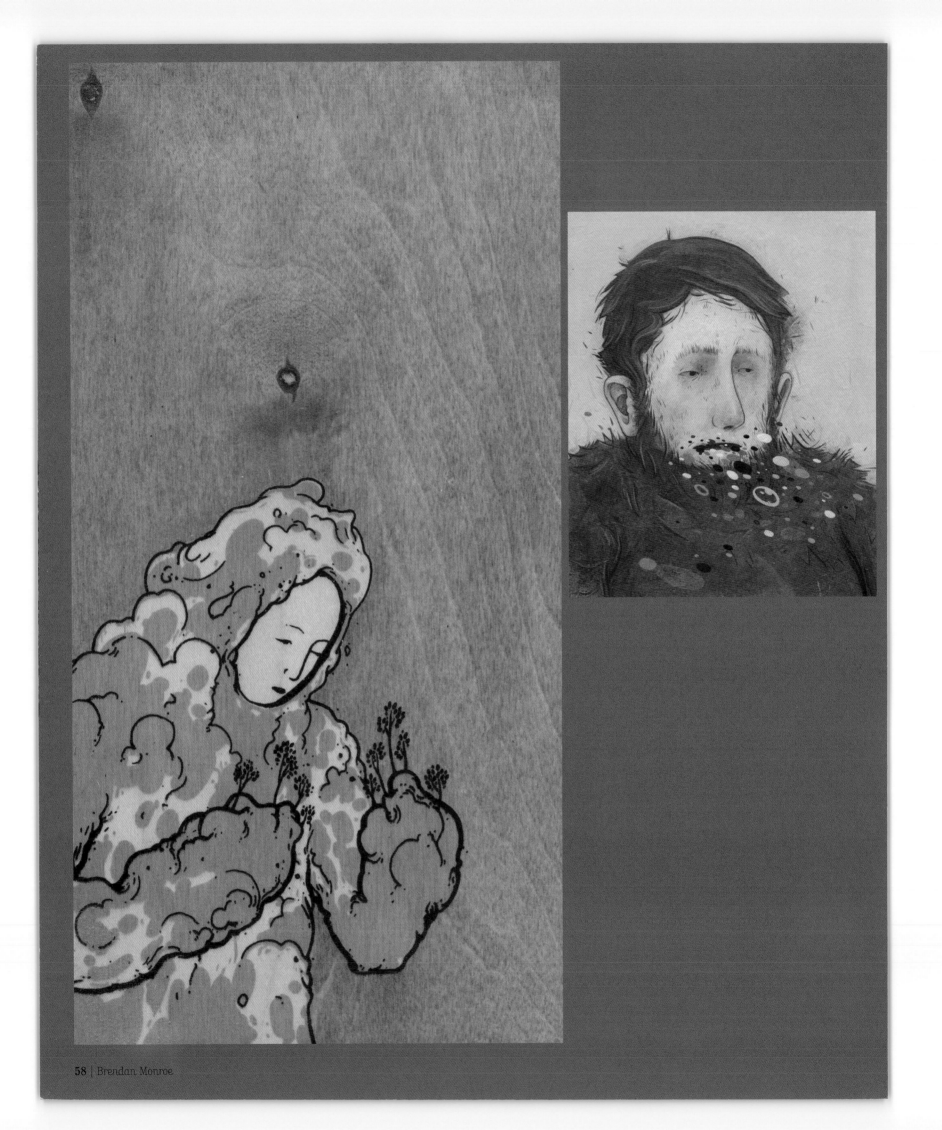

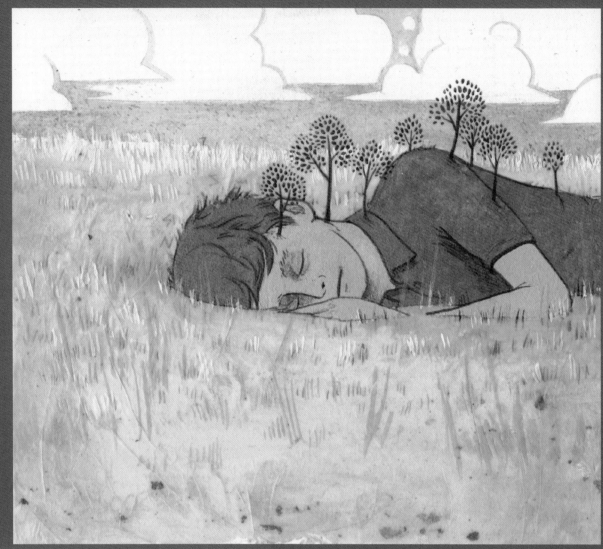

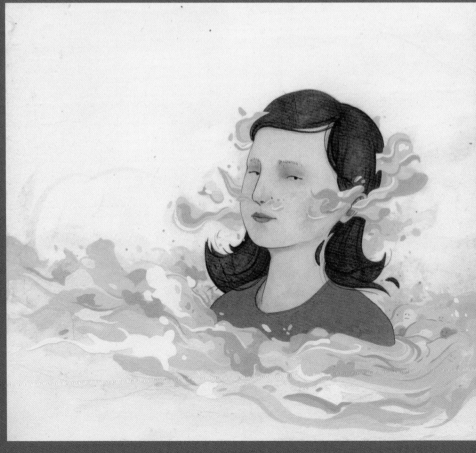

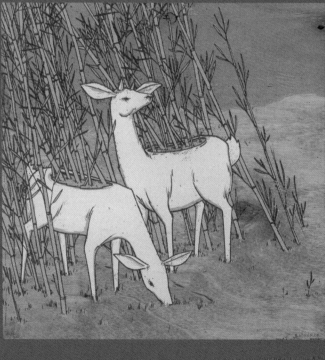

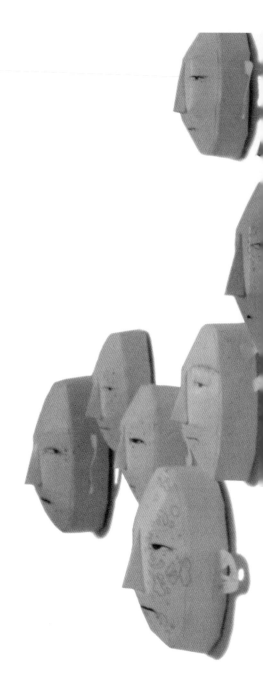

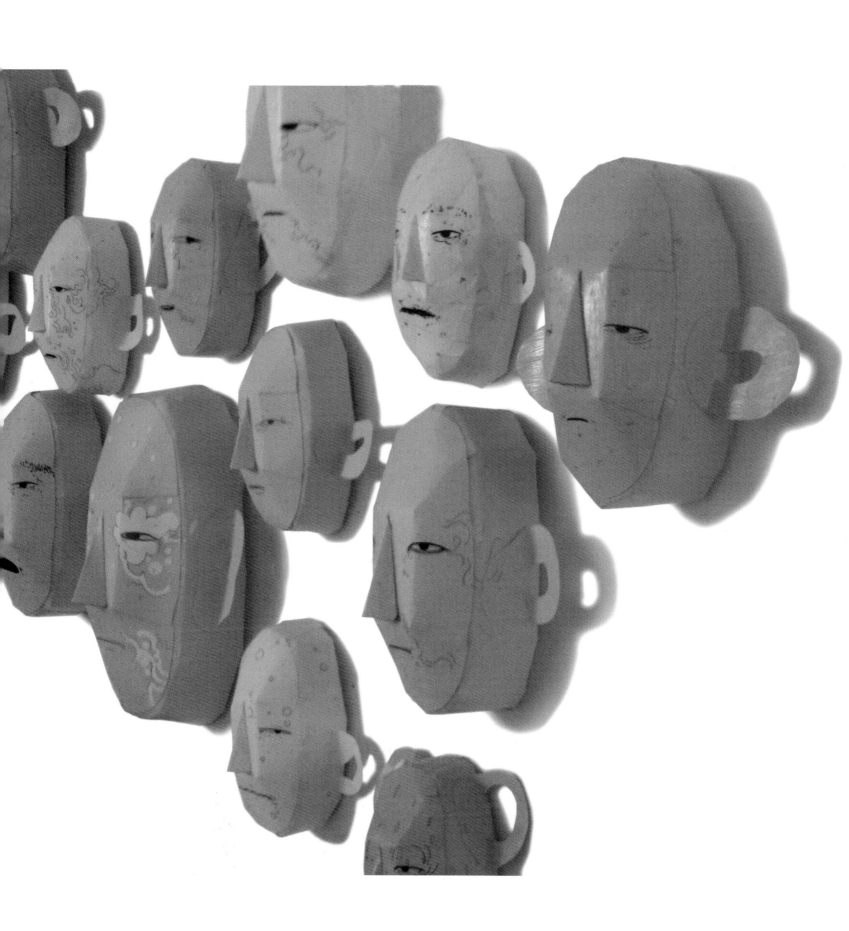

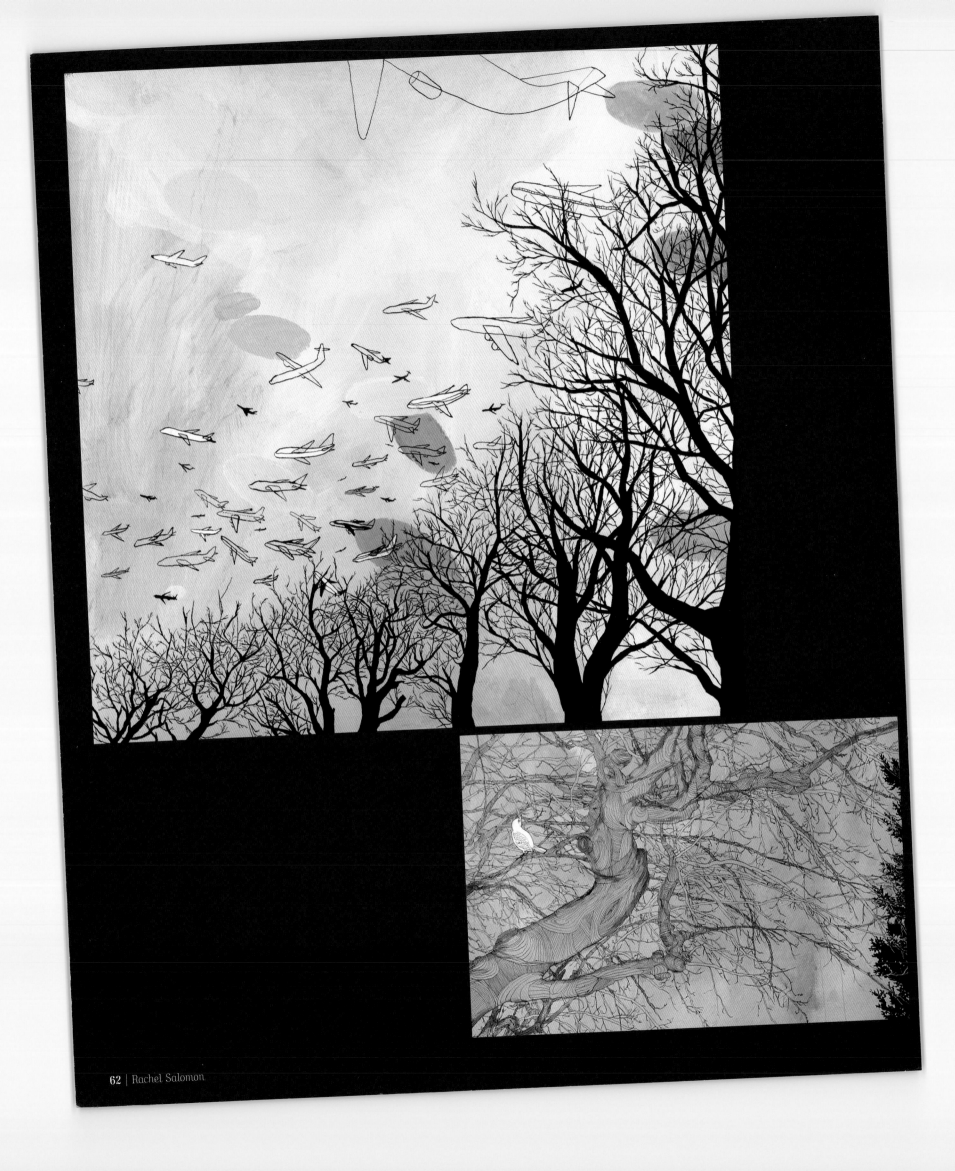

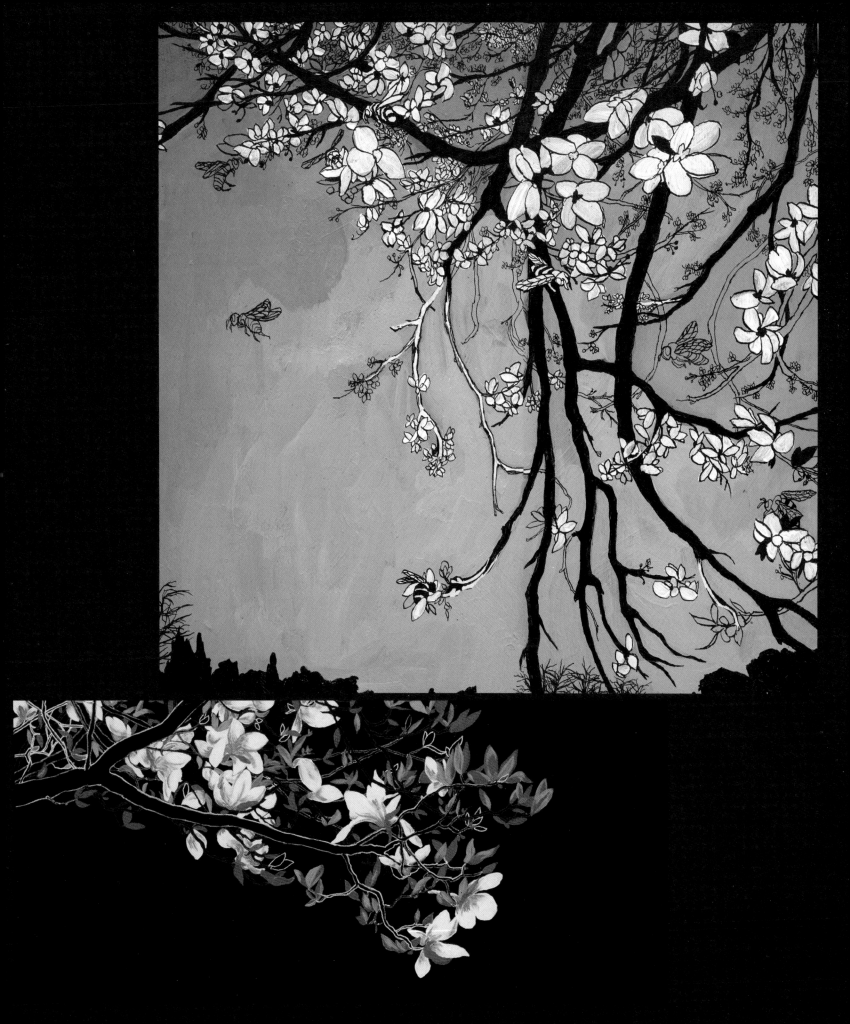

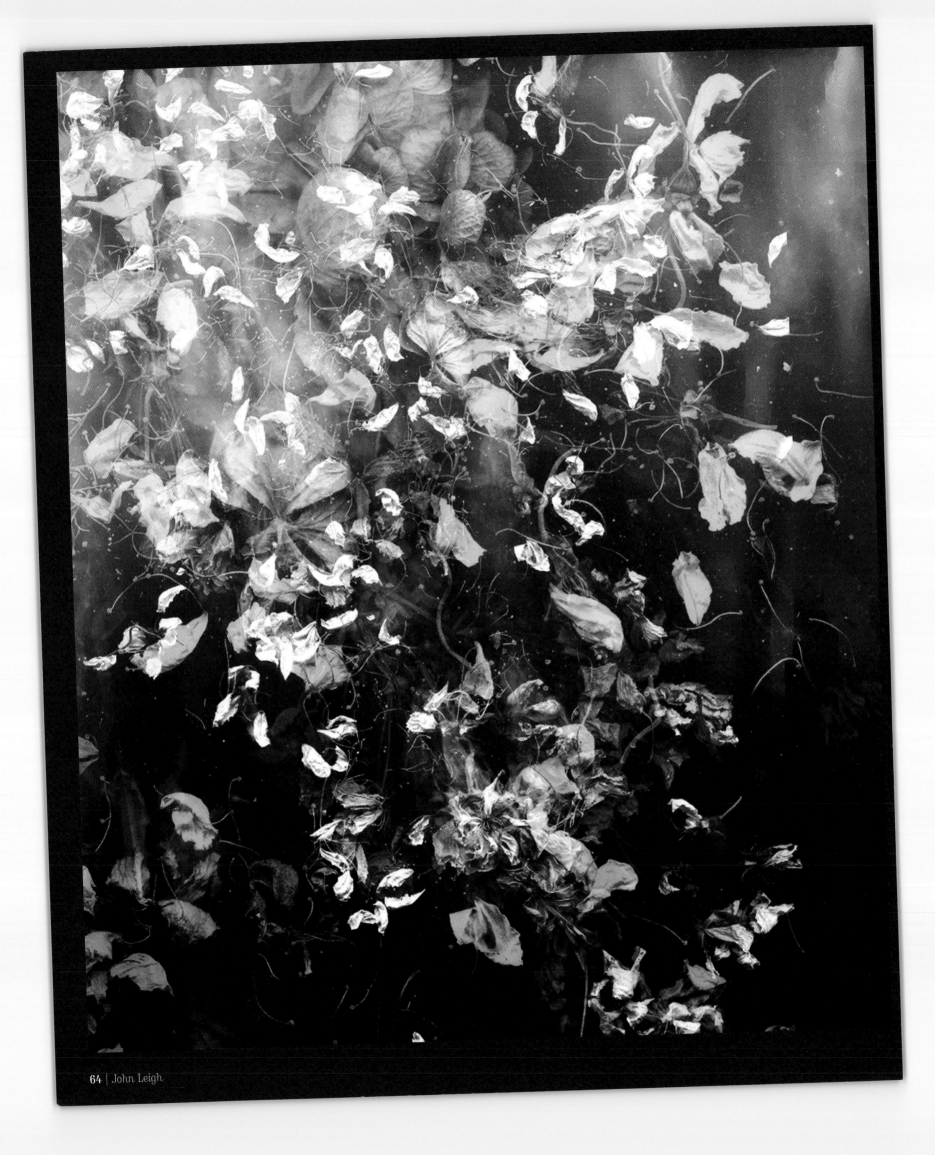

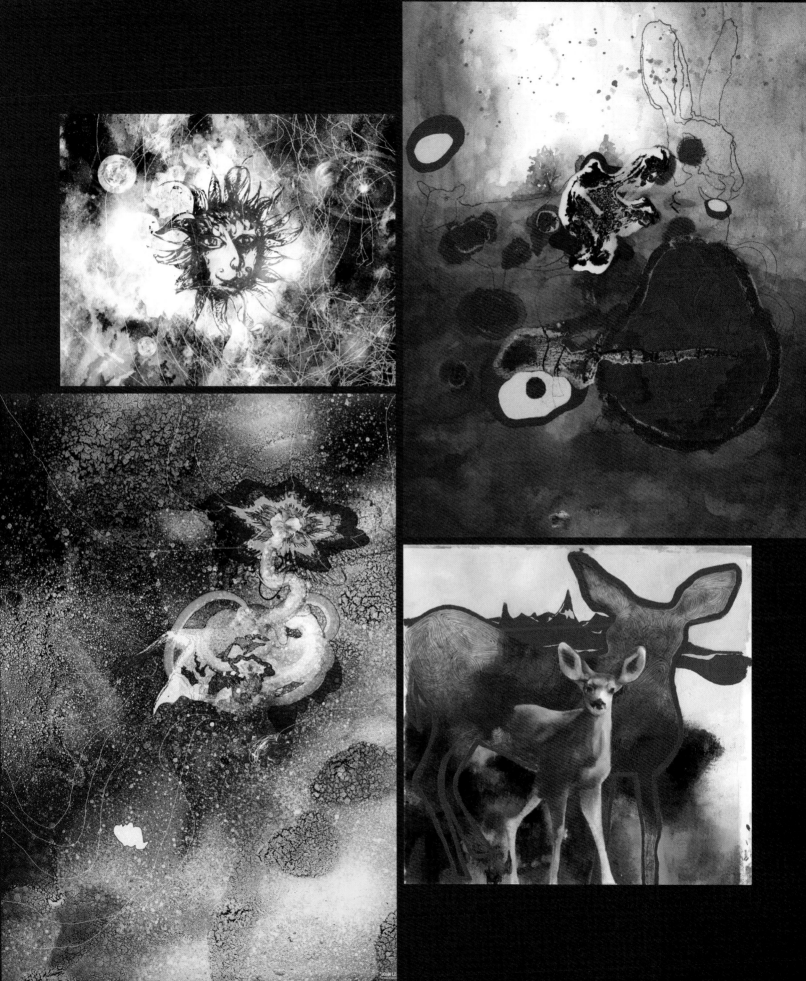

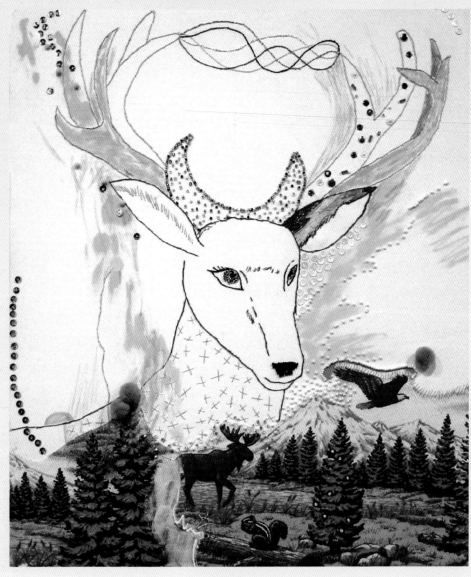

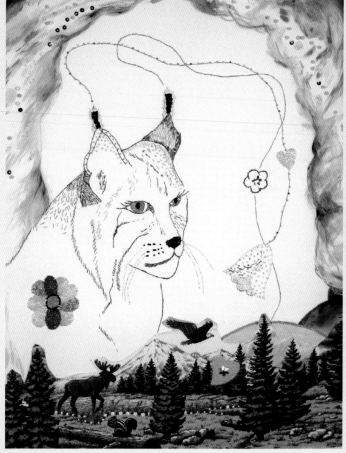

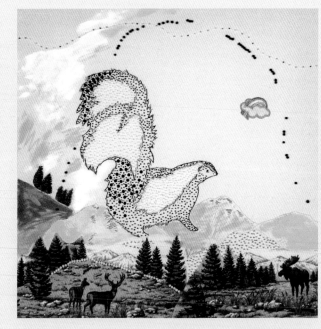

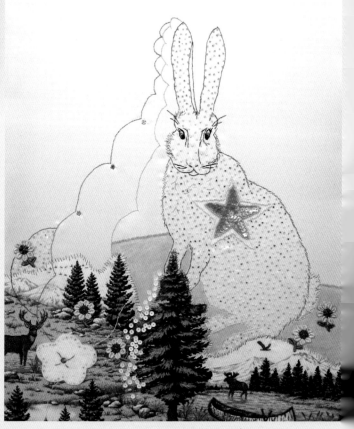

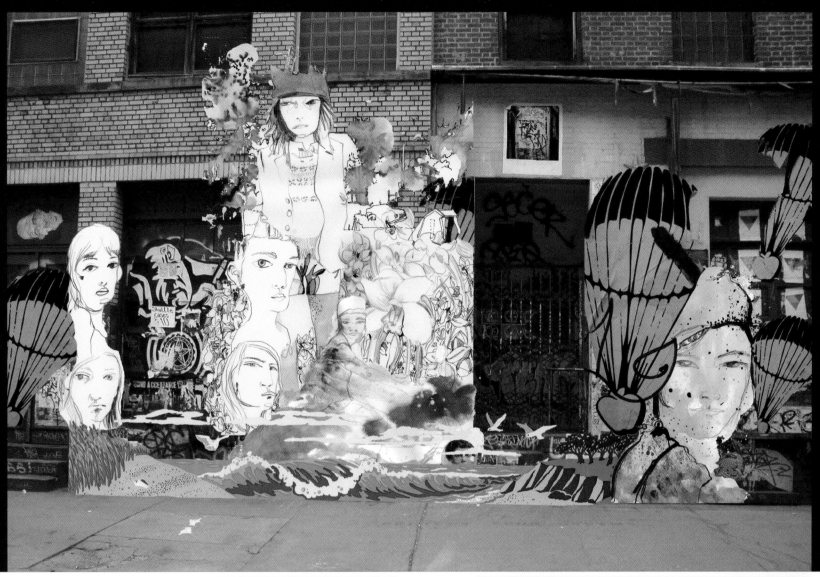

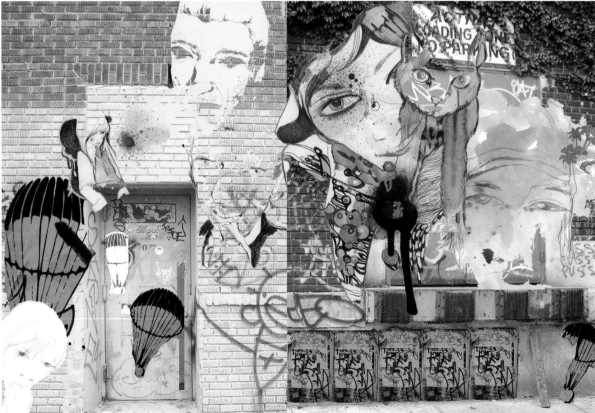

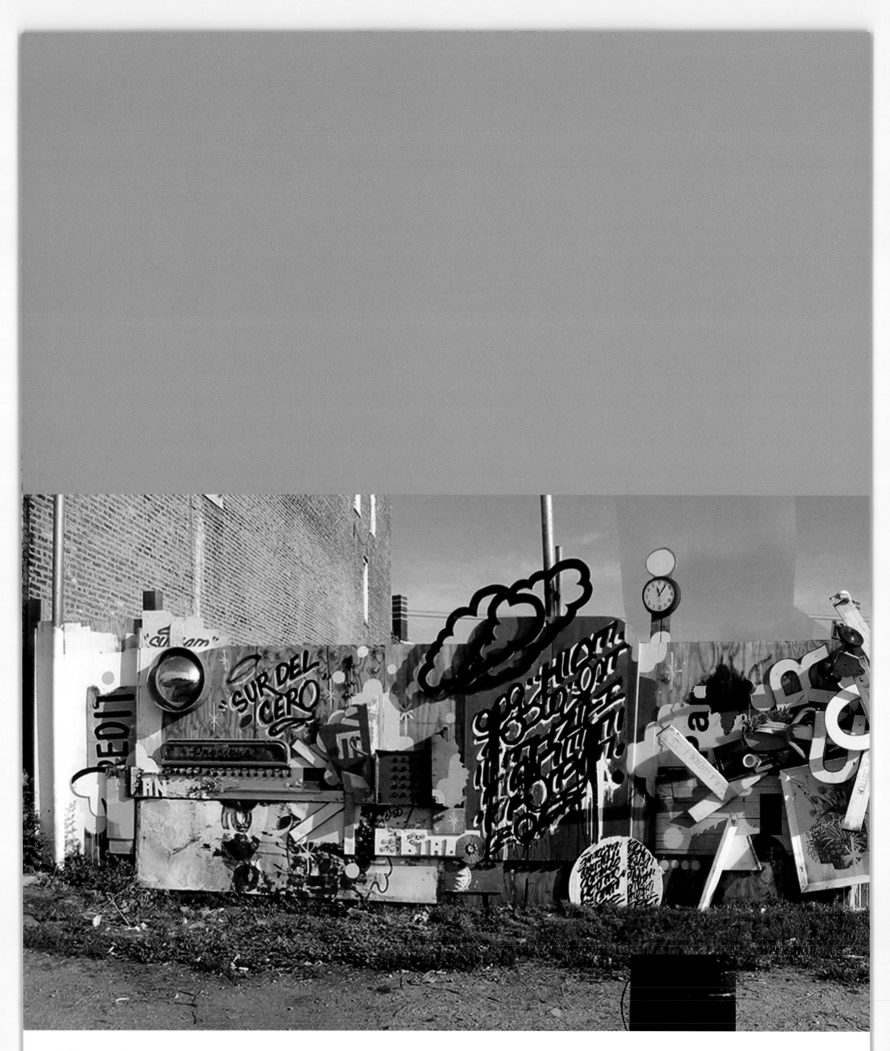

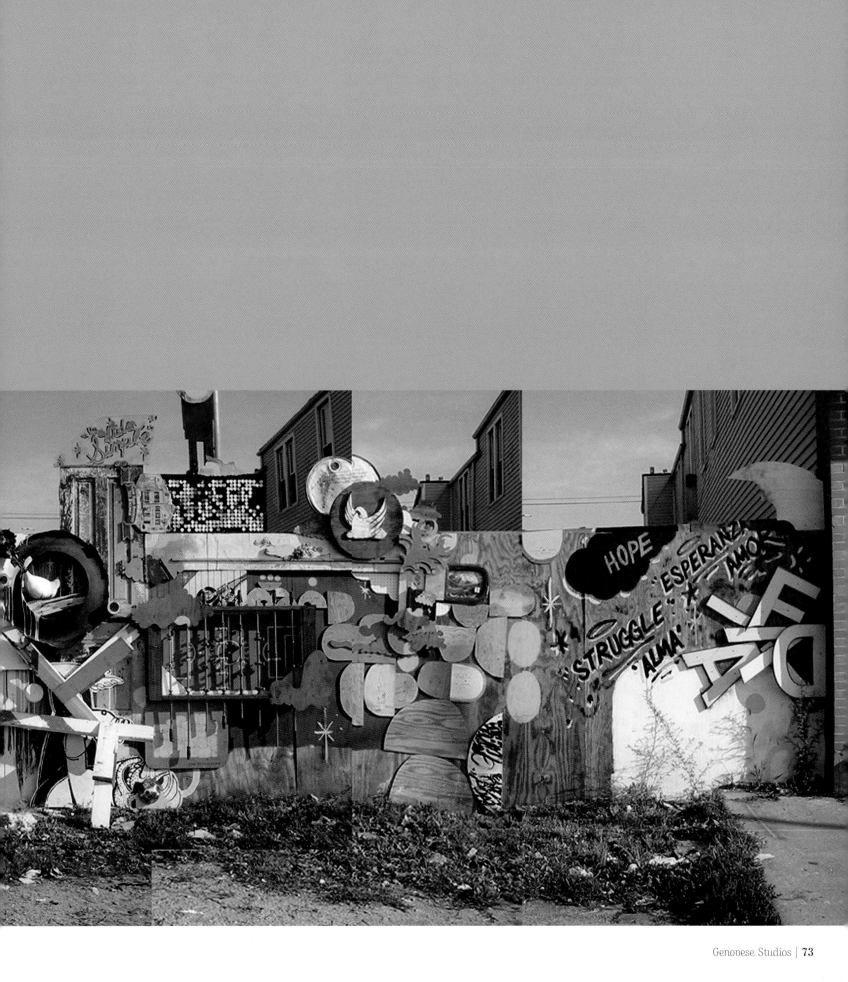

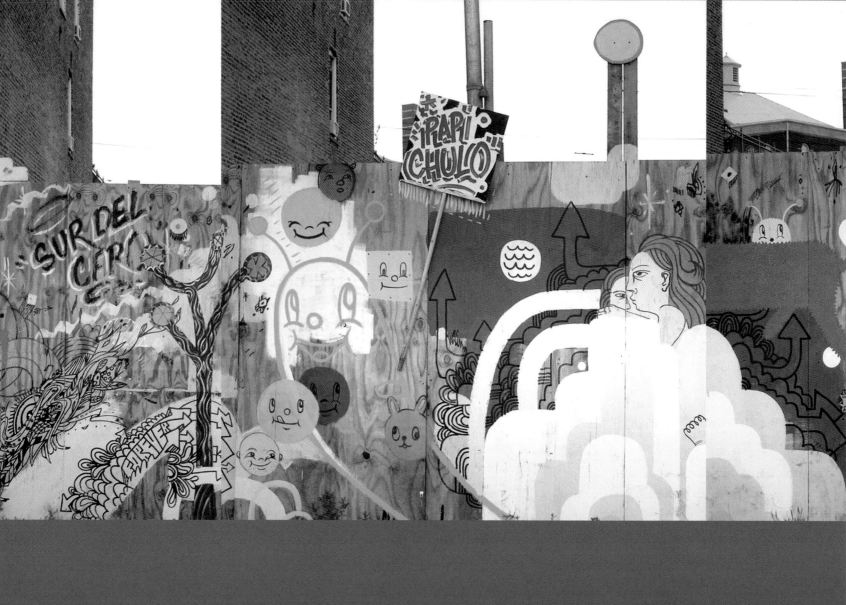

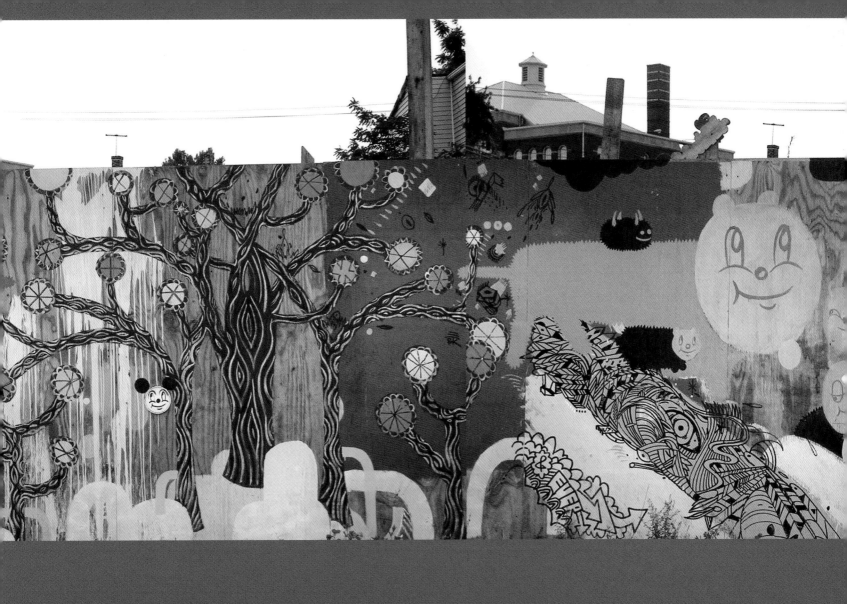

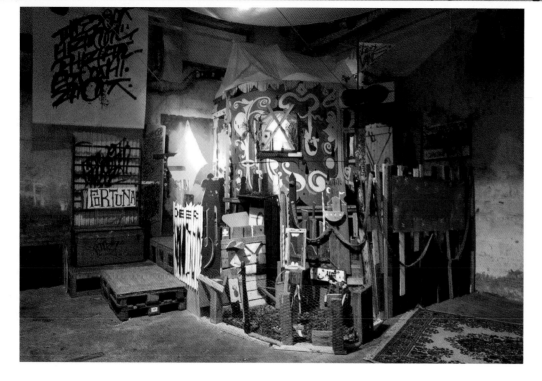

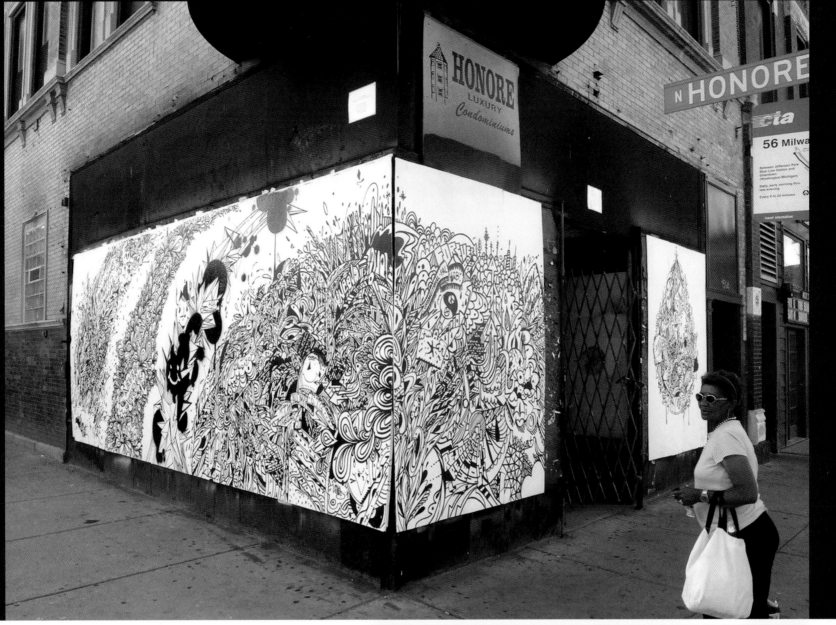

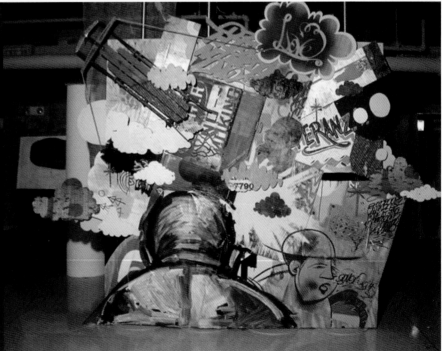

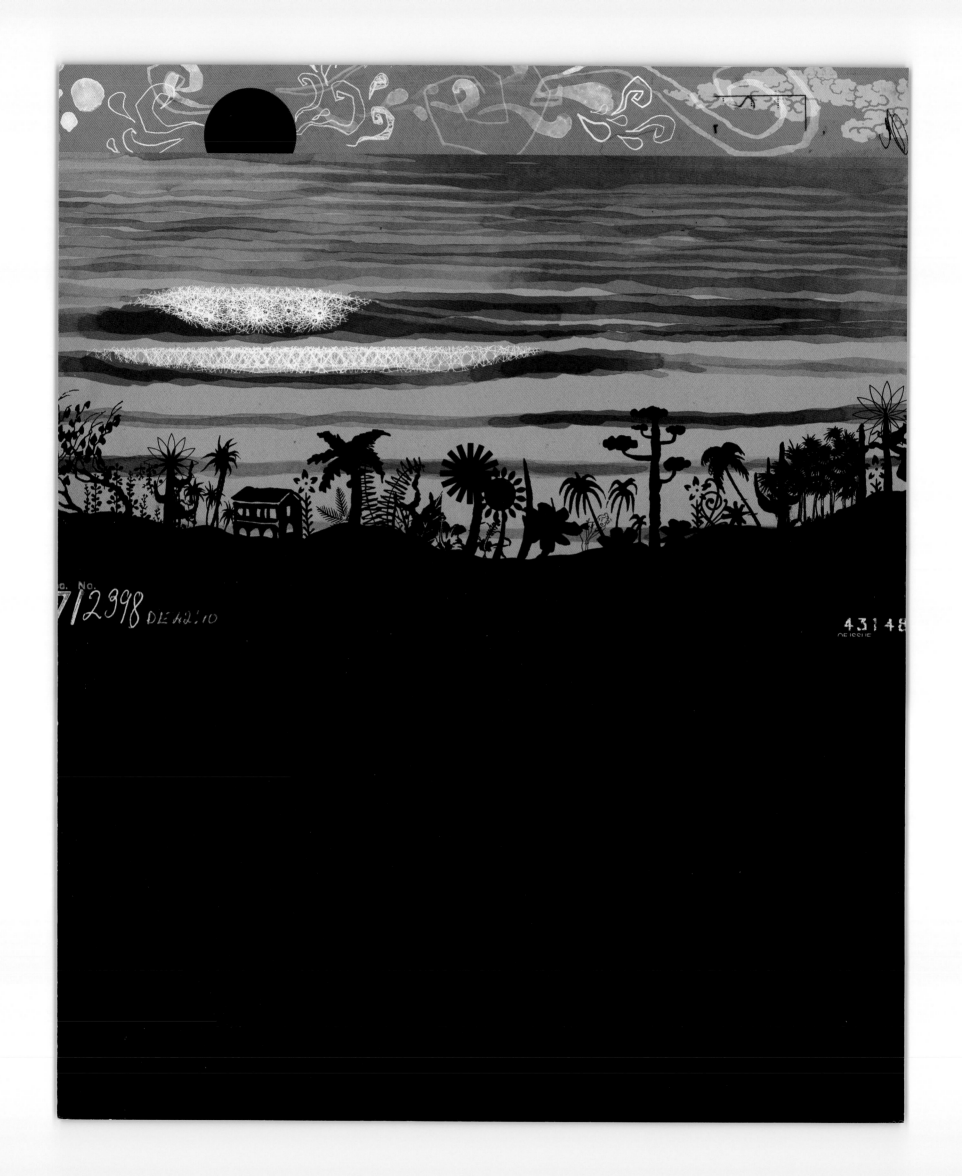

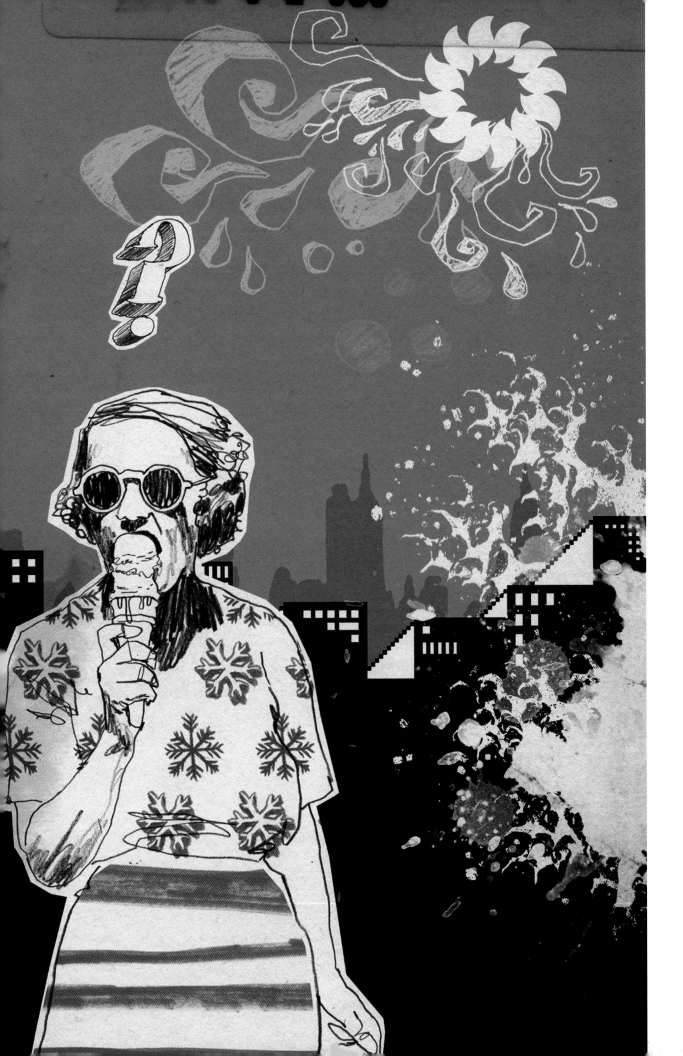

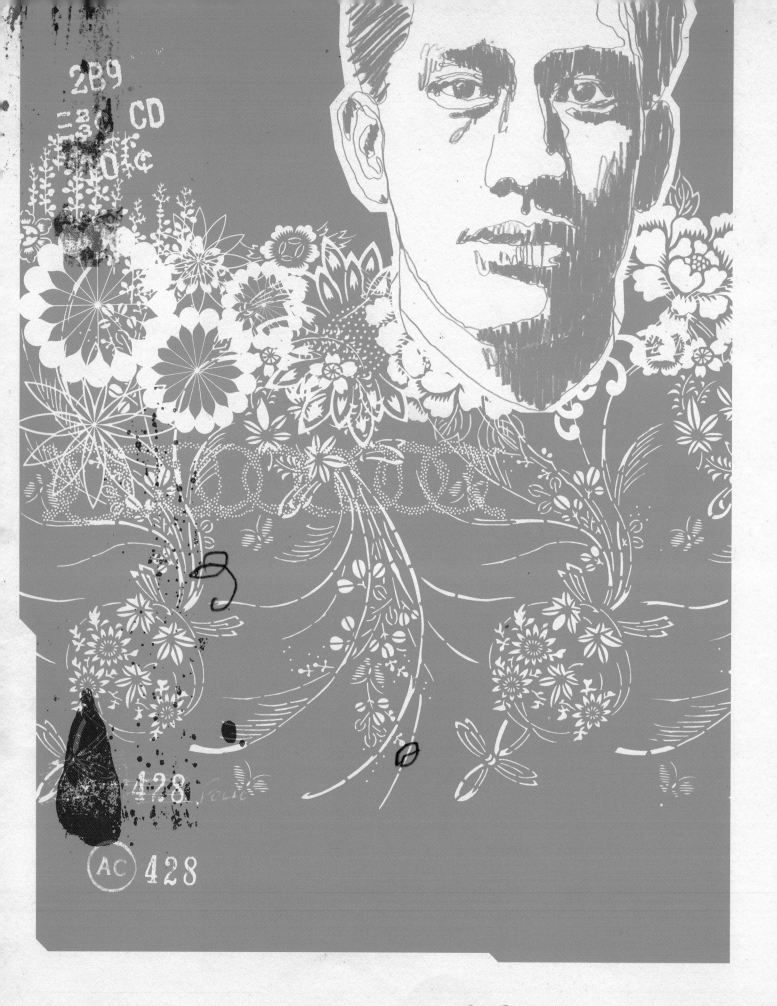

E 000028177.

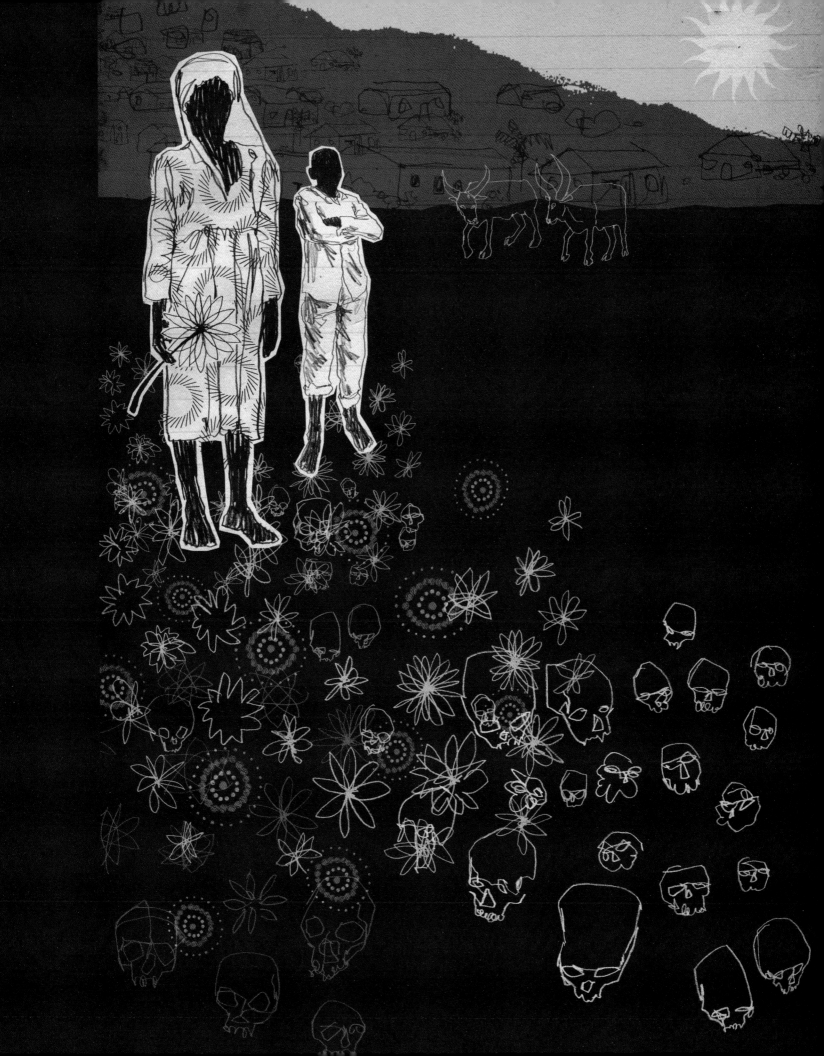

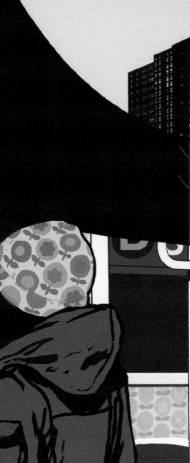

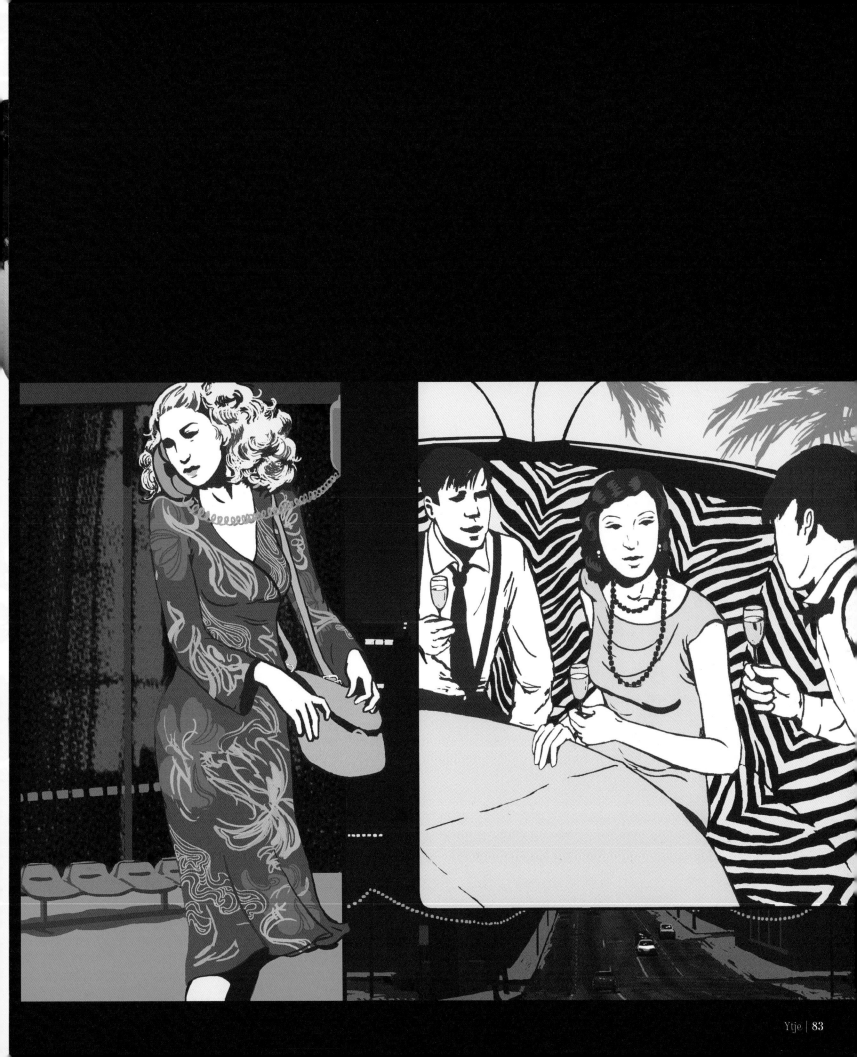

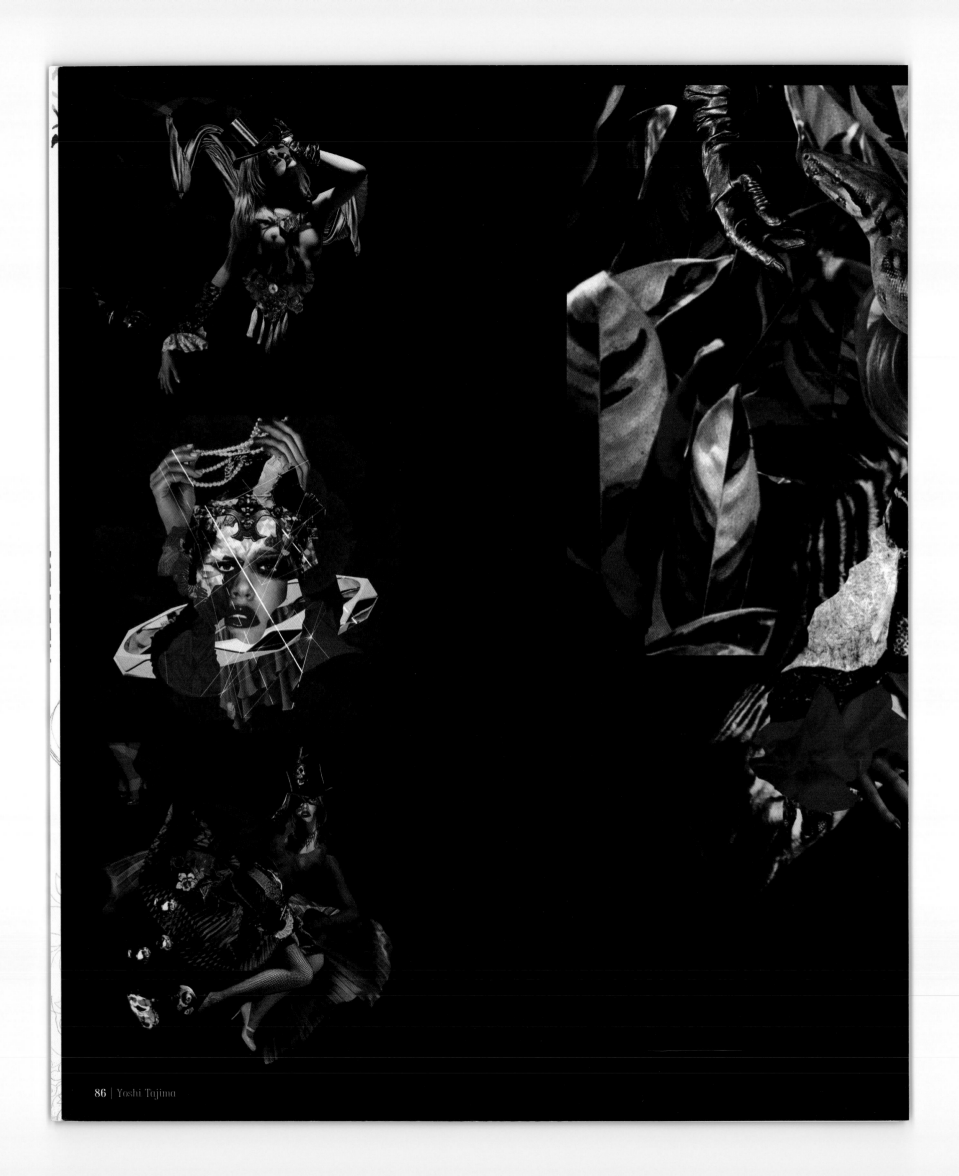

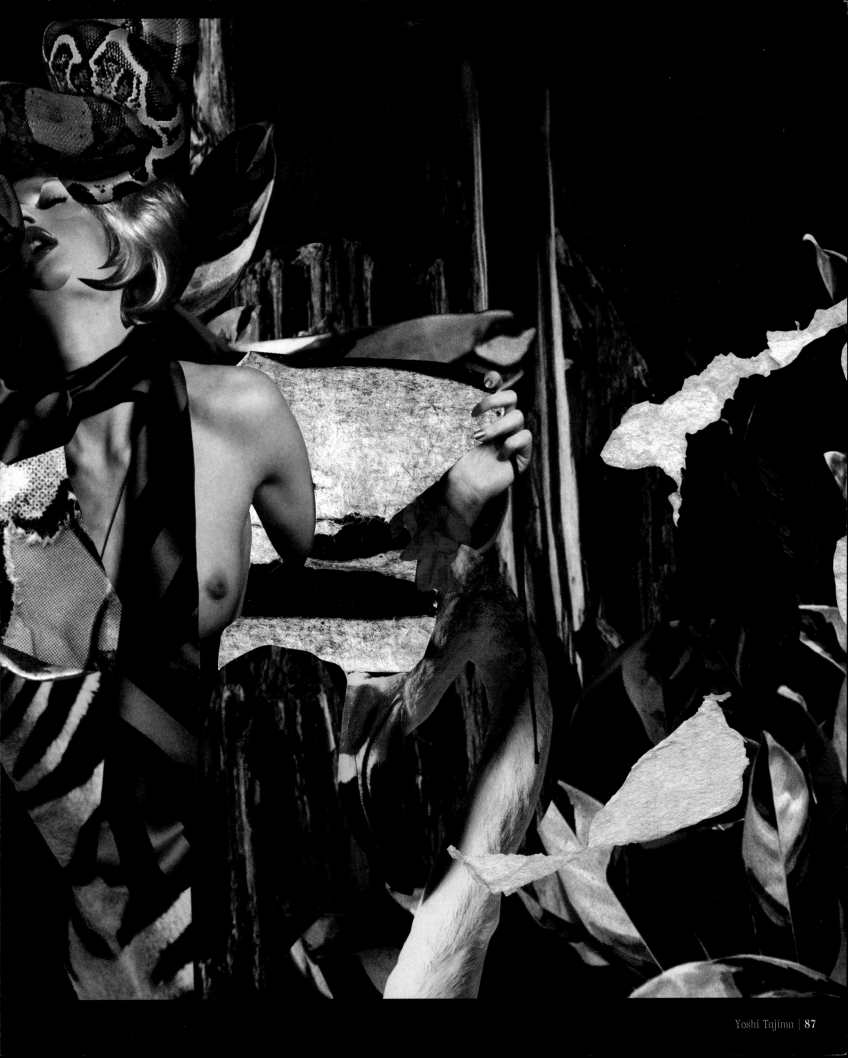

Yoshi Tajima | 87

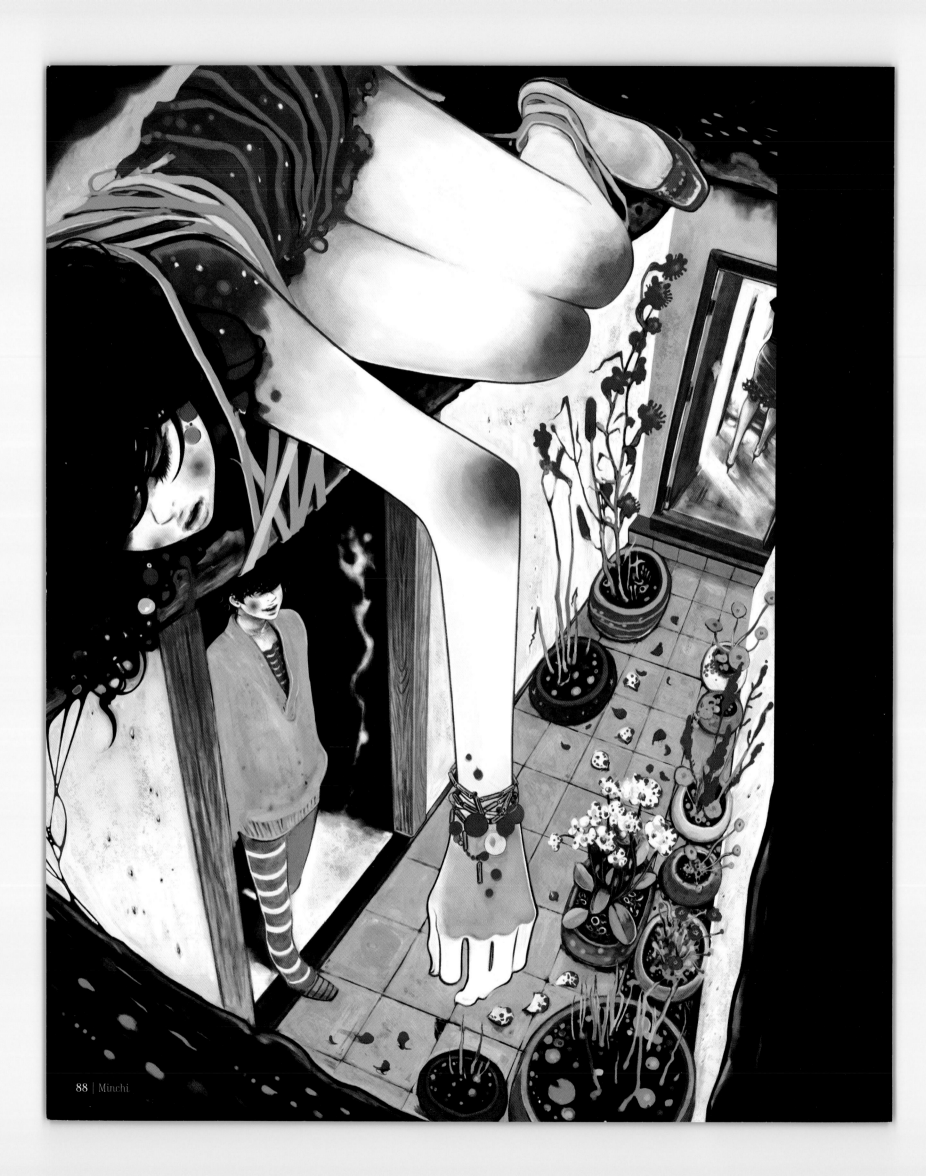

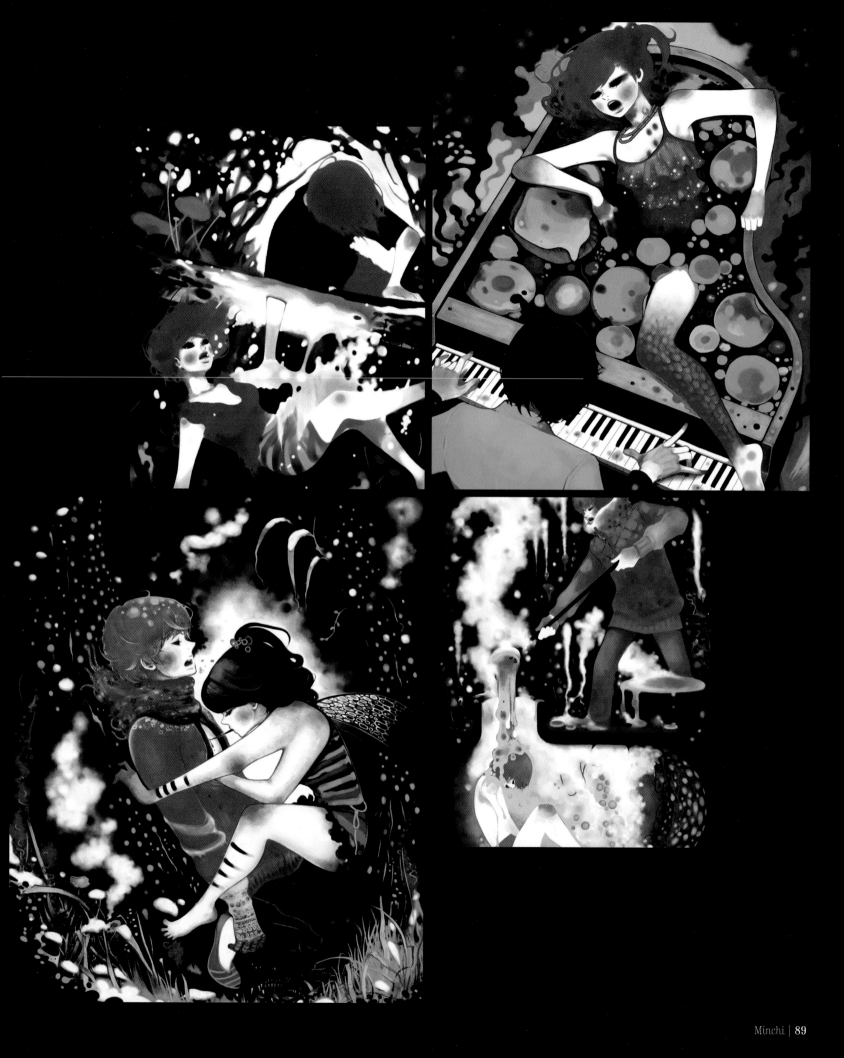

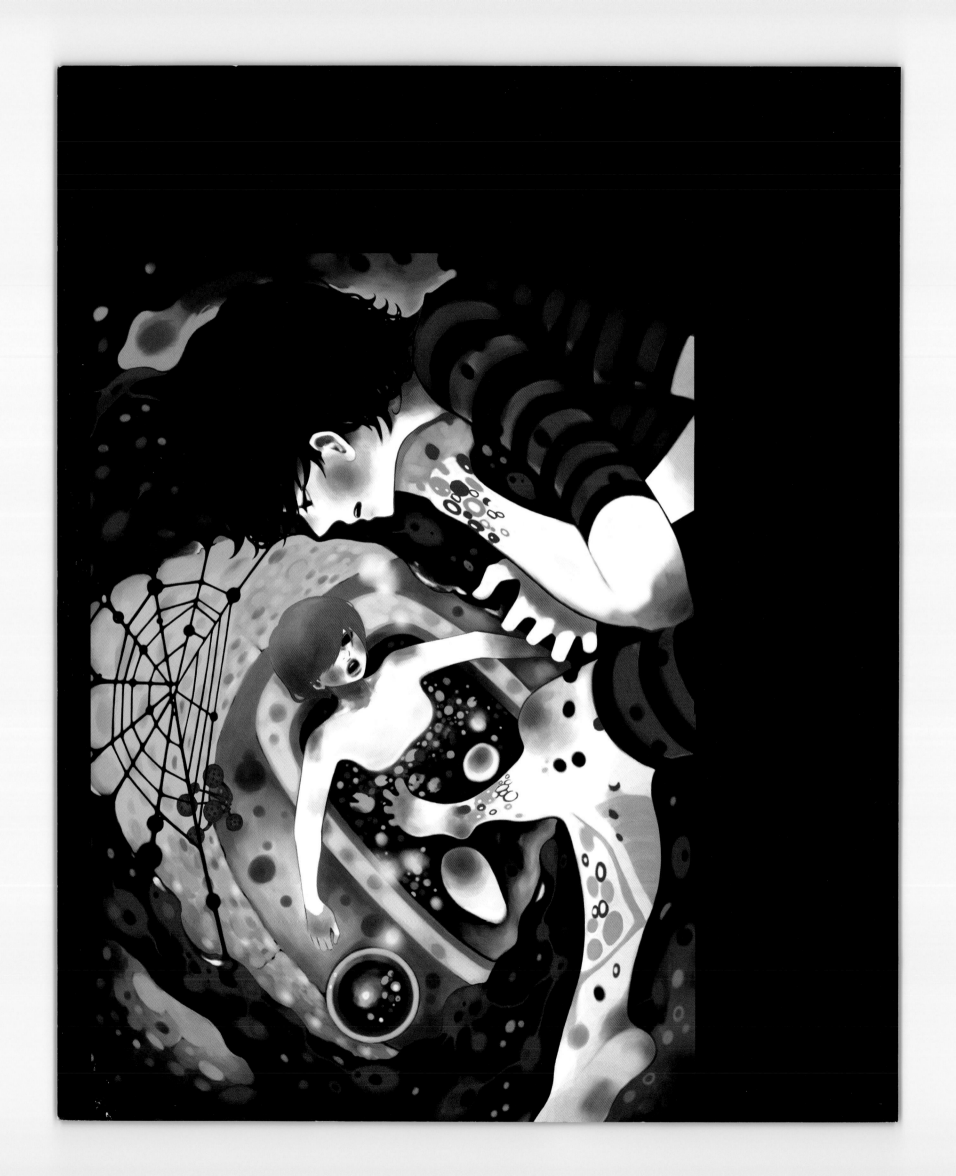

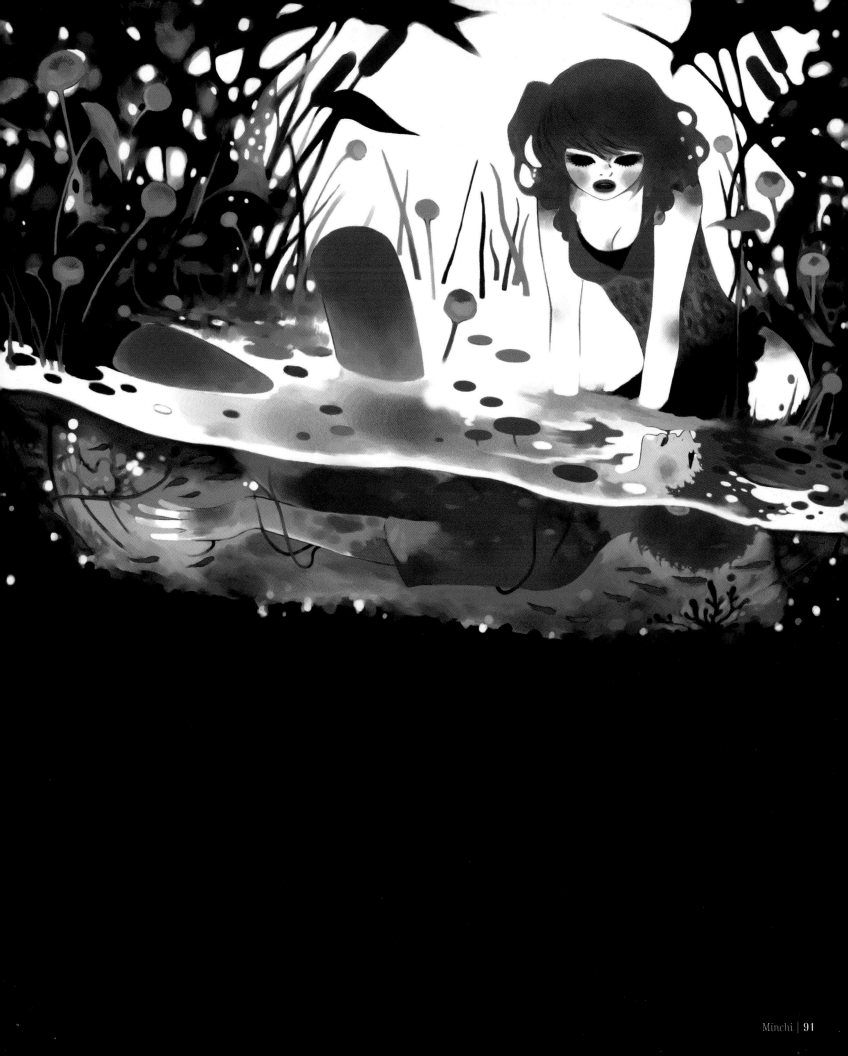

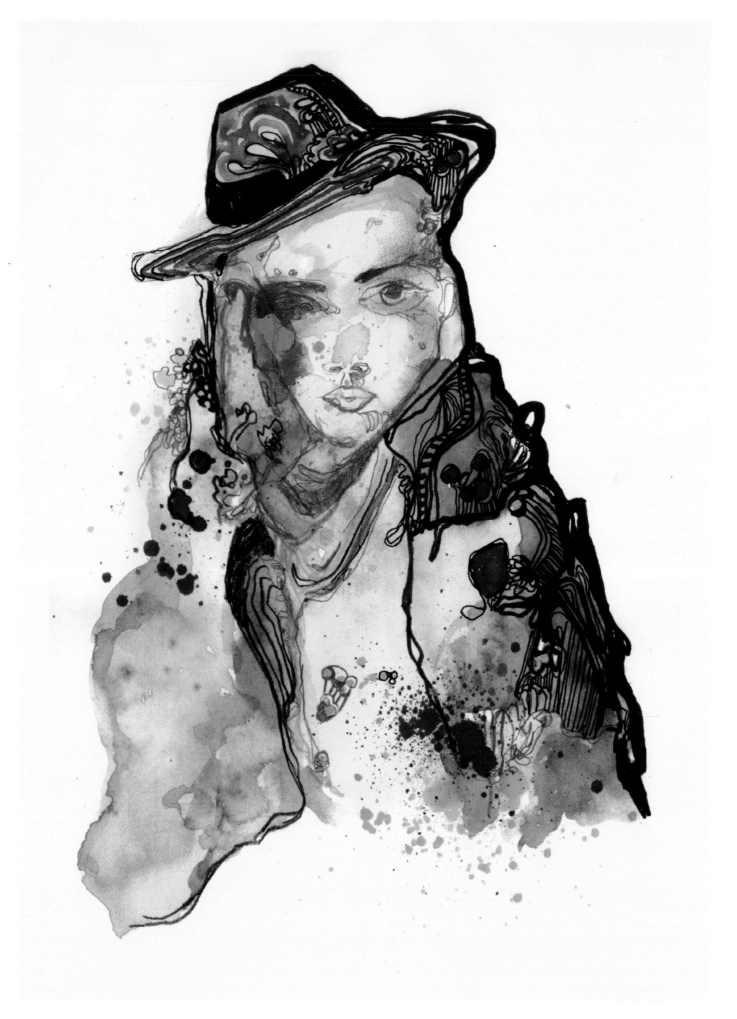

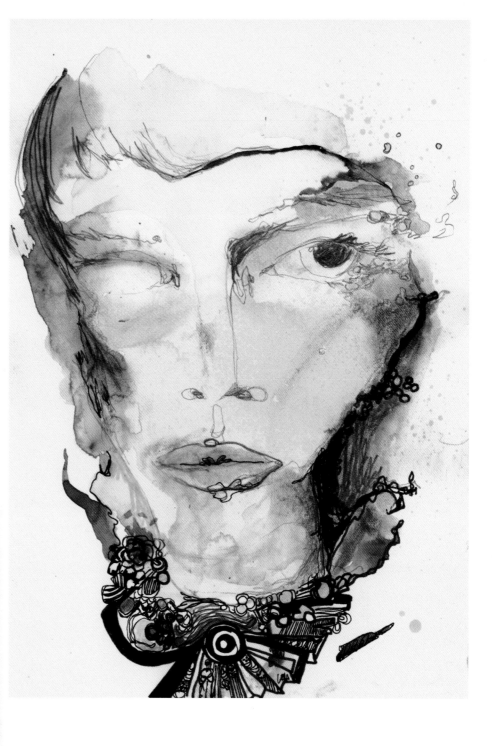

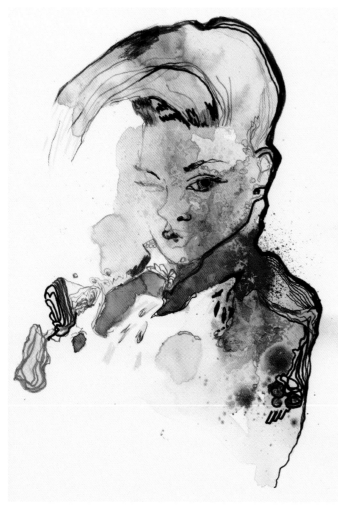

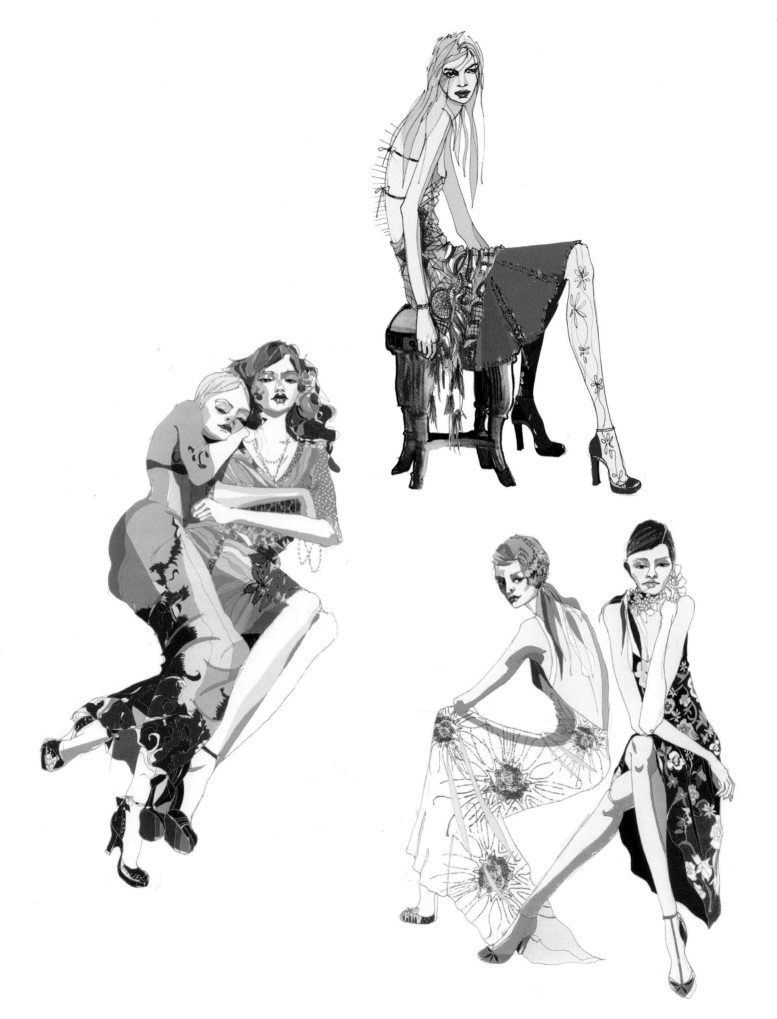

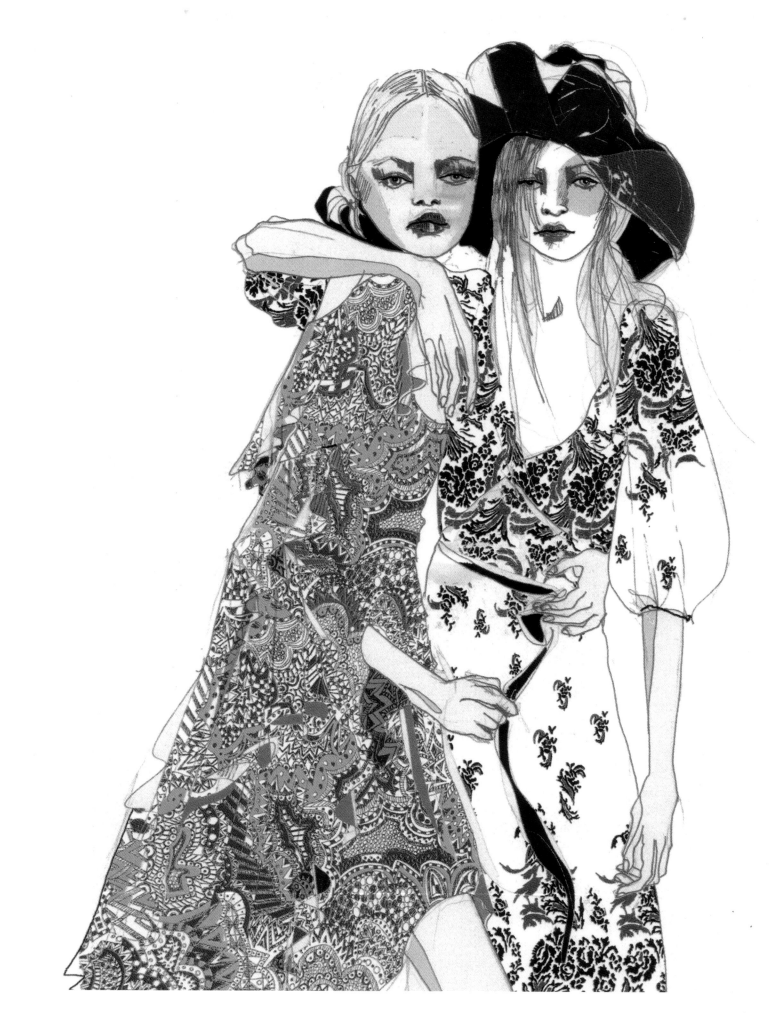

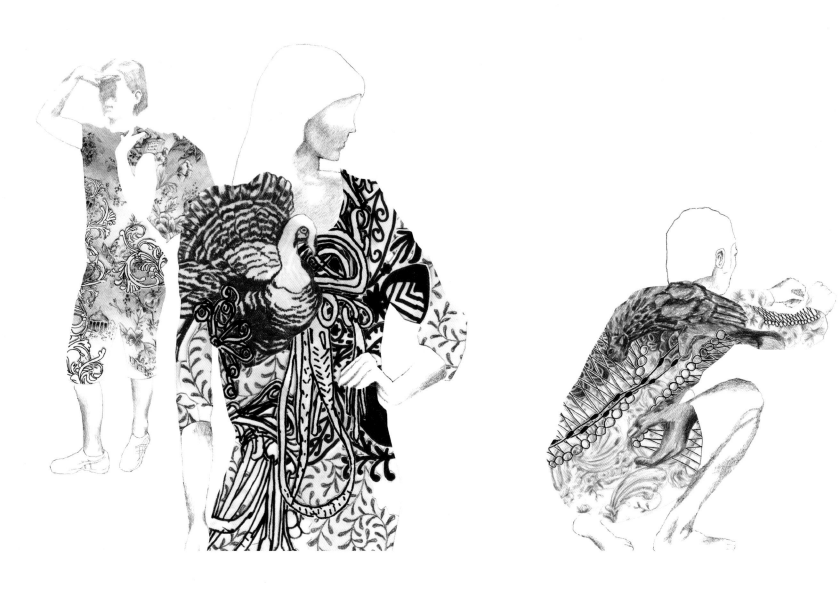

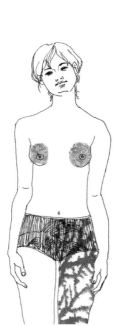

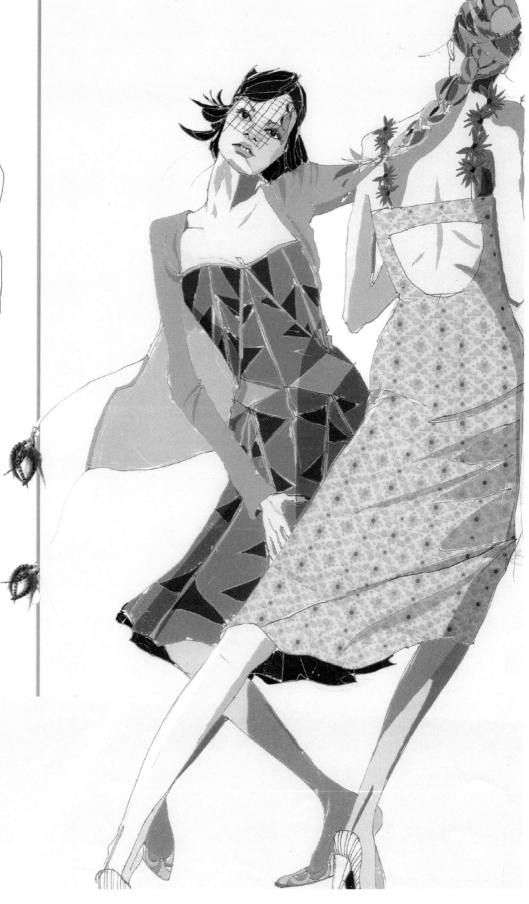

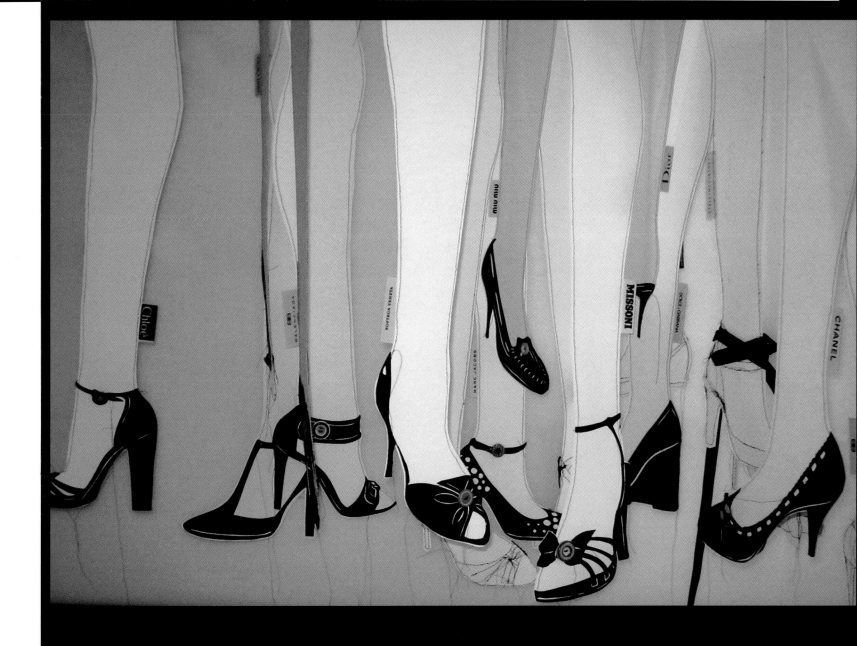

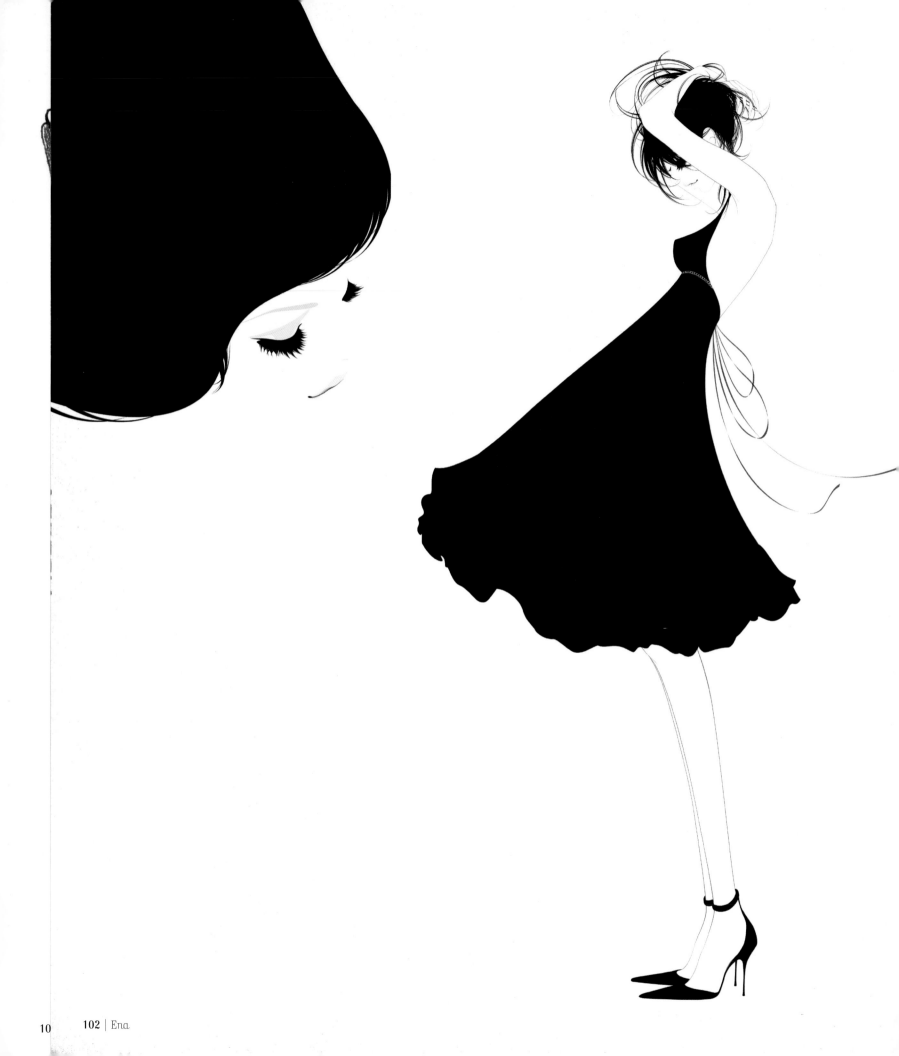

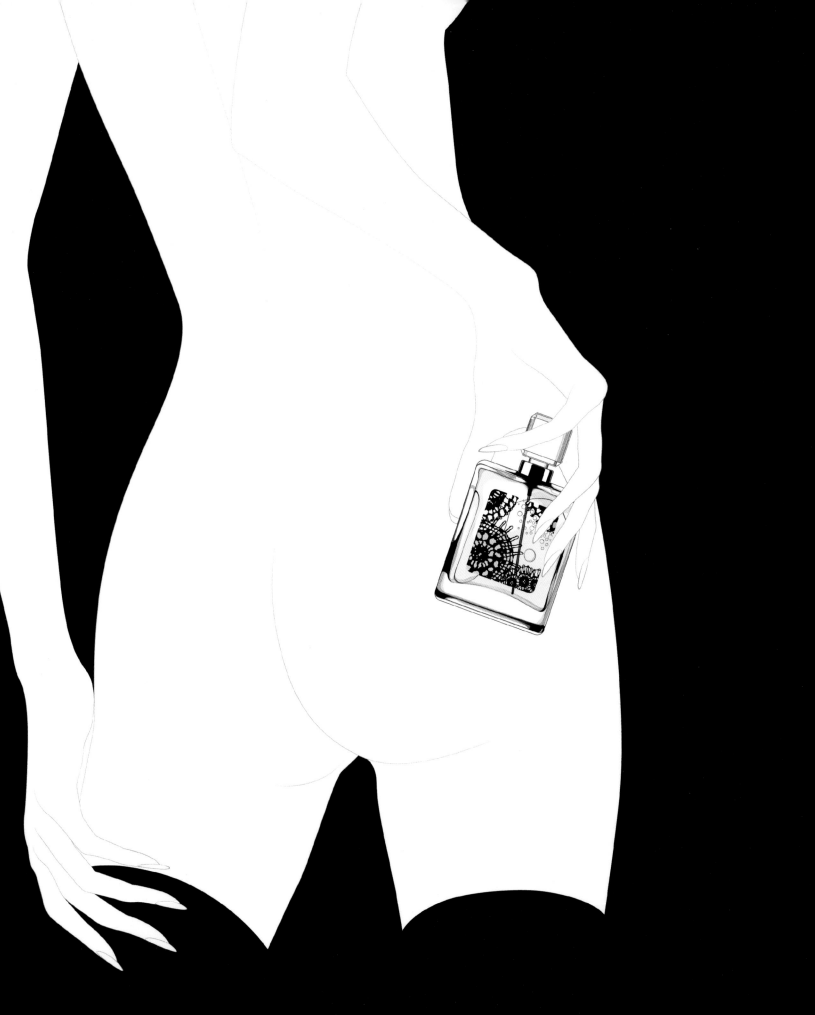

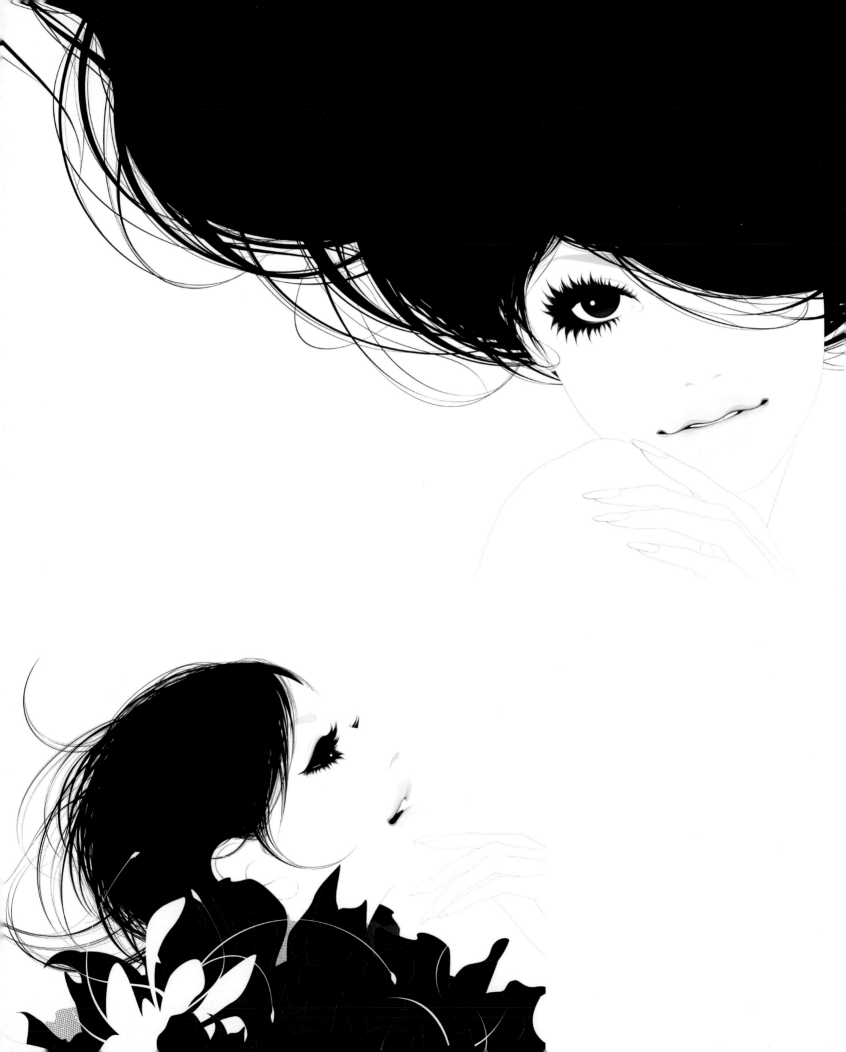

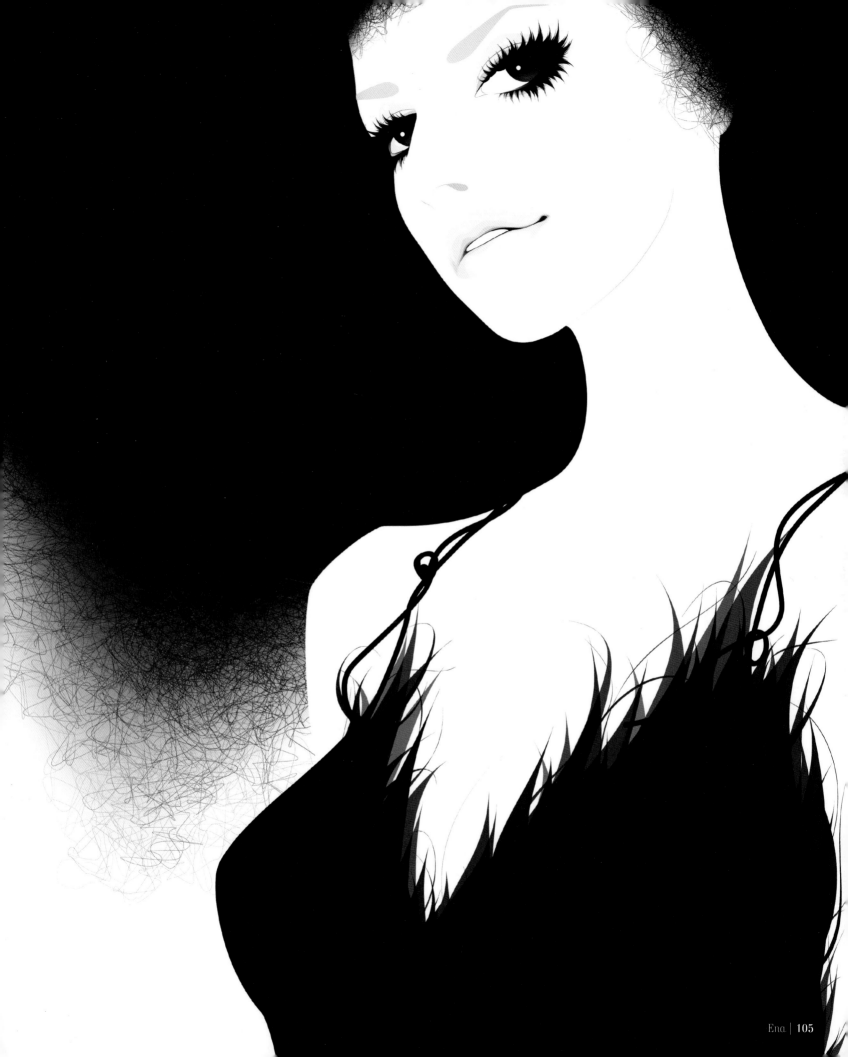

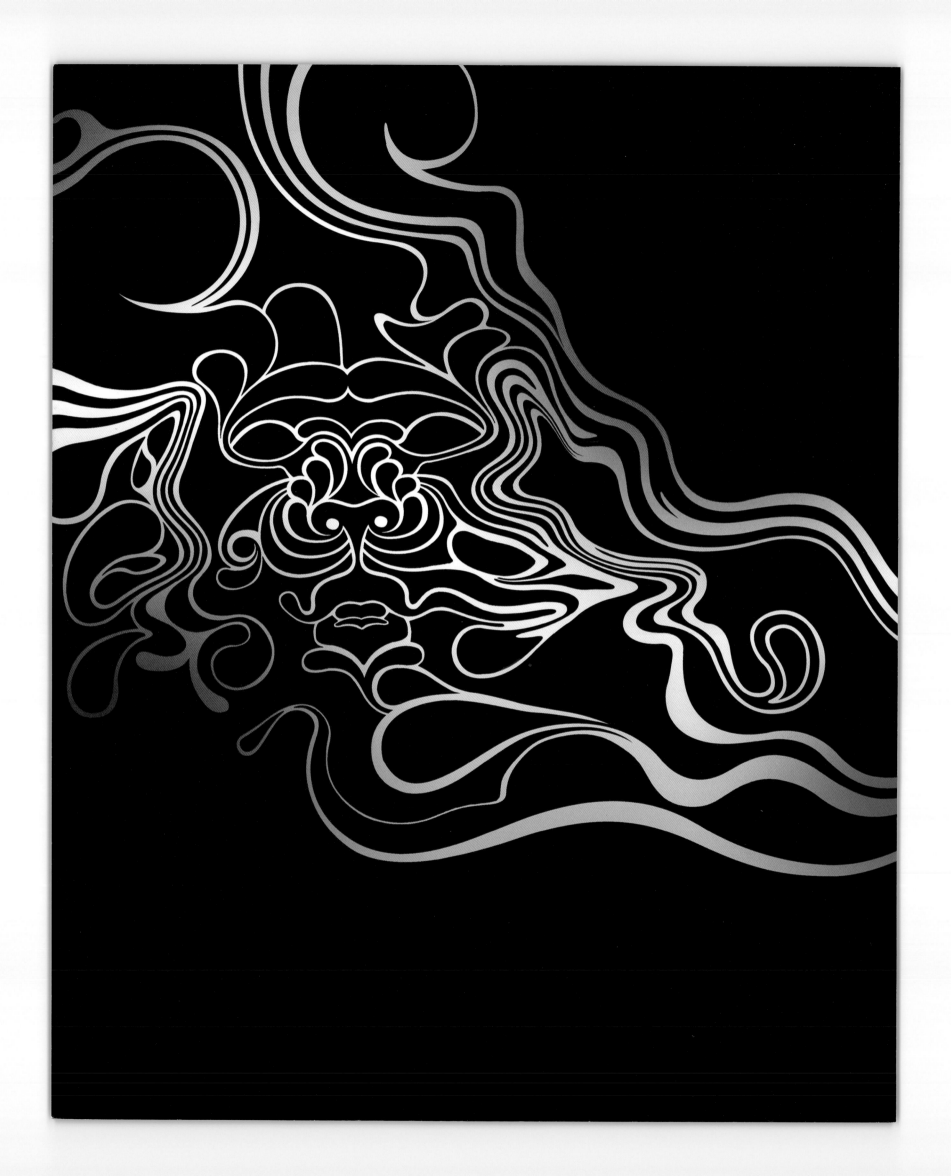

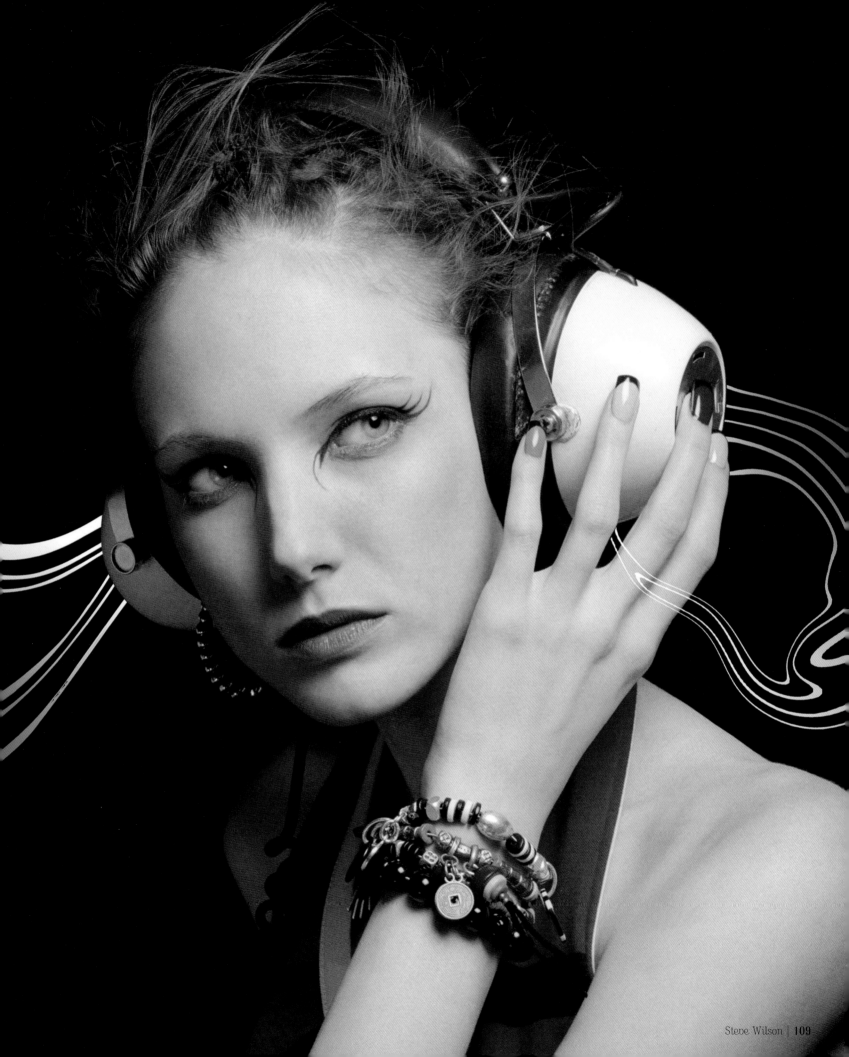

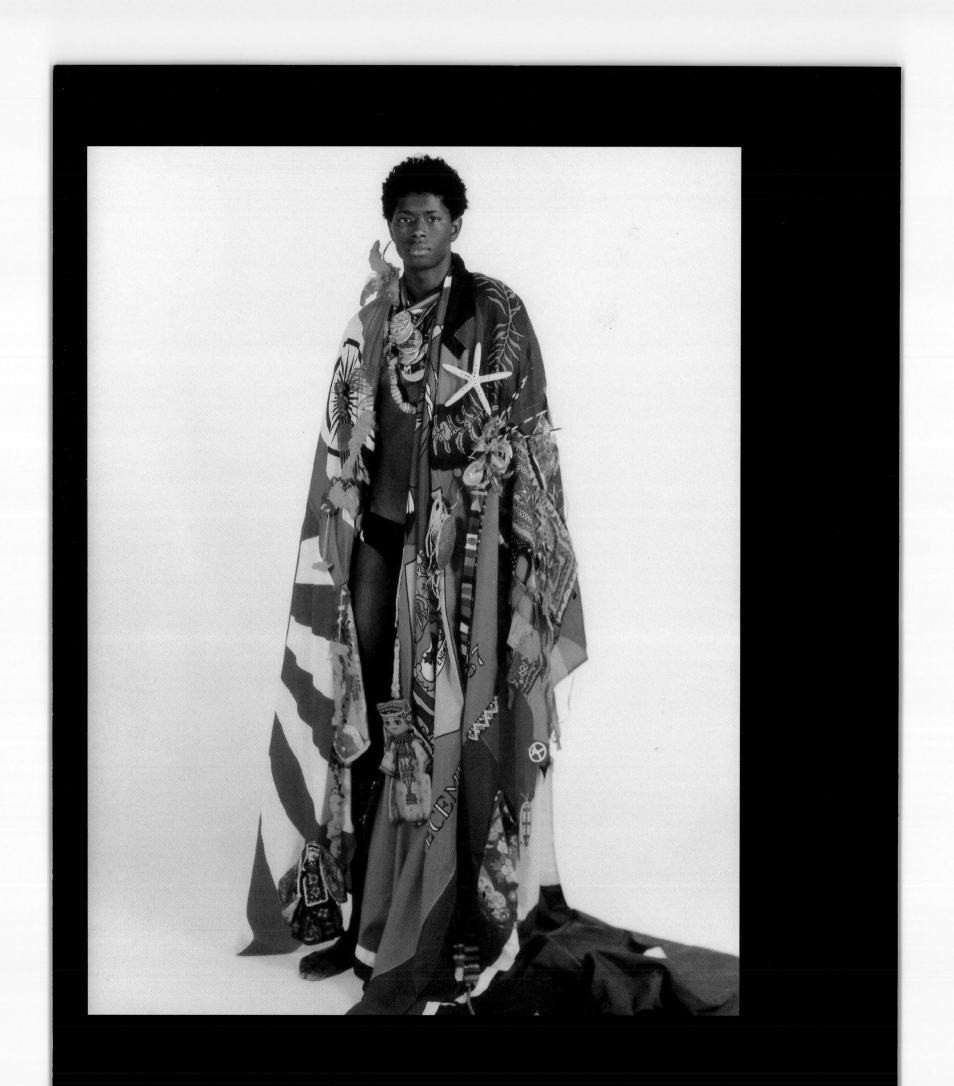

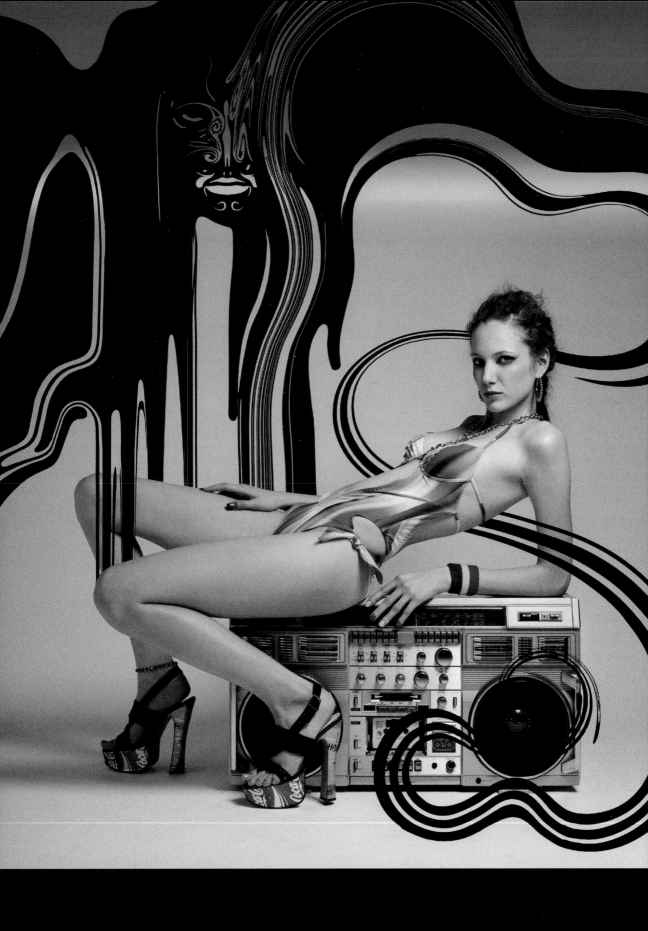

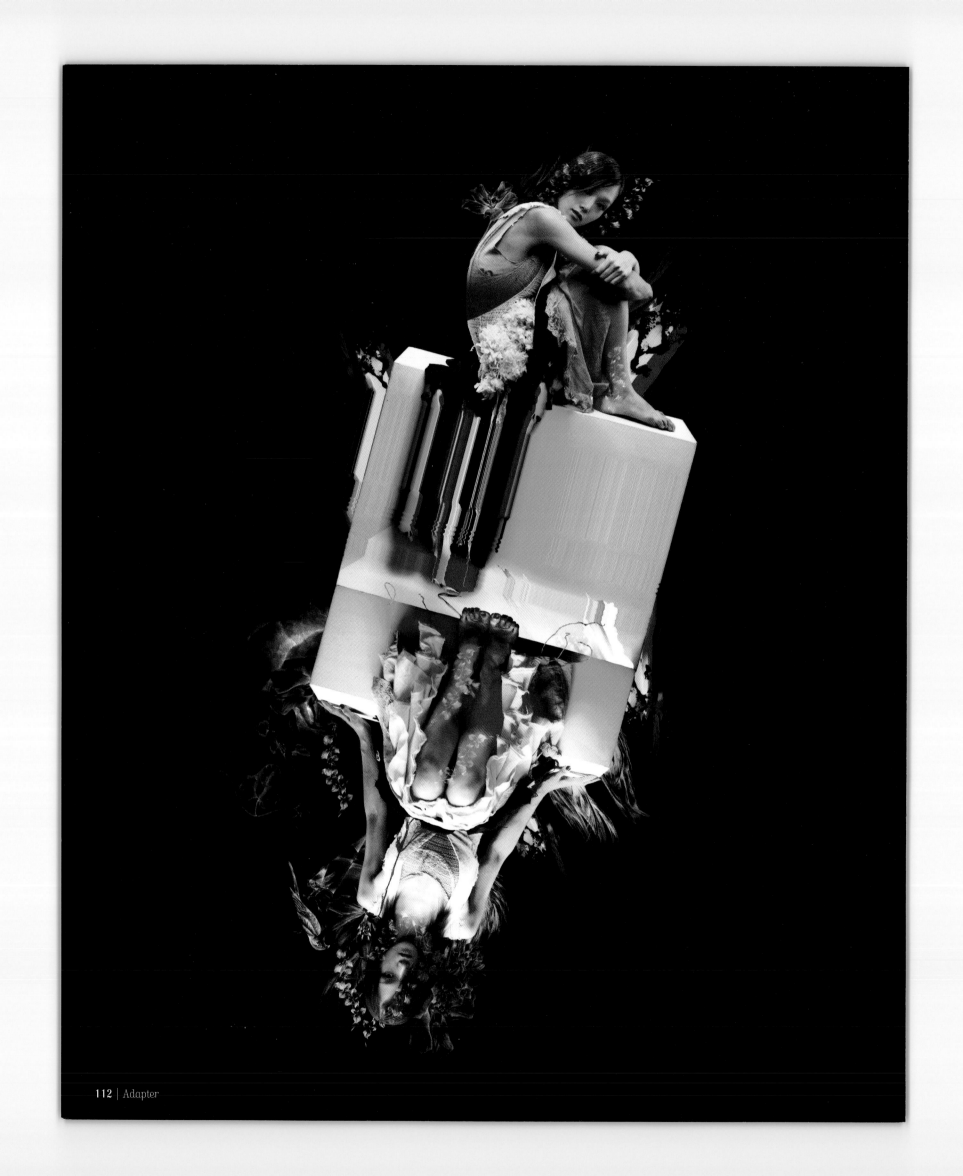

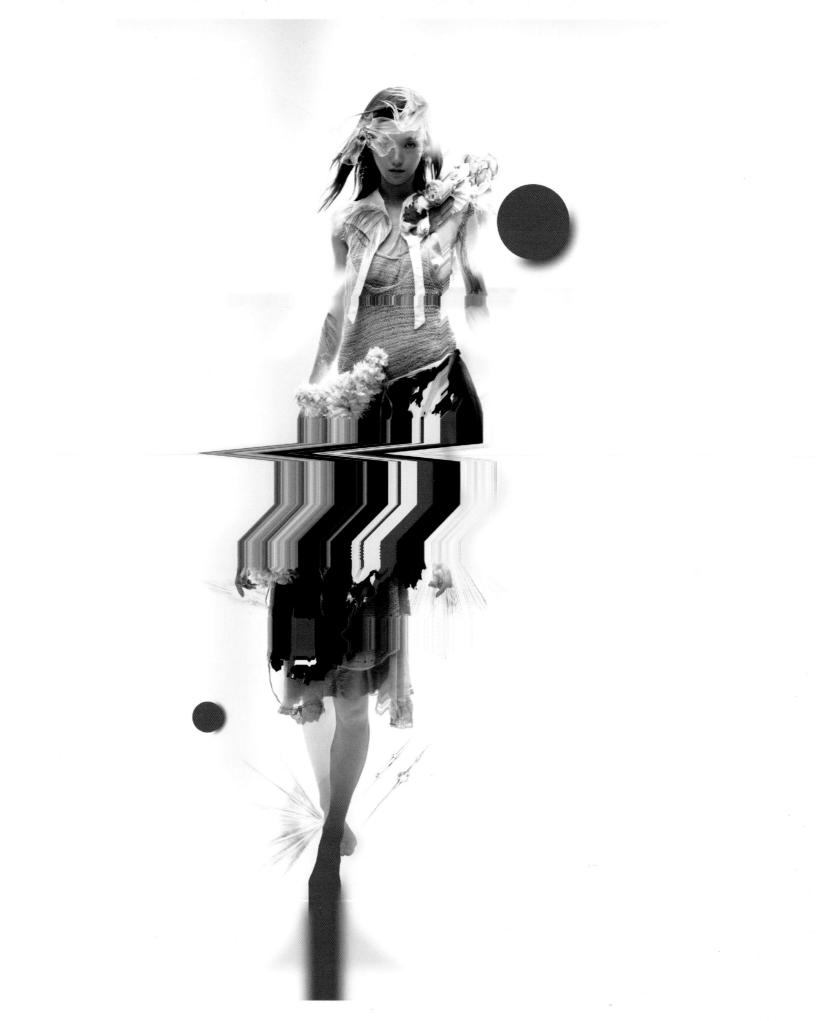

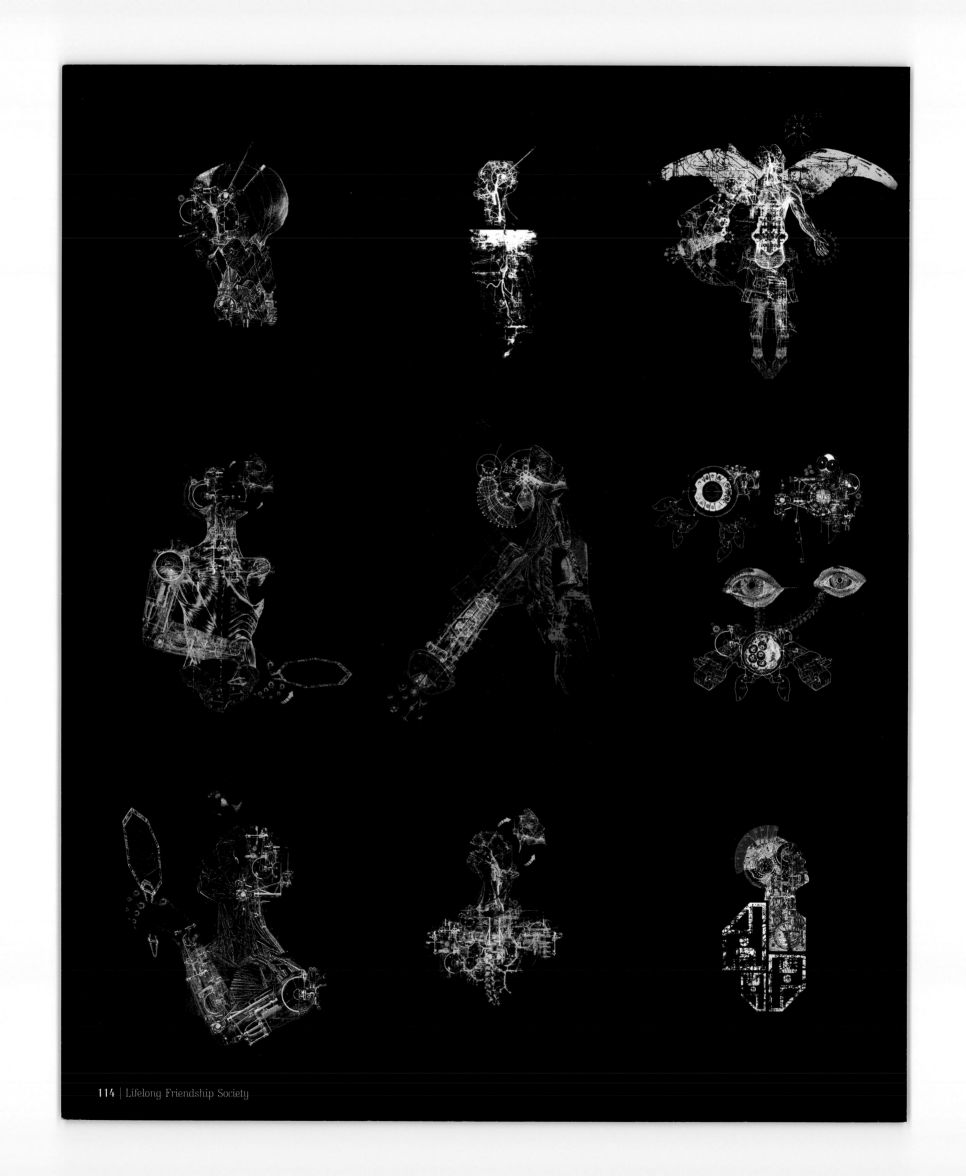

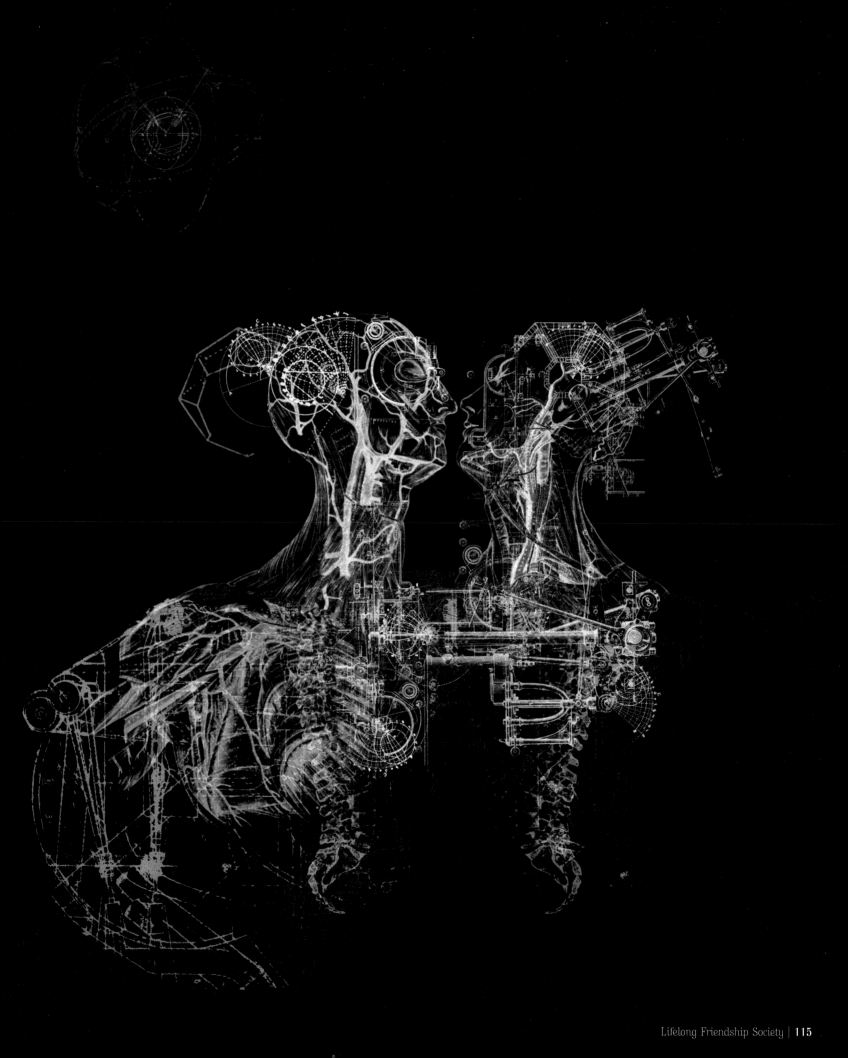

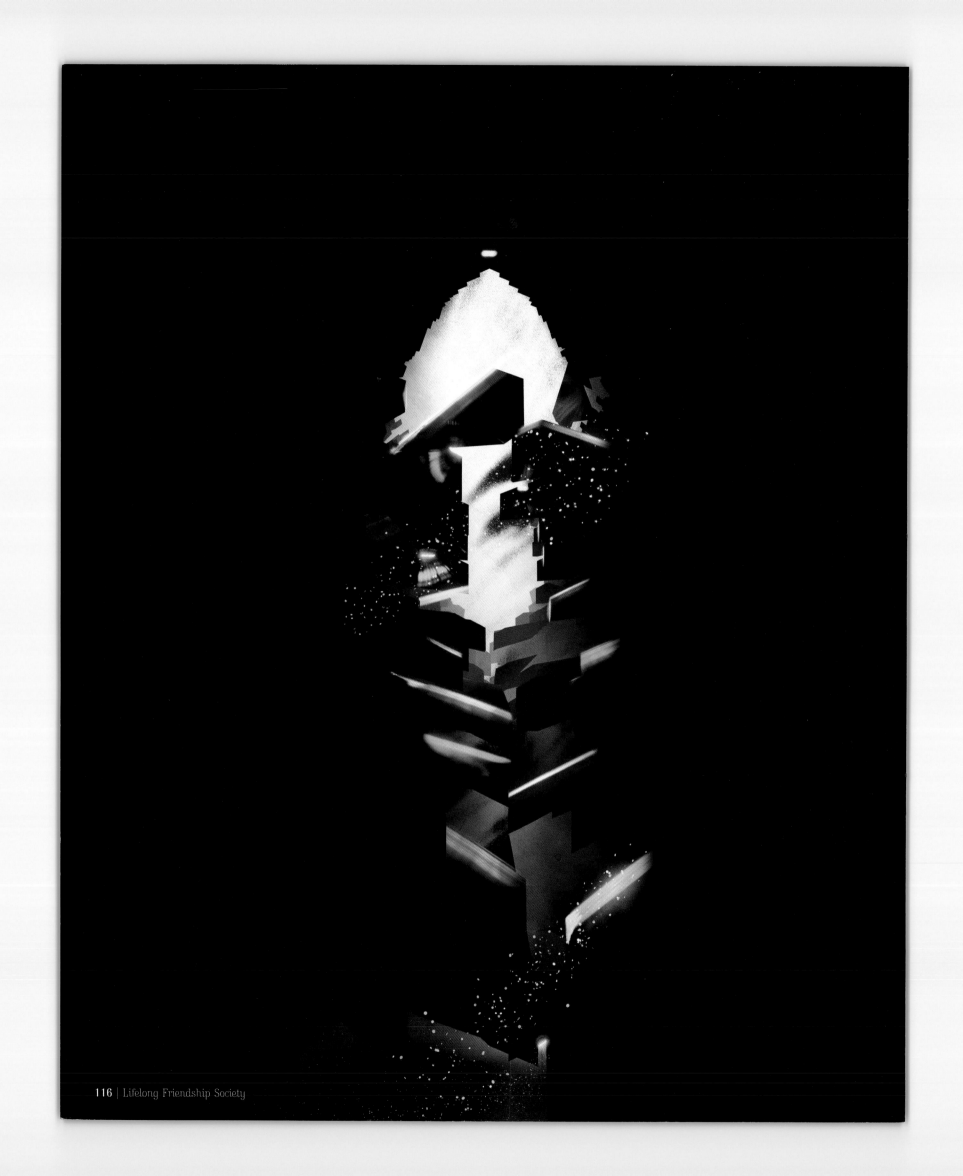

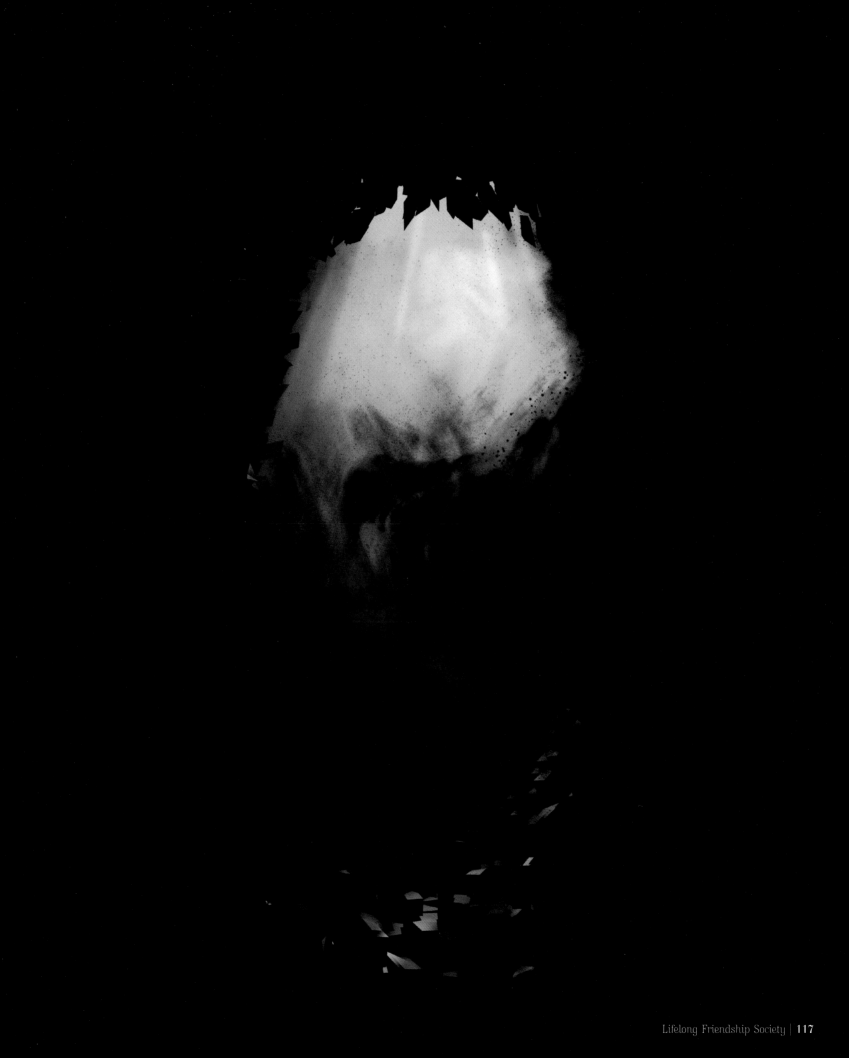

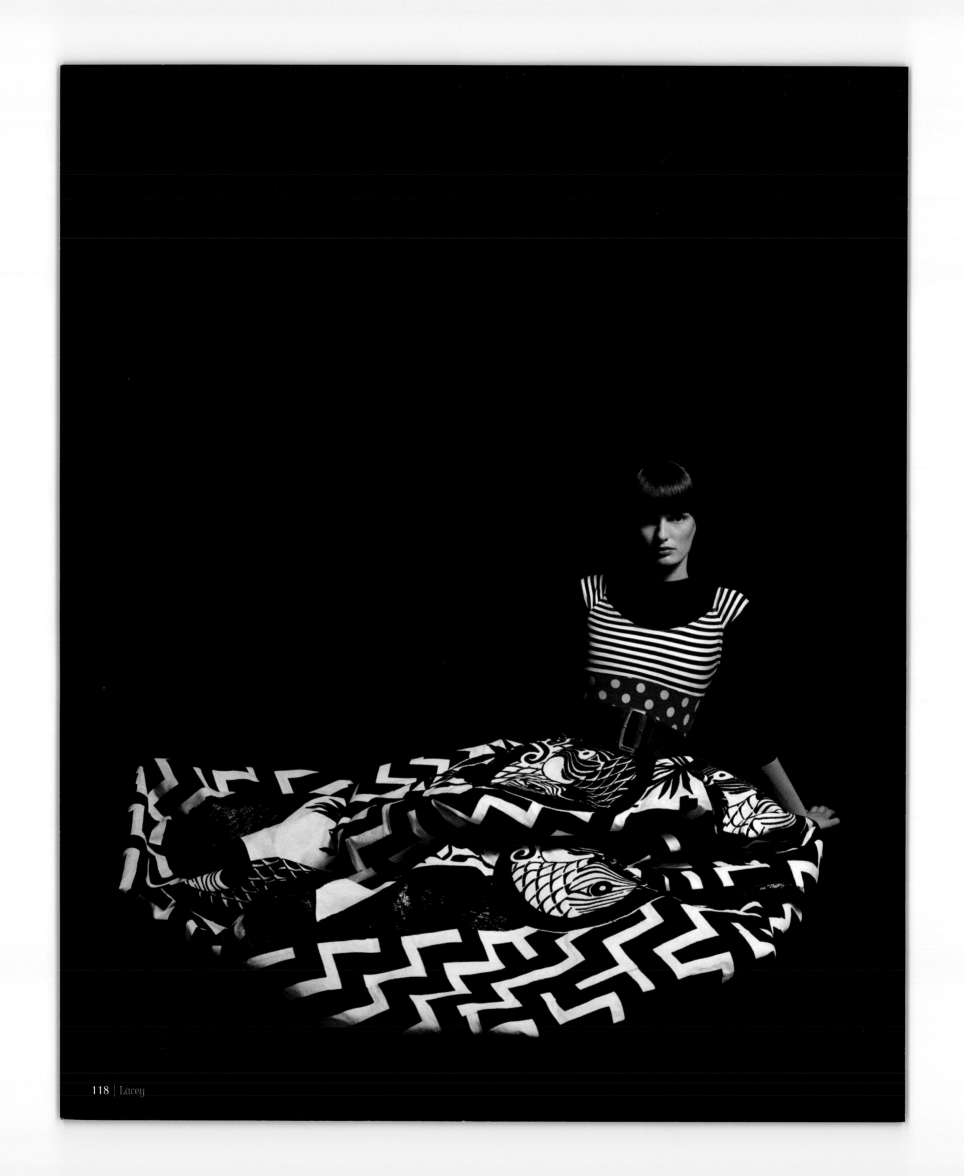

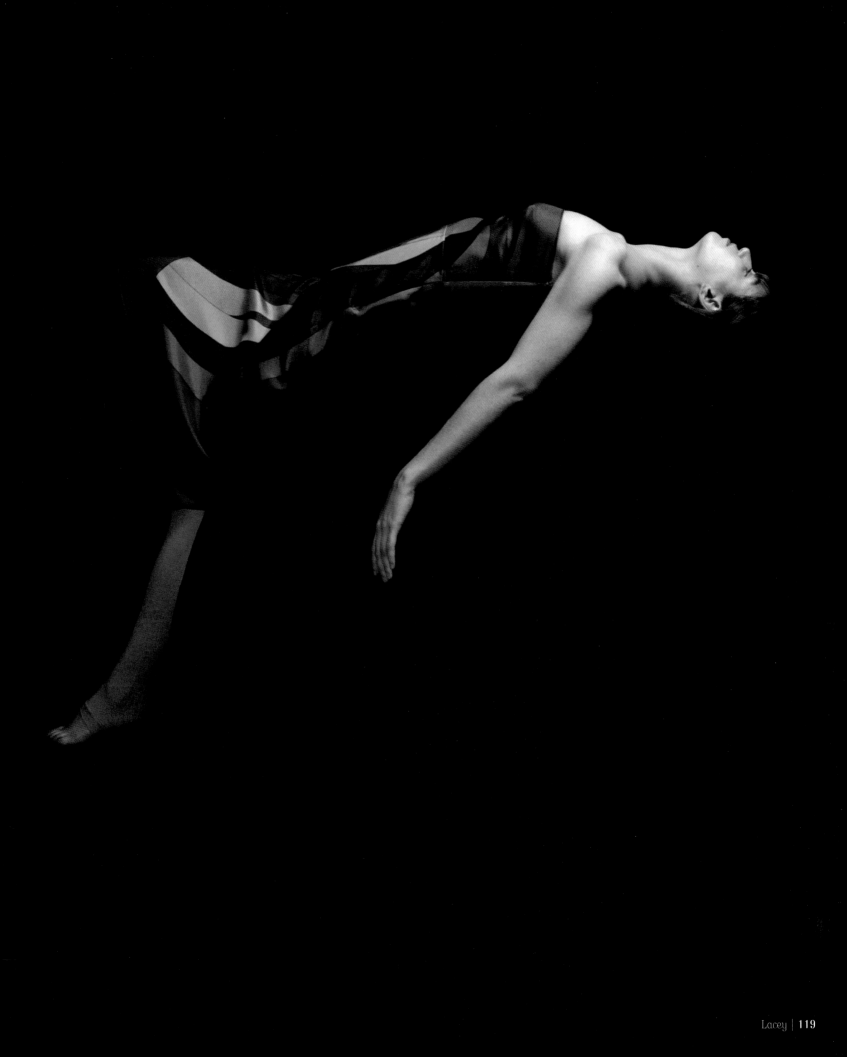

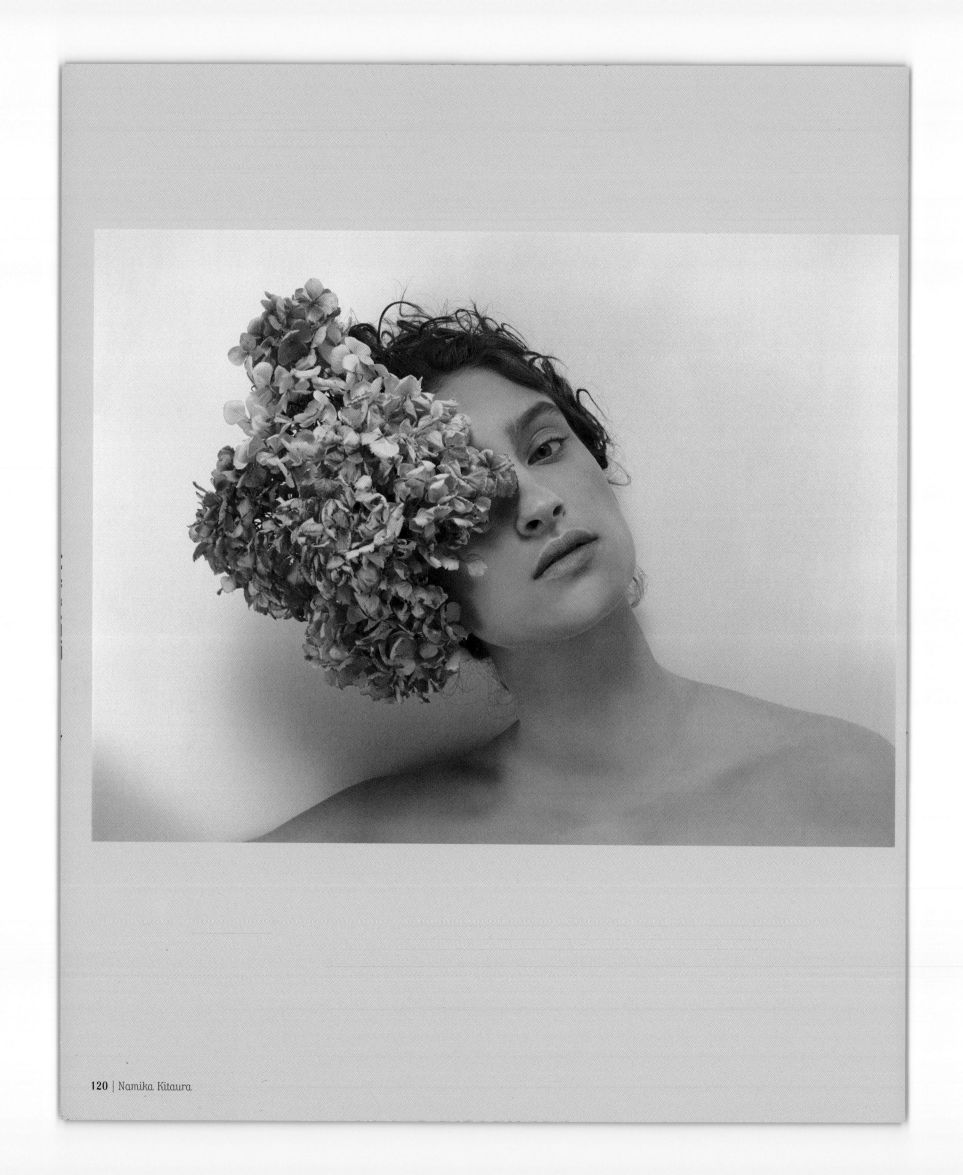

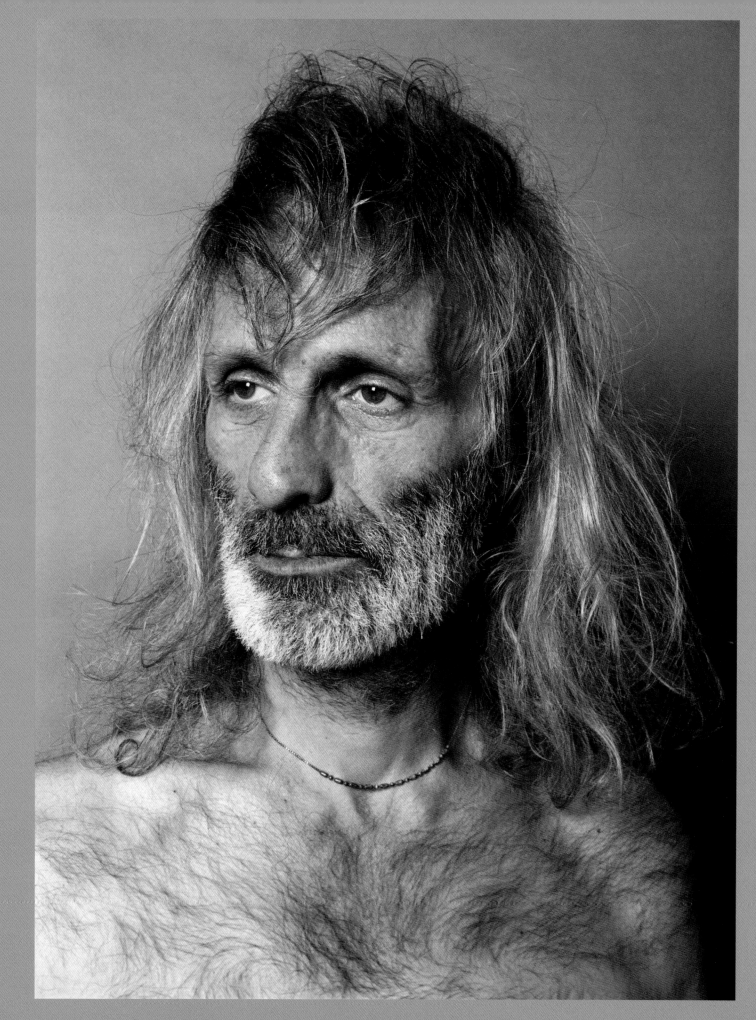

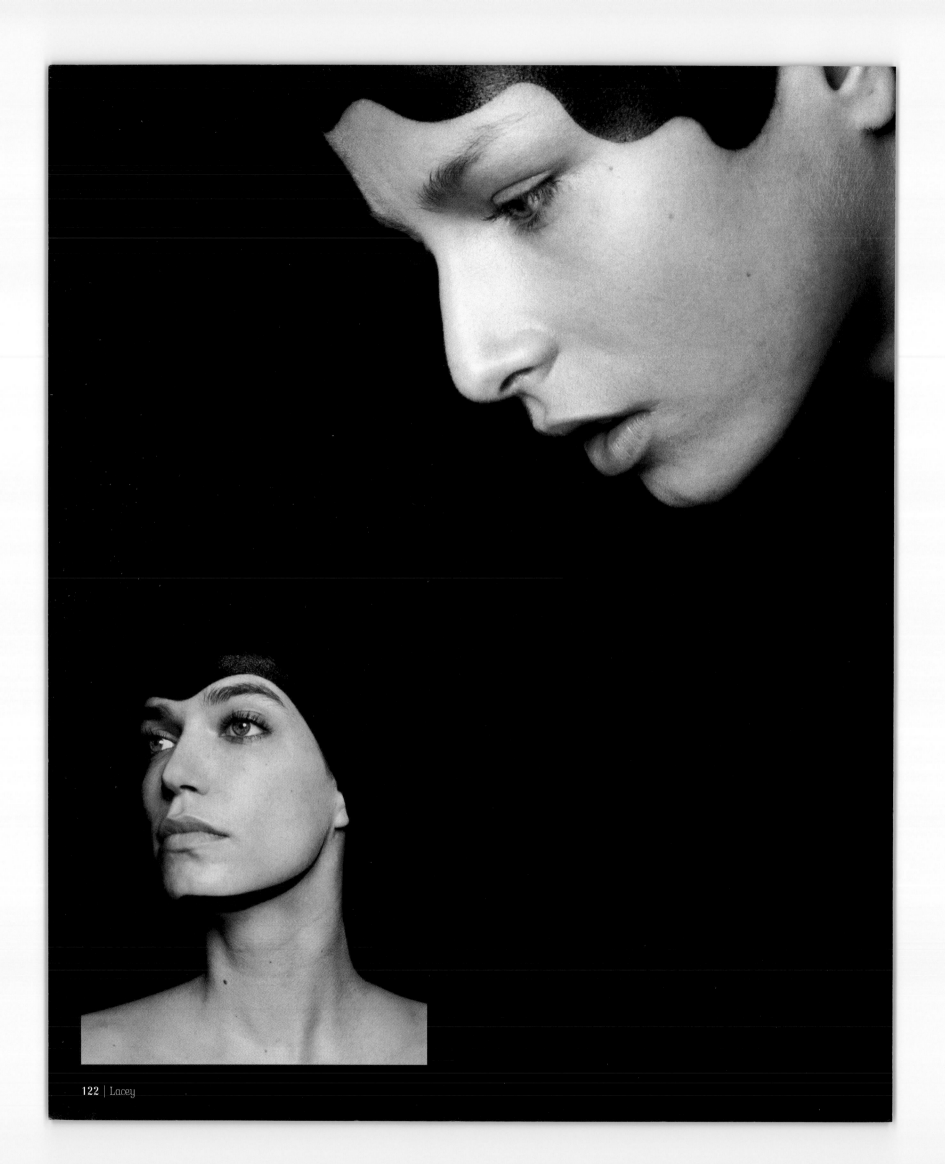

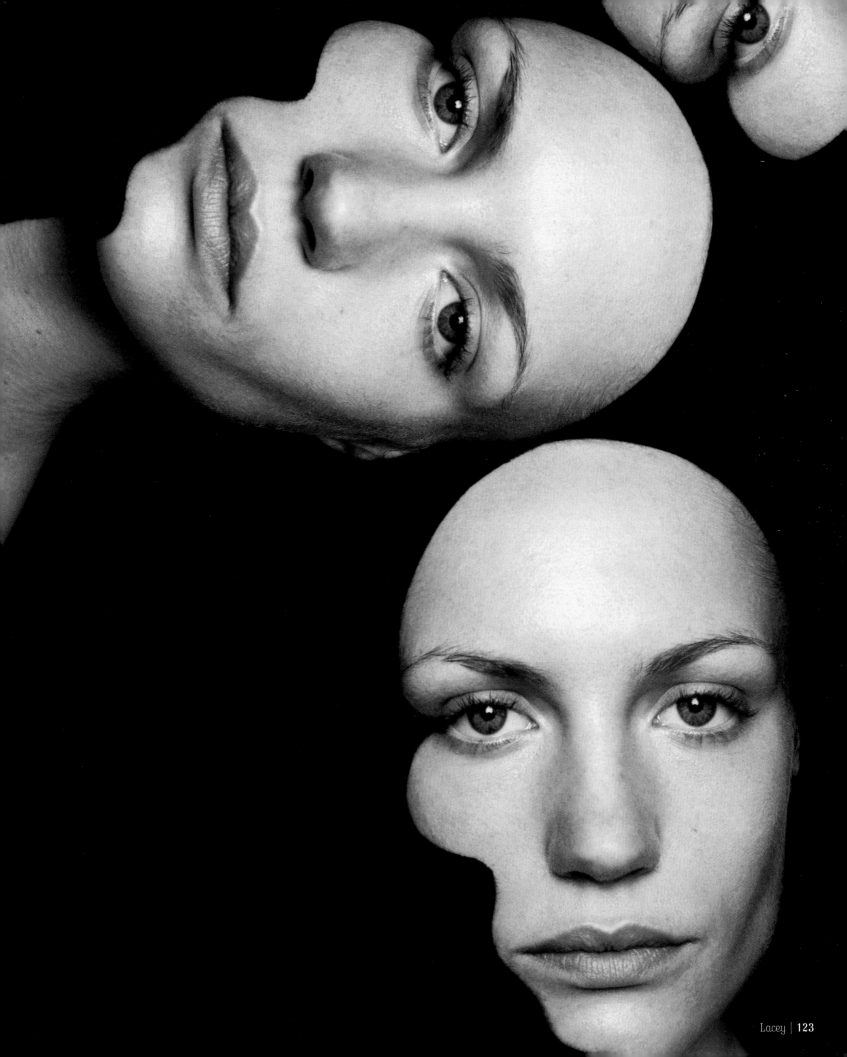

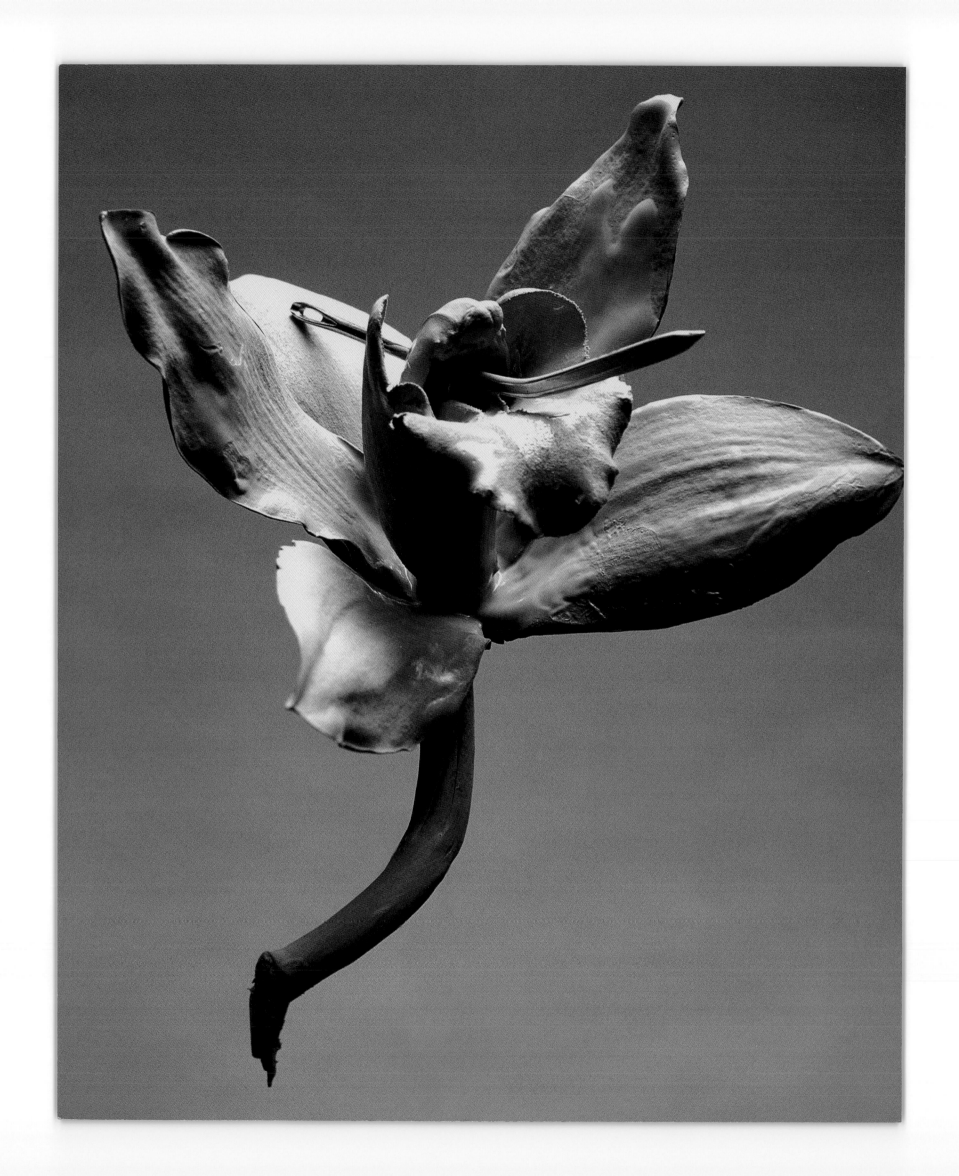

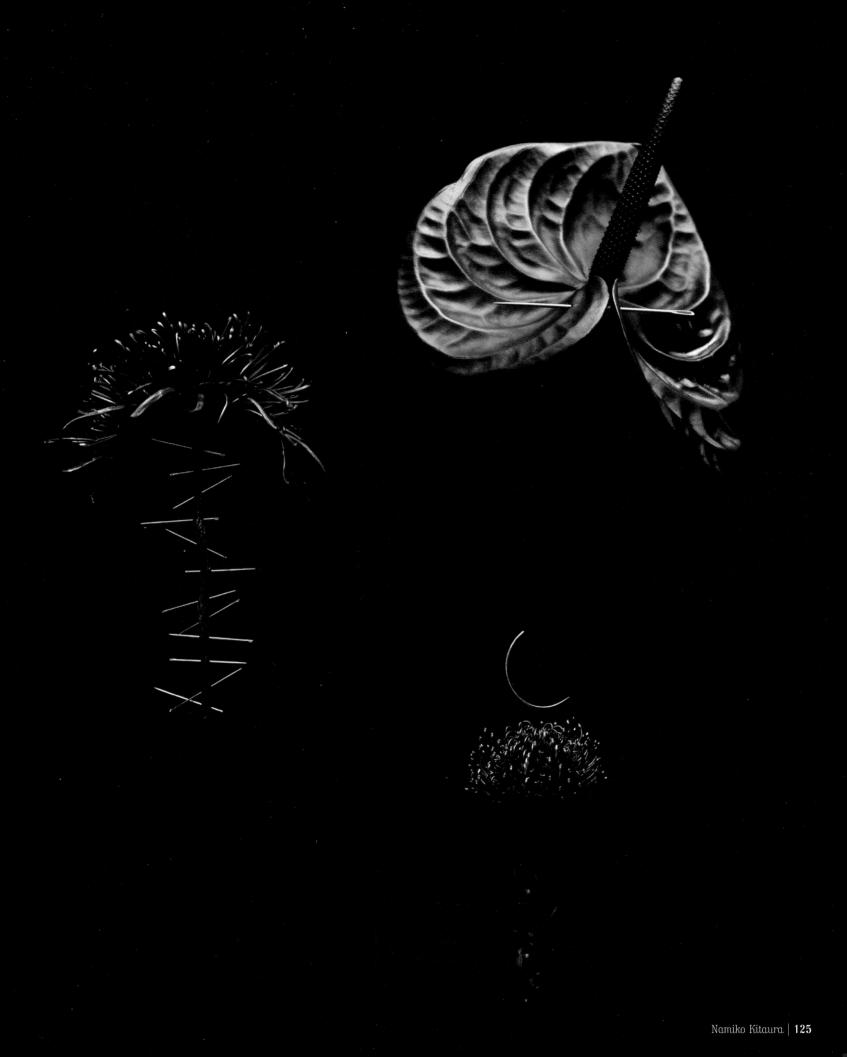

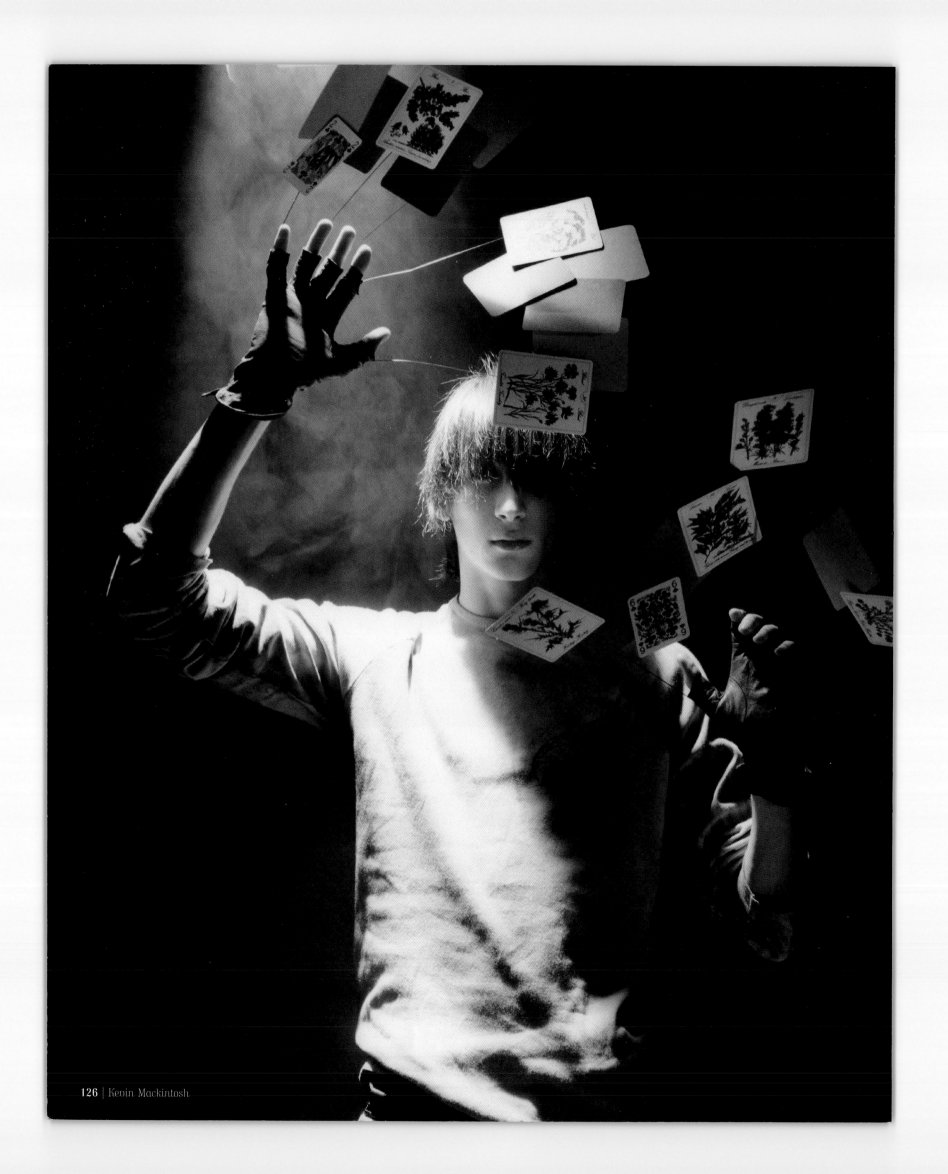

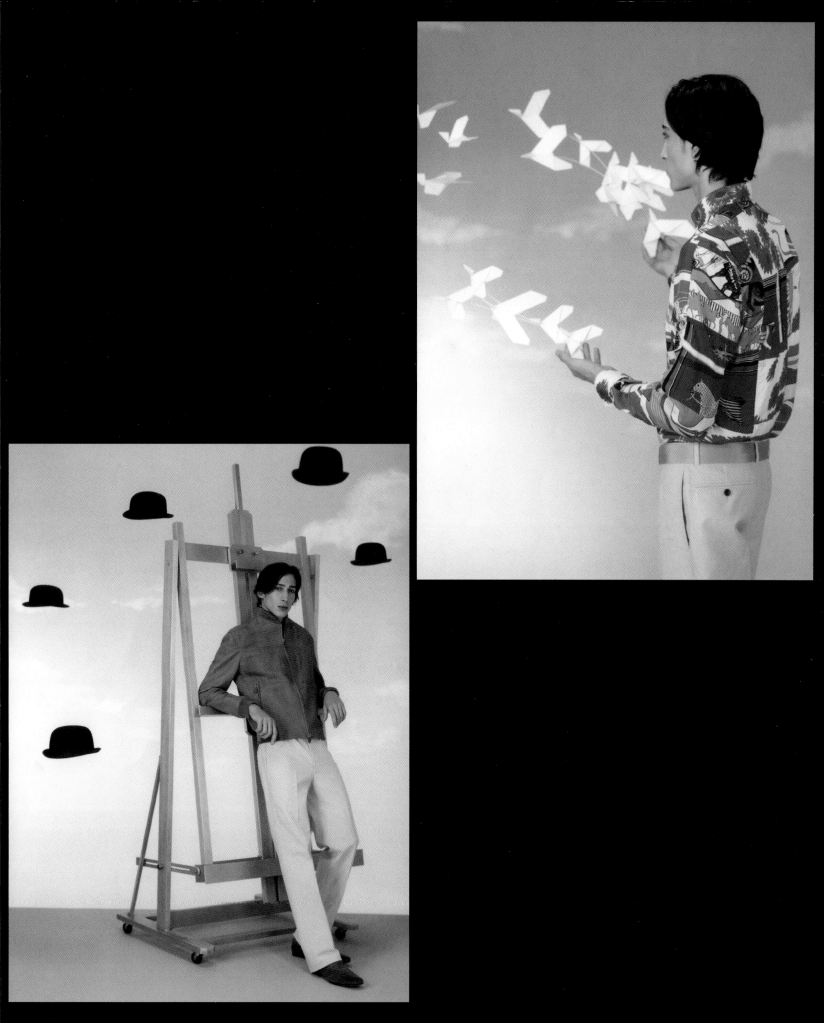

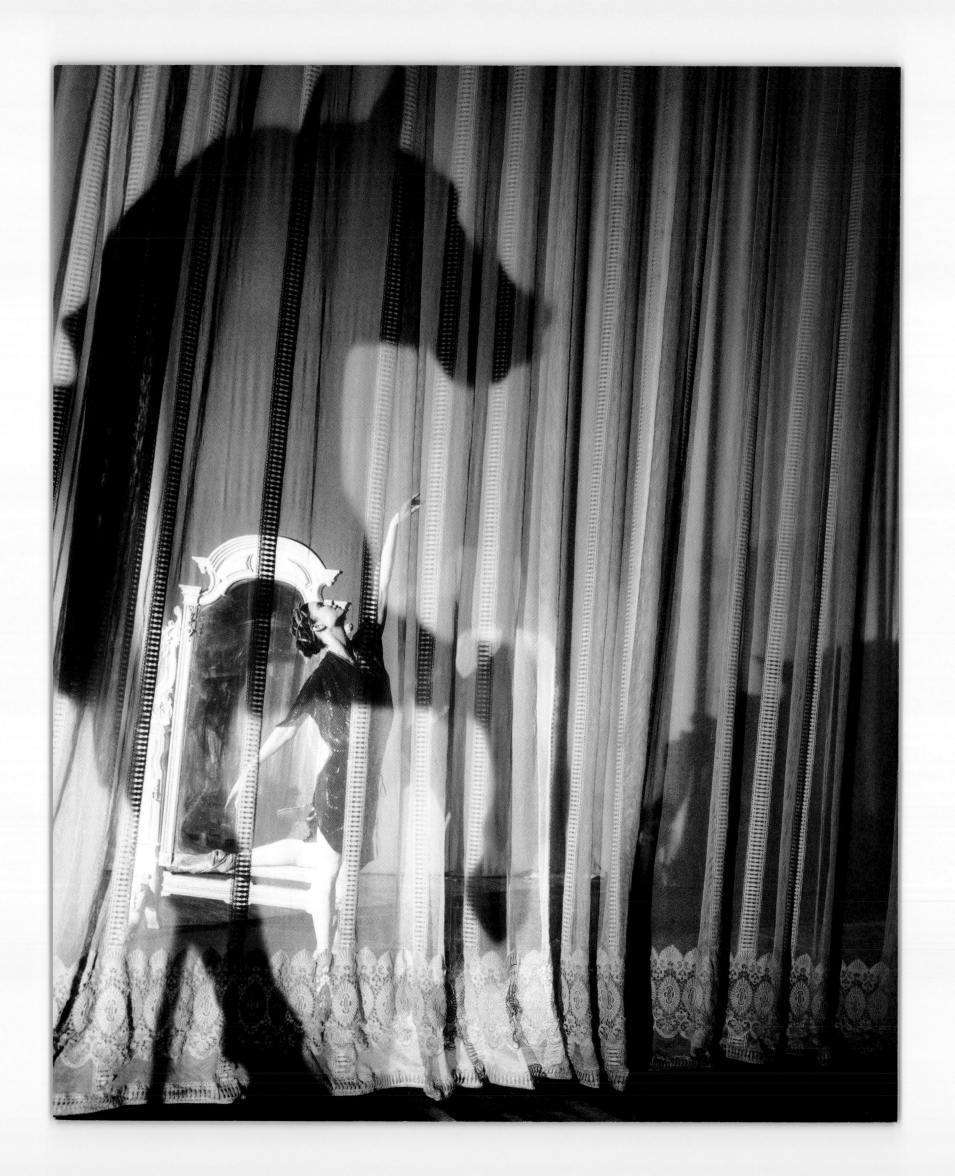

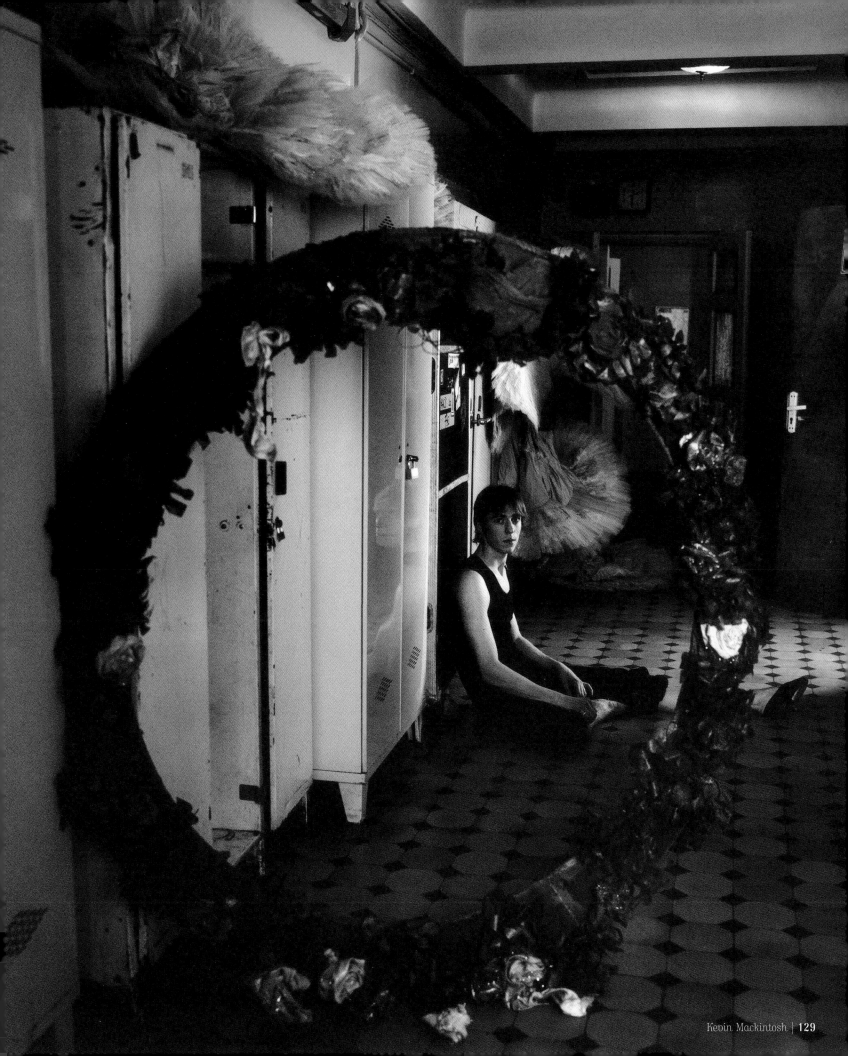

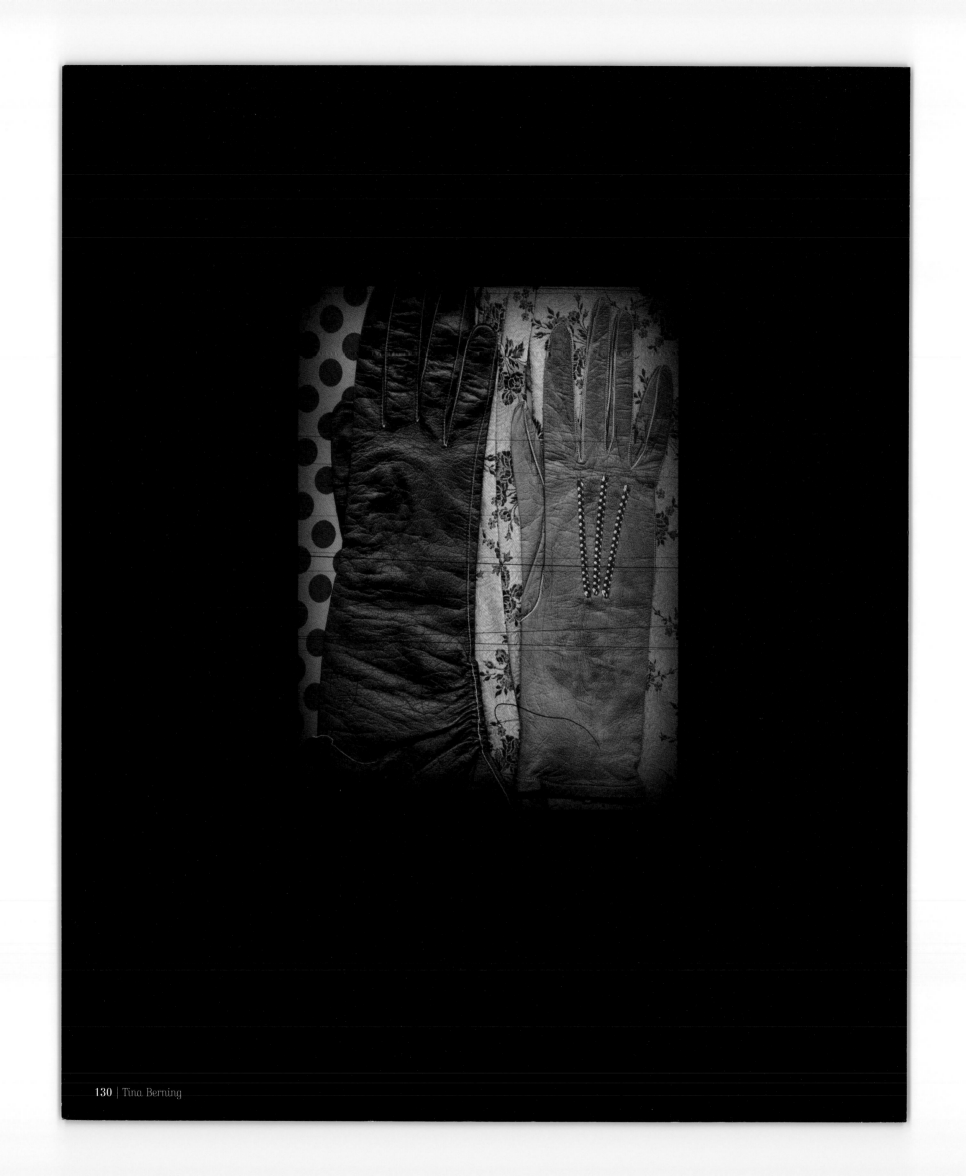

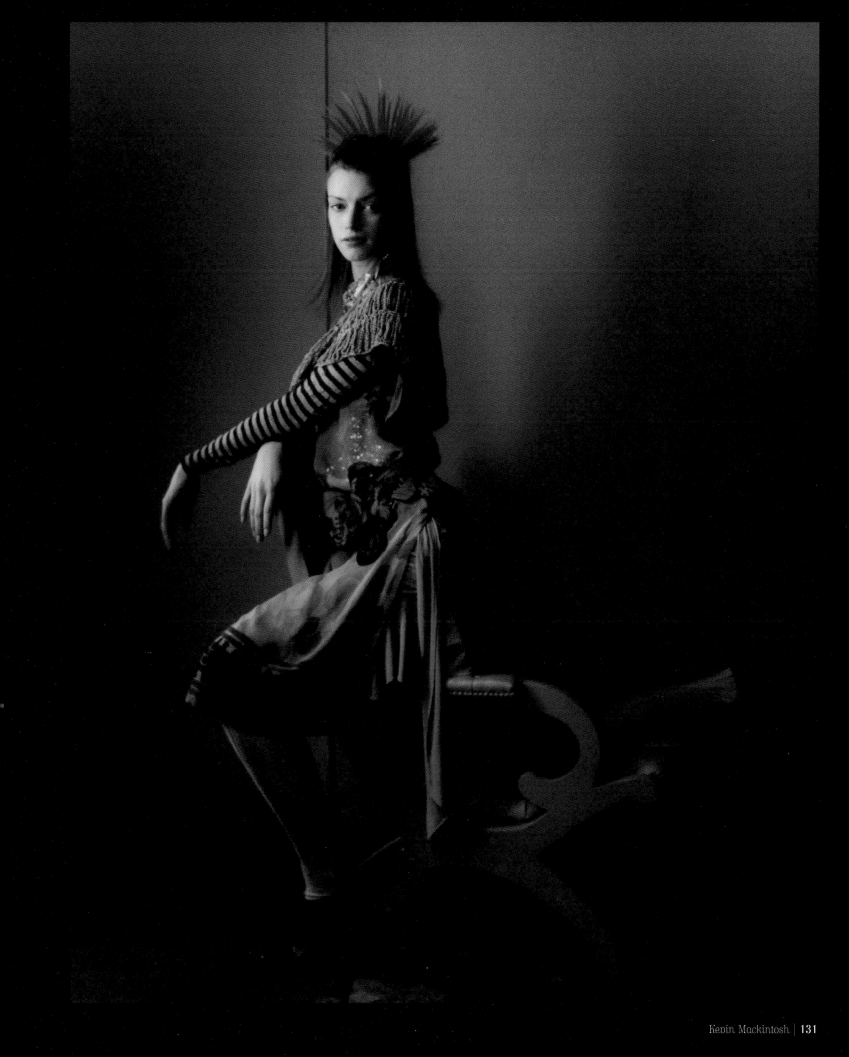

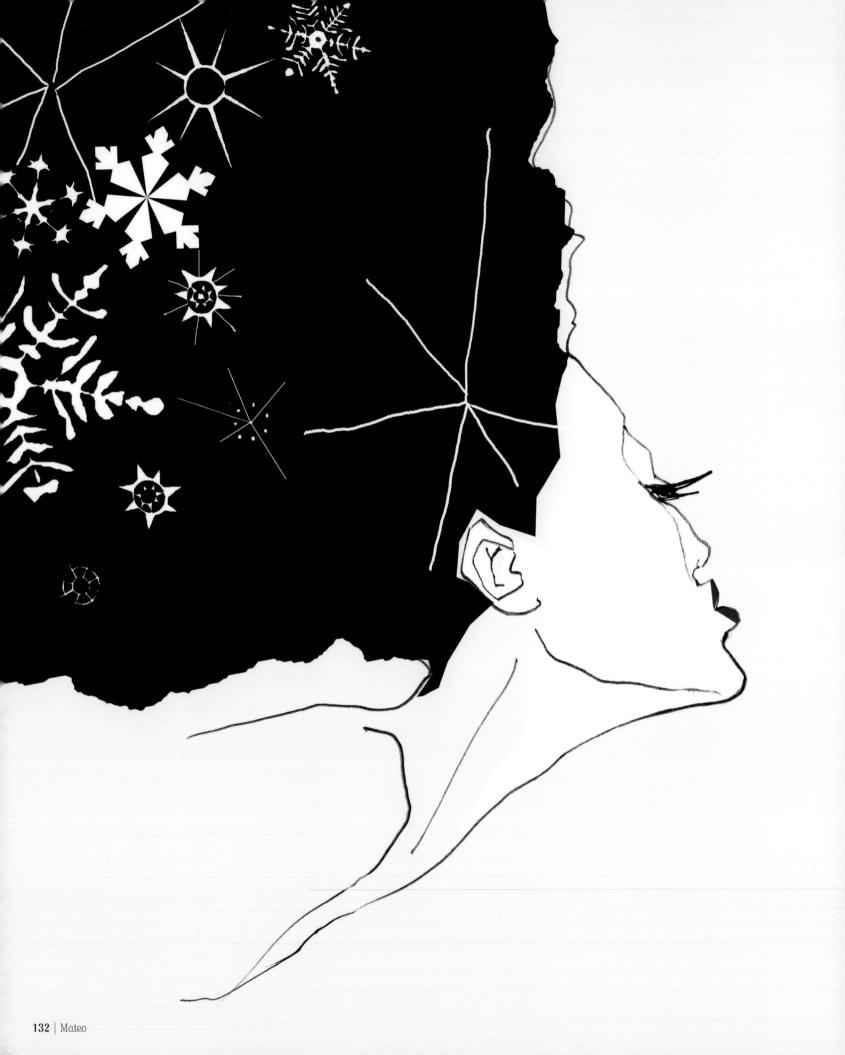

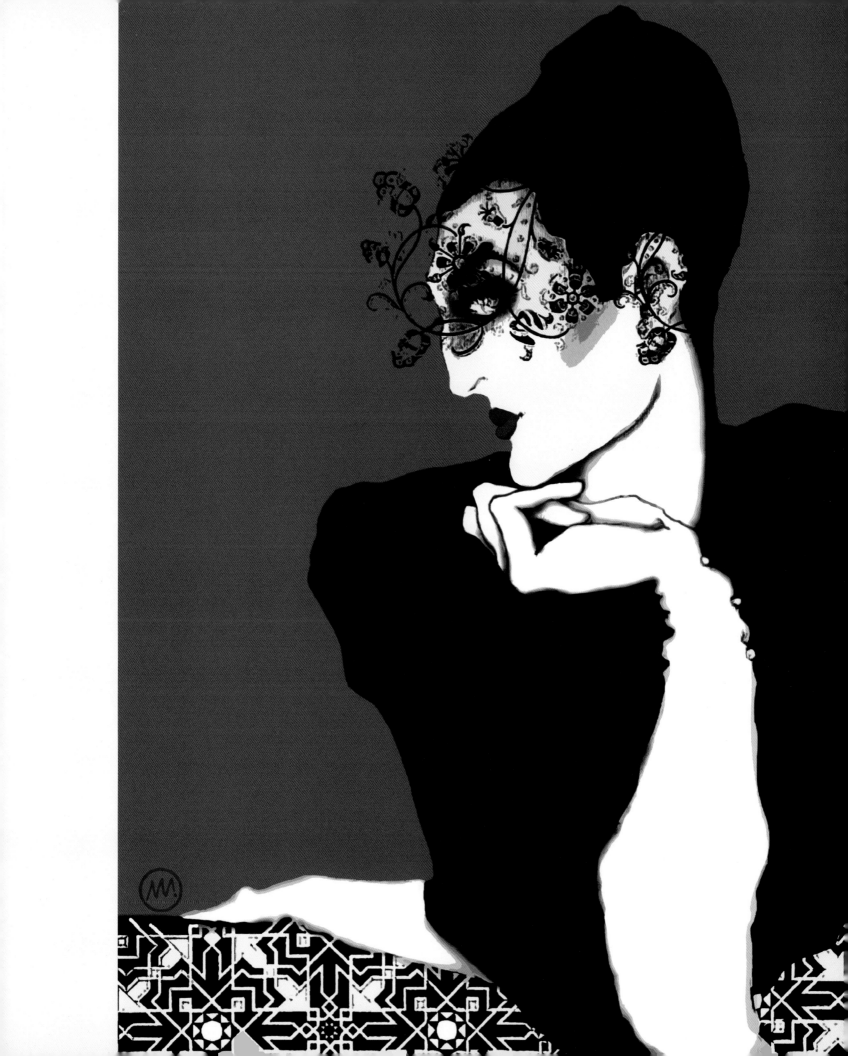

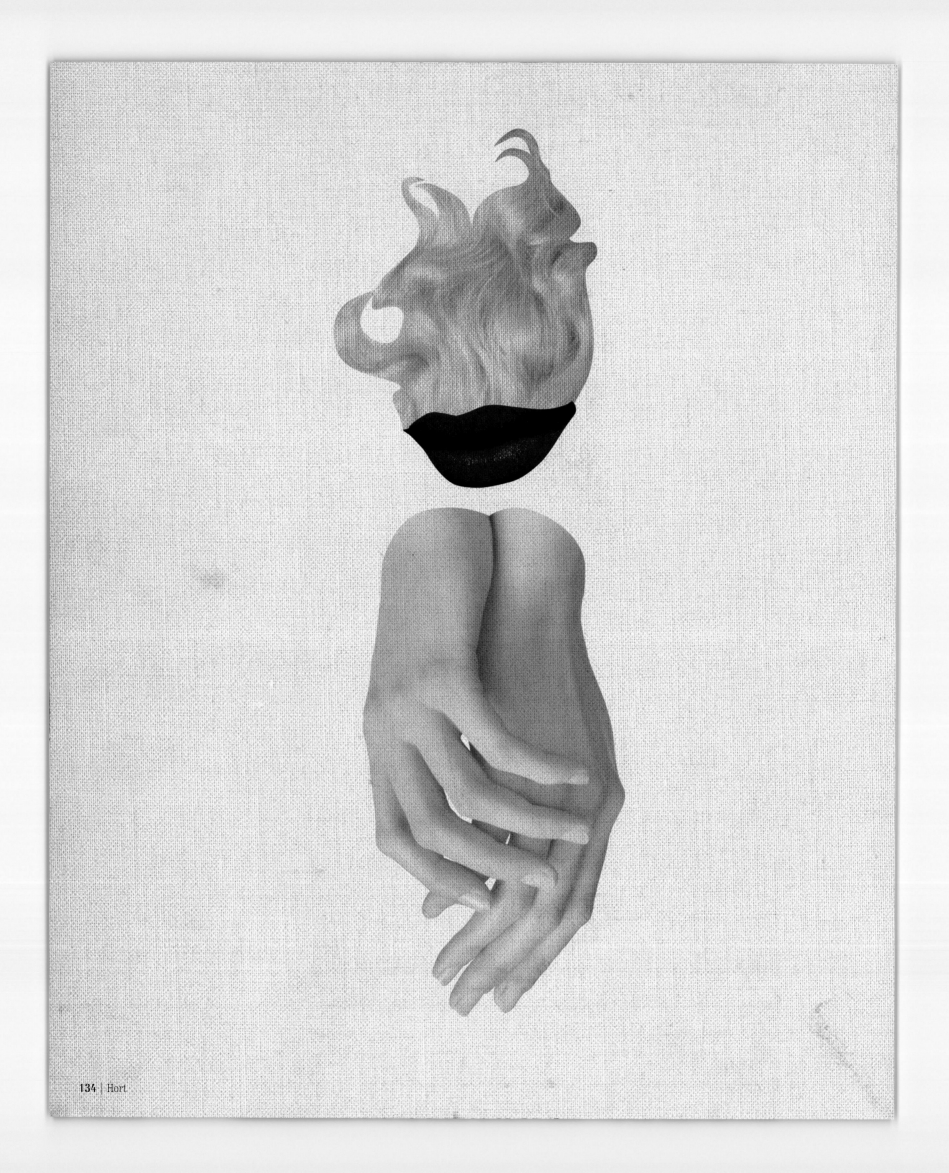

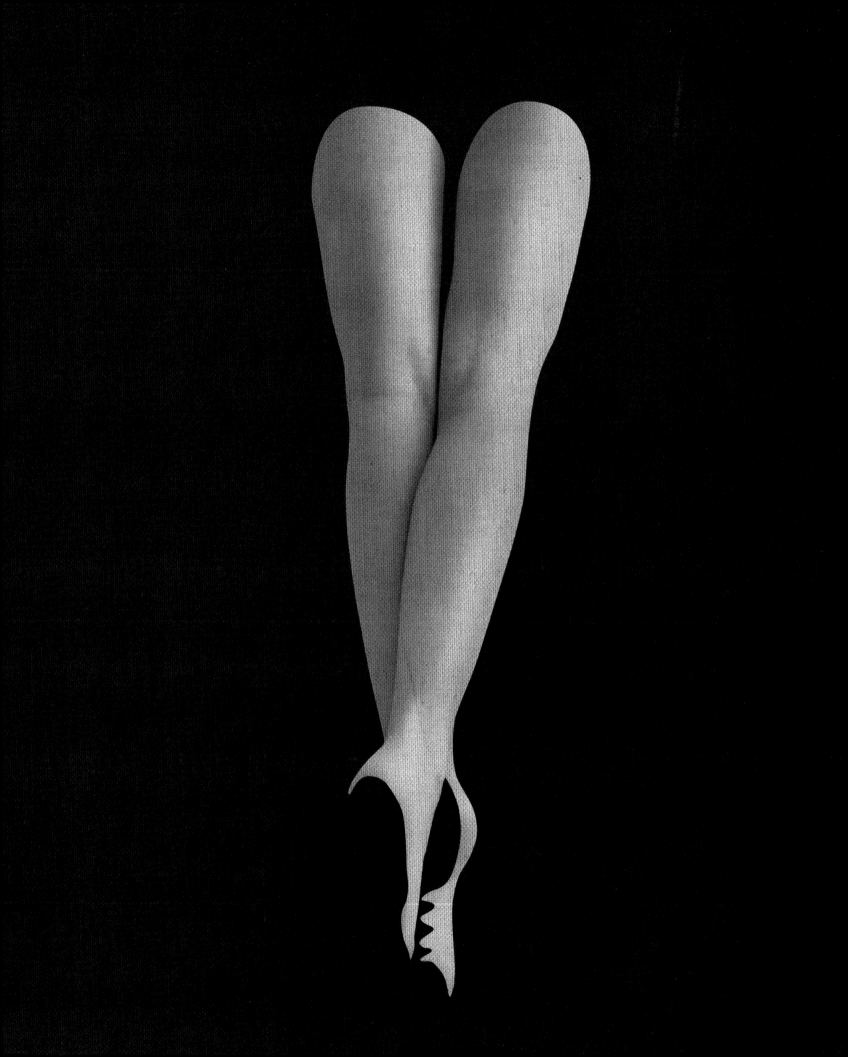

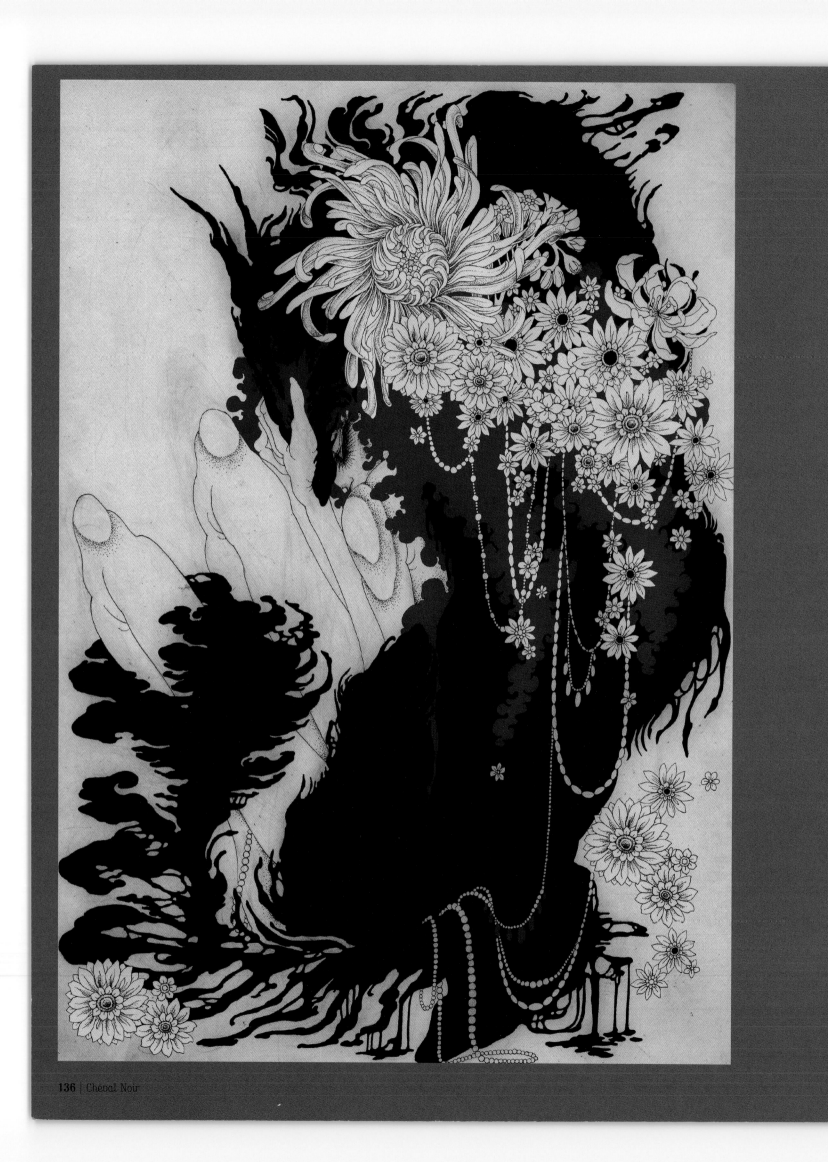

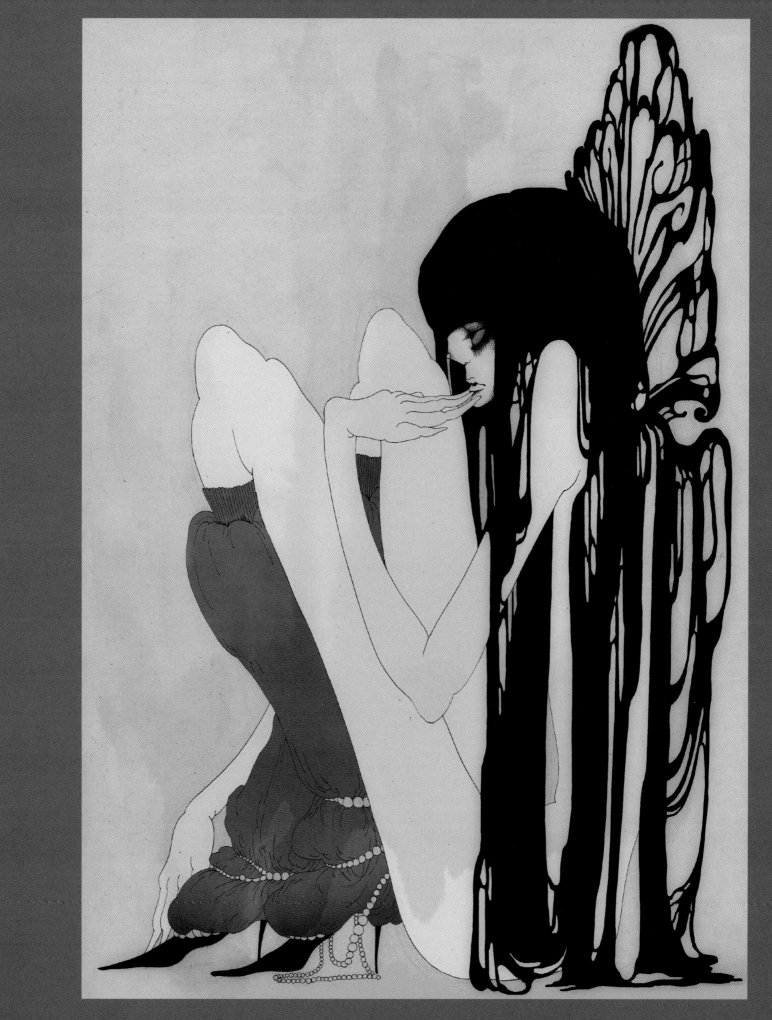

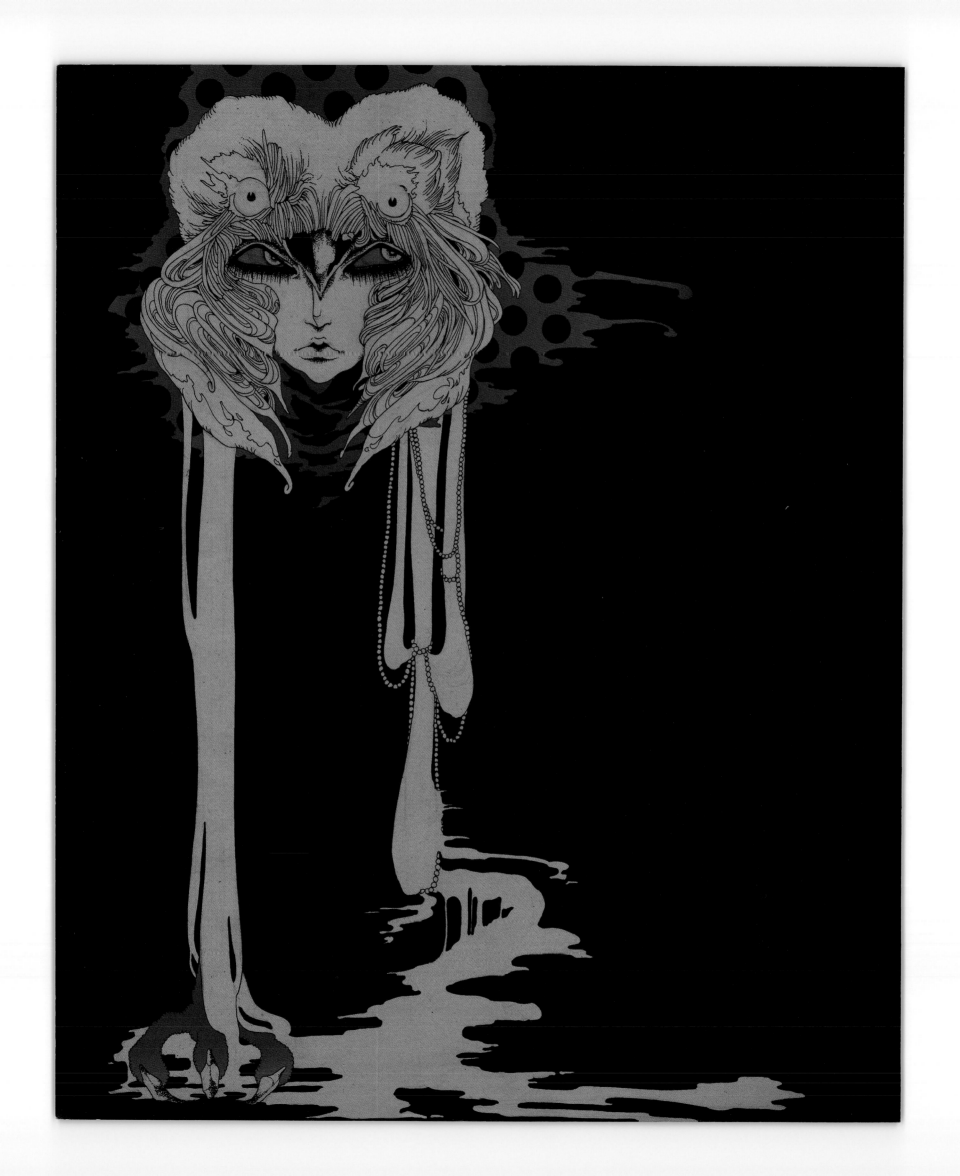

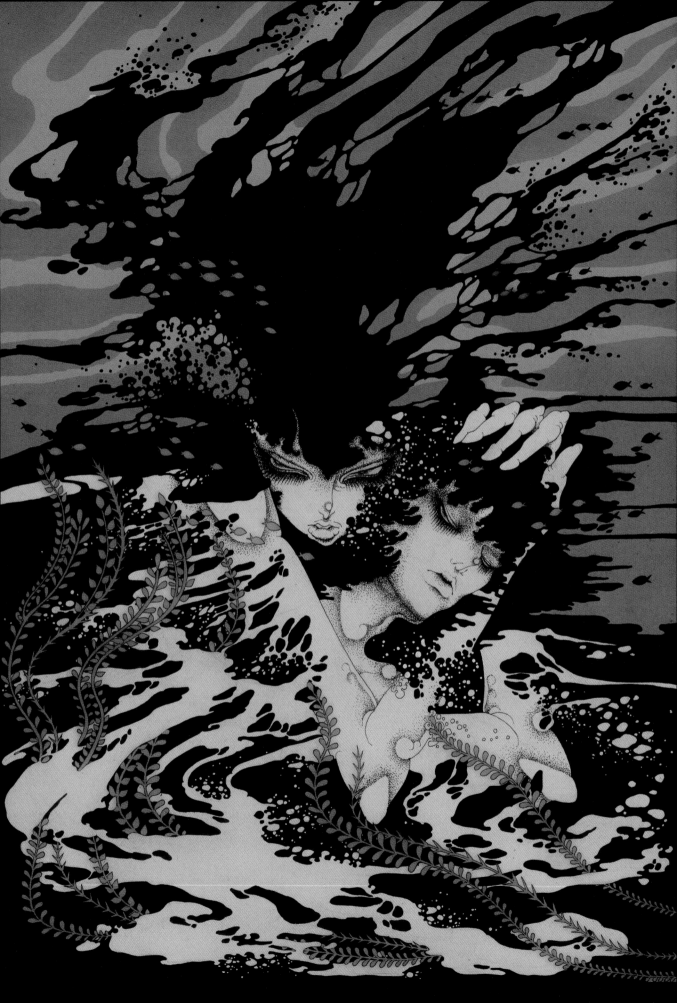

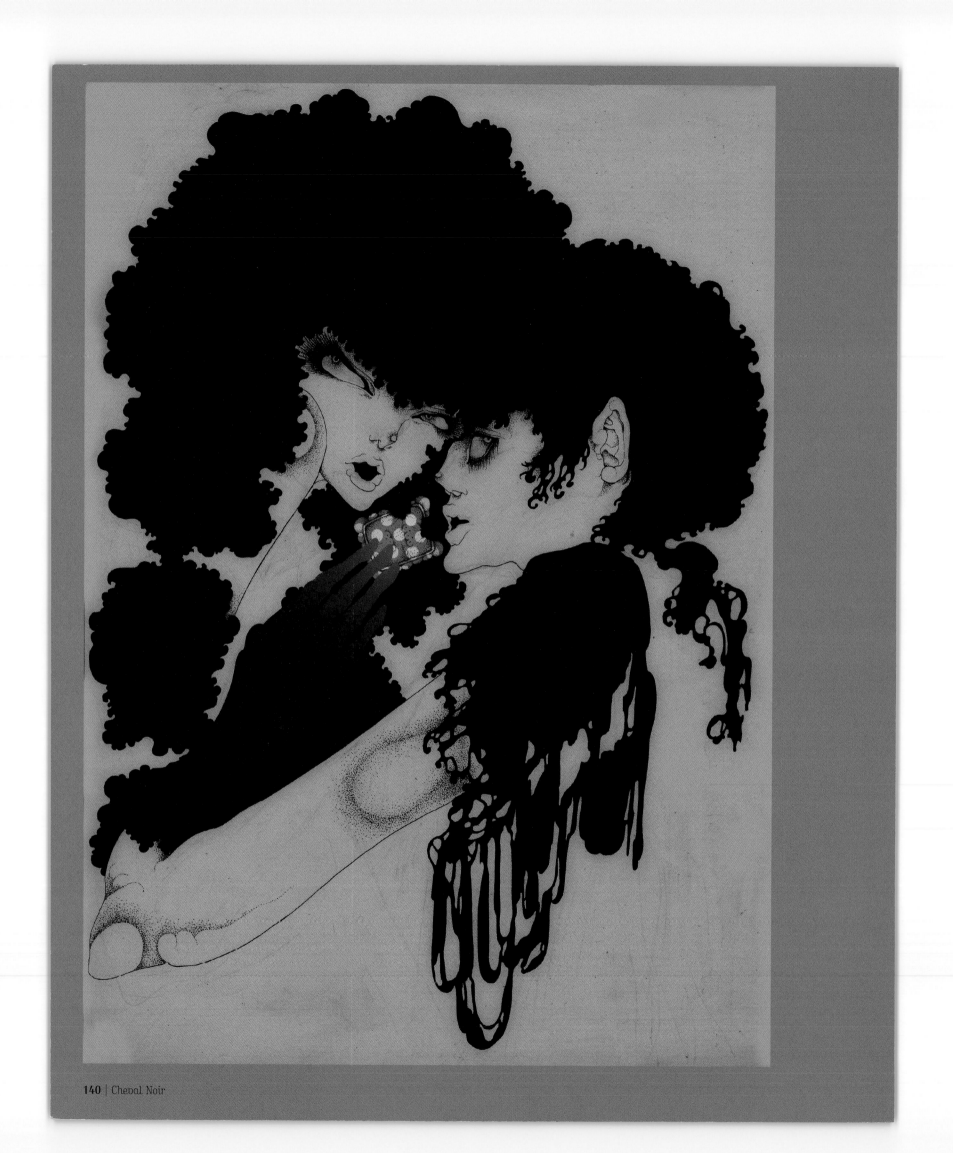

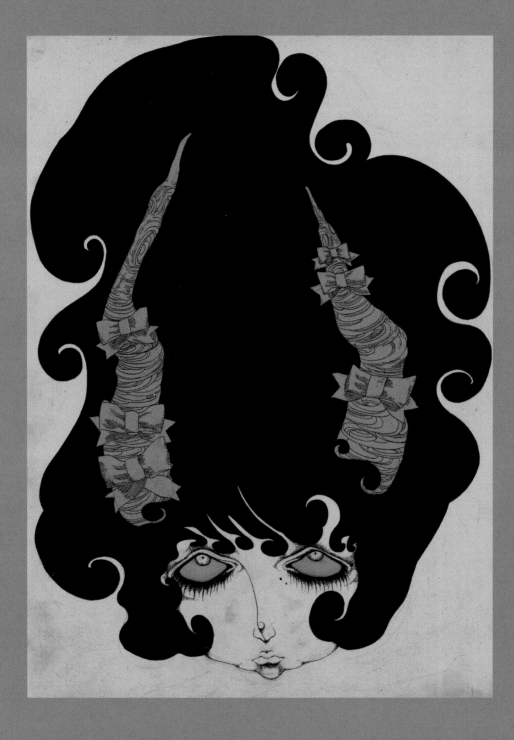

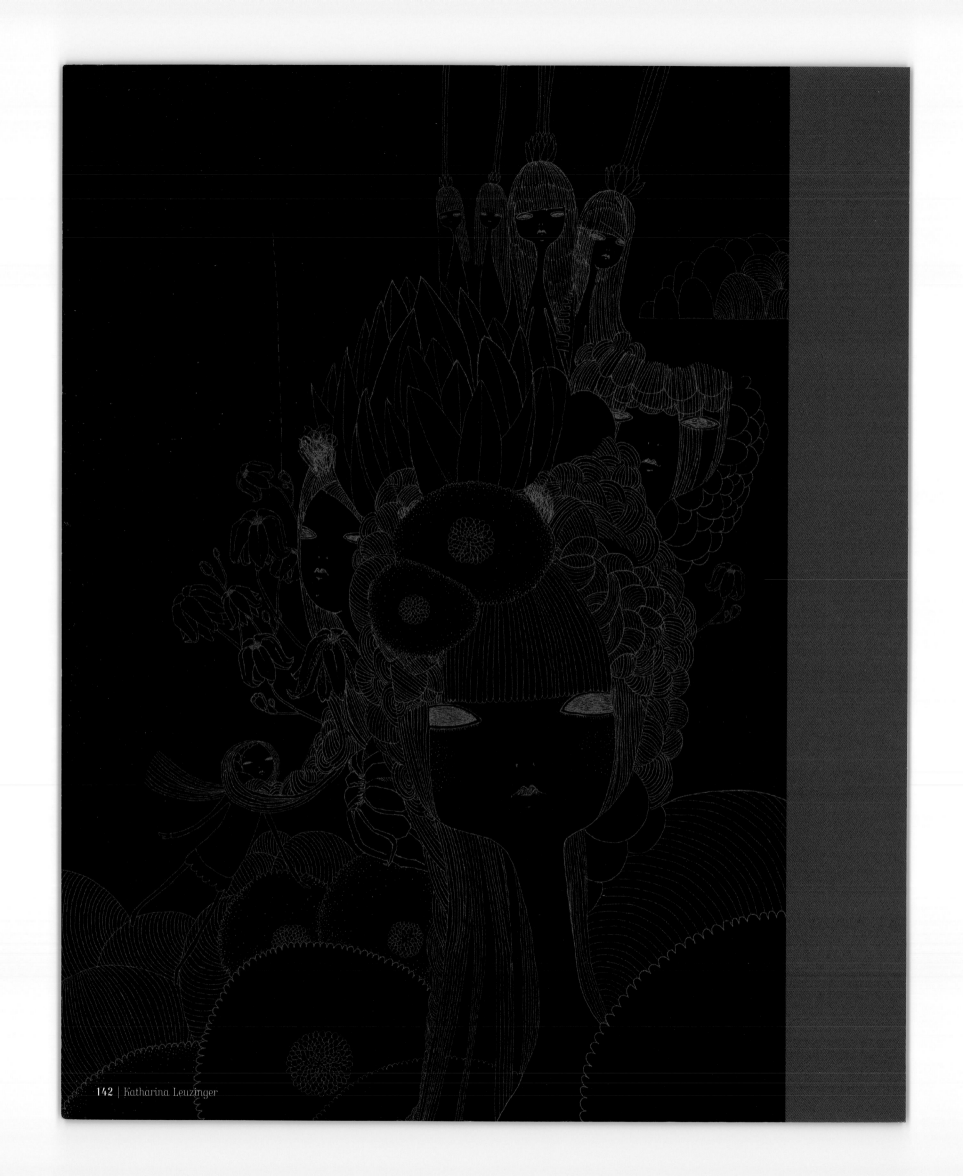

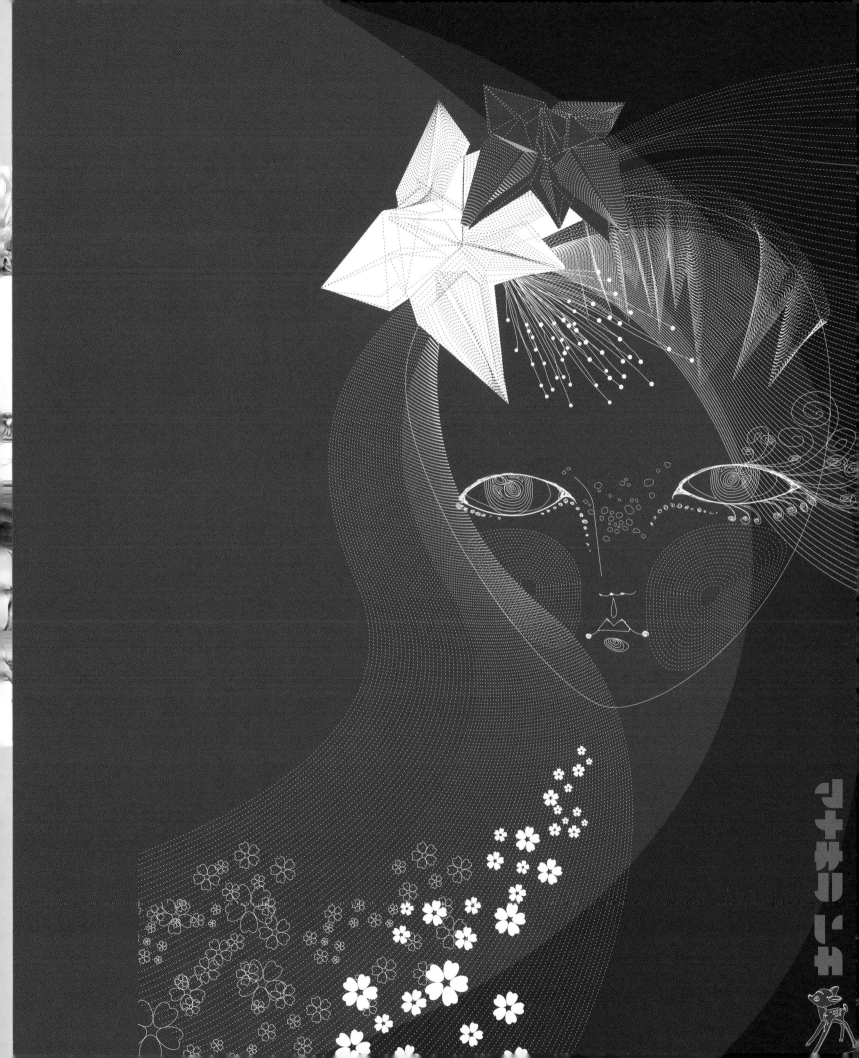

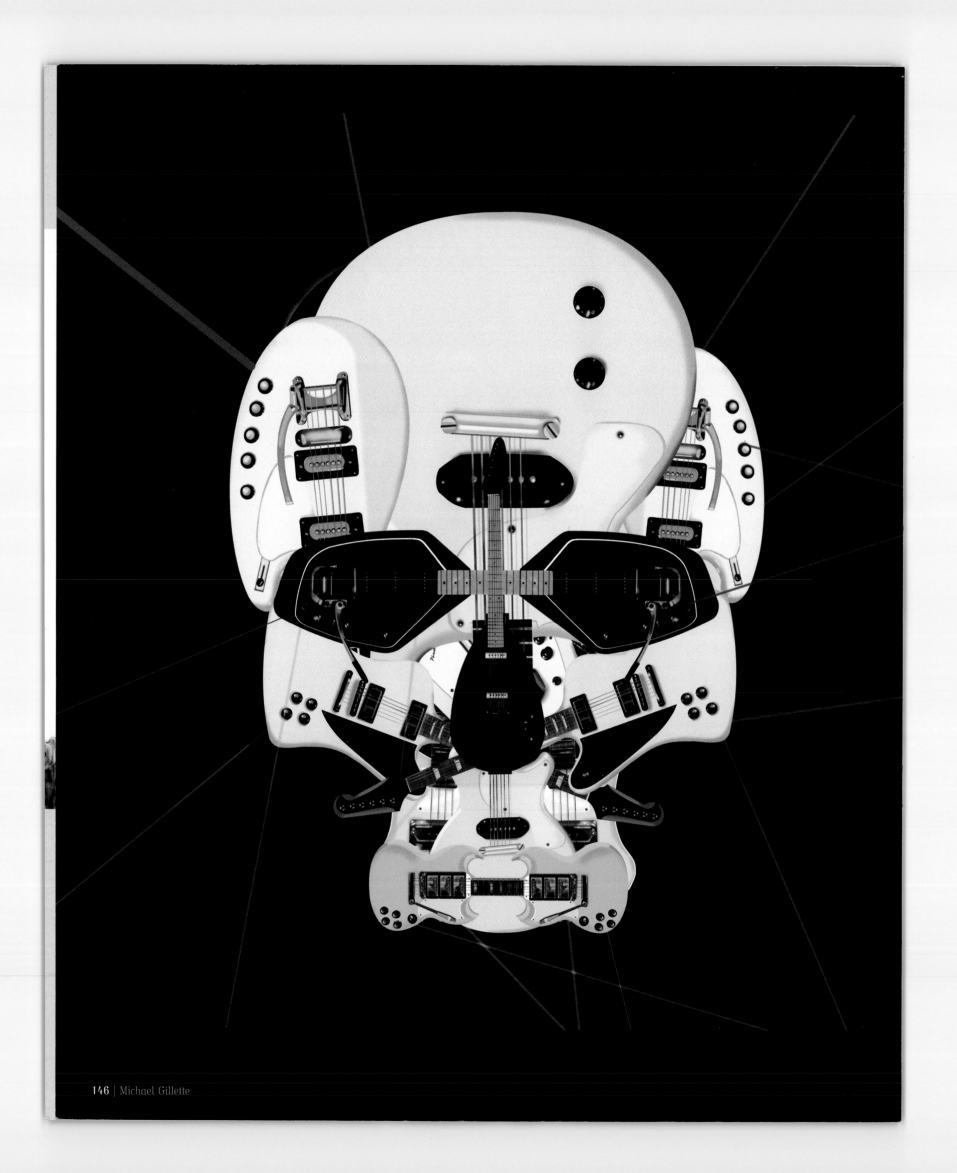

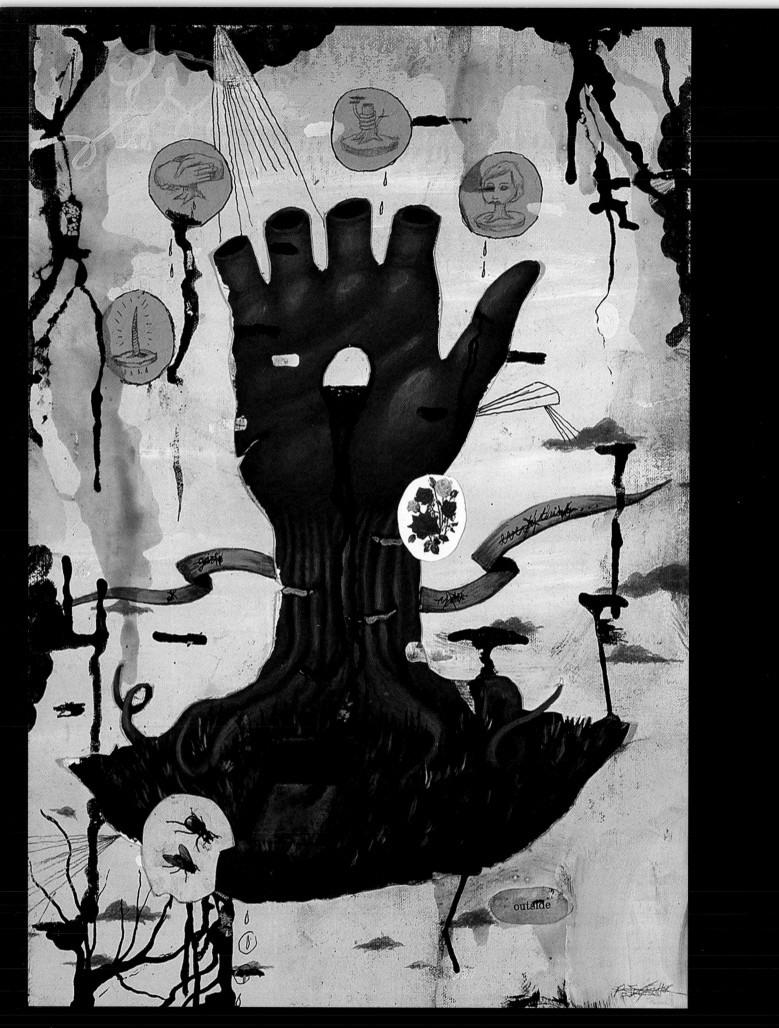

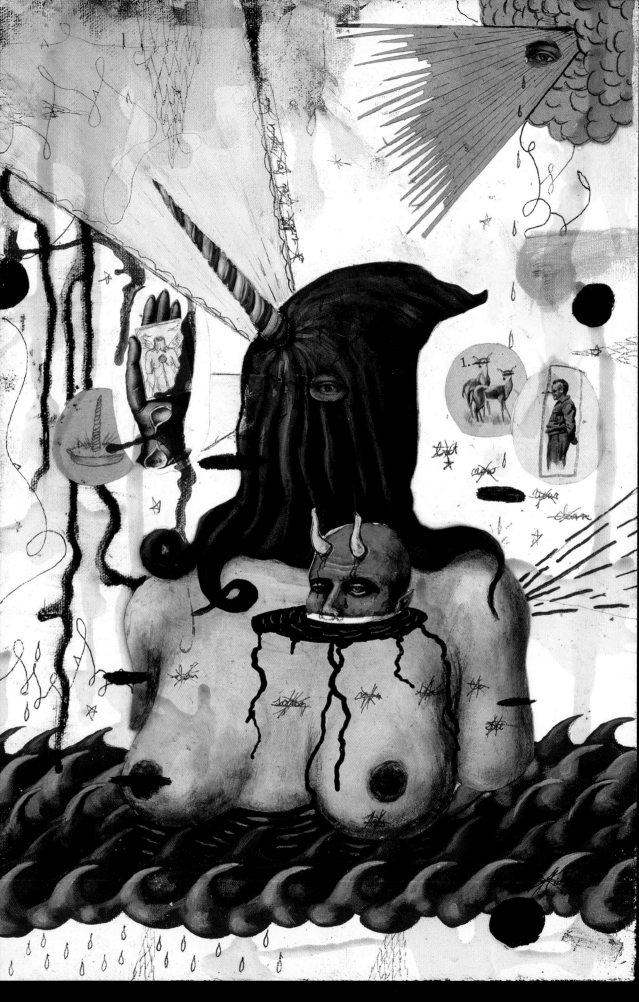

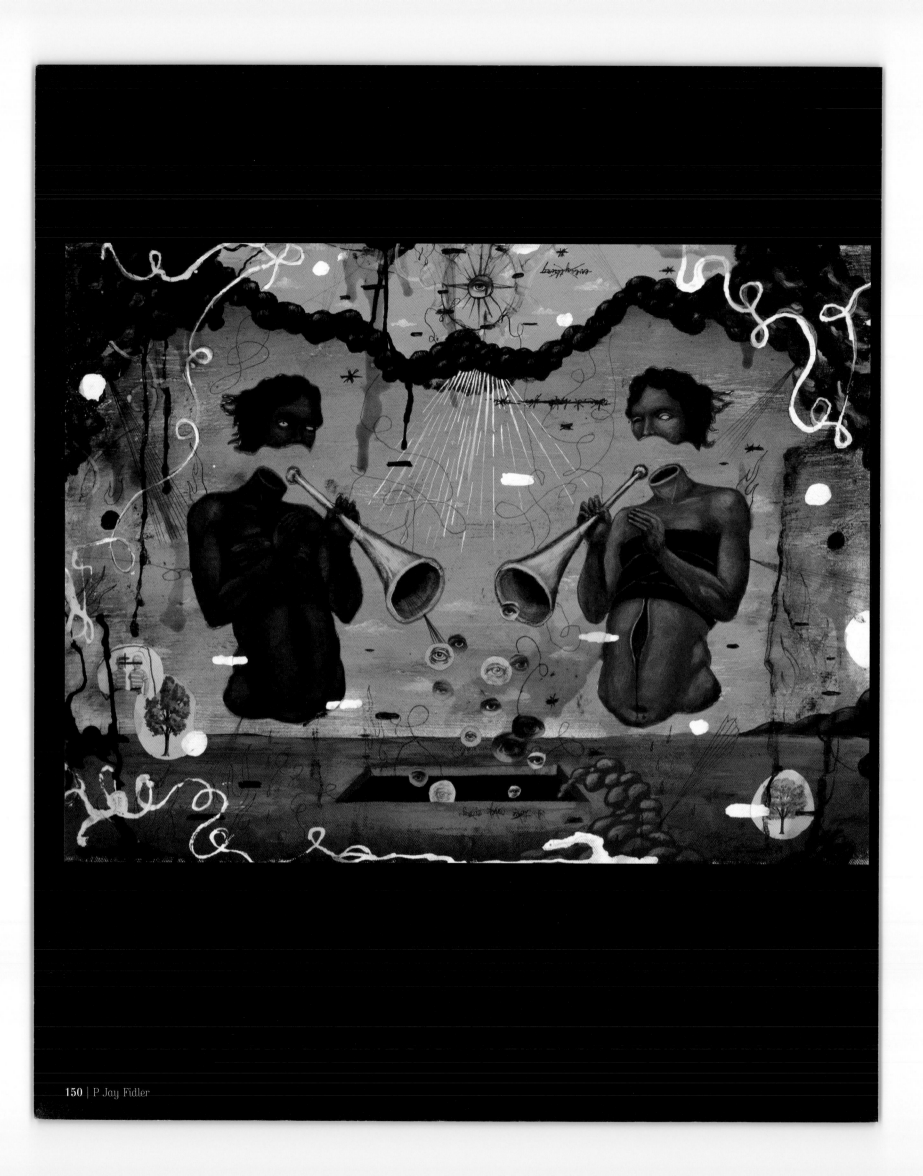

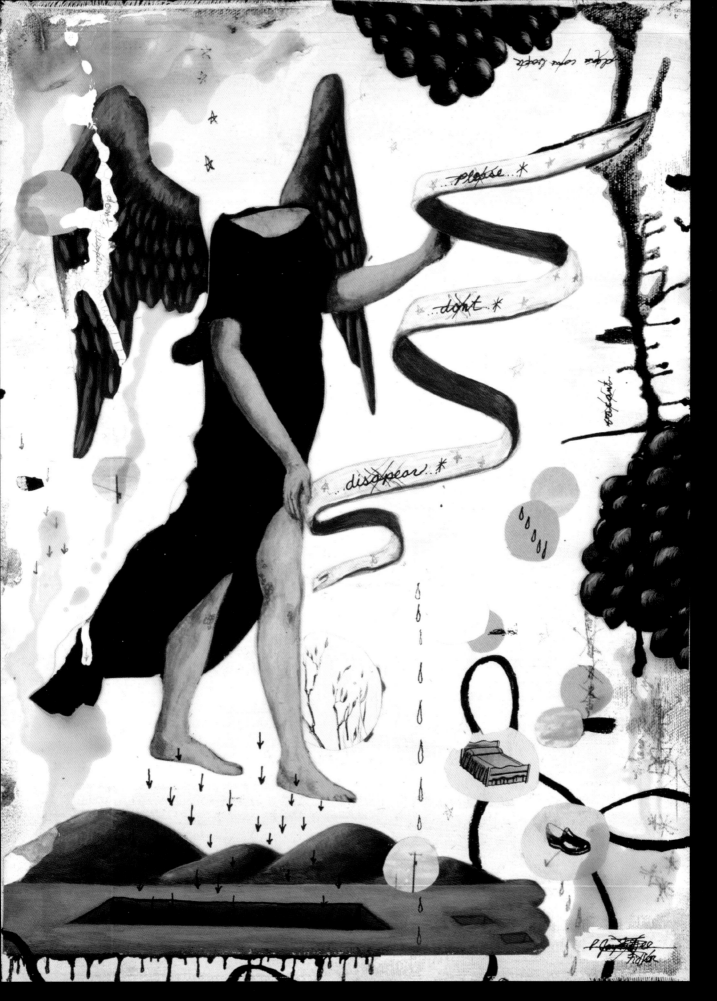

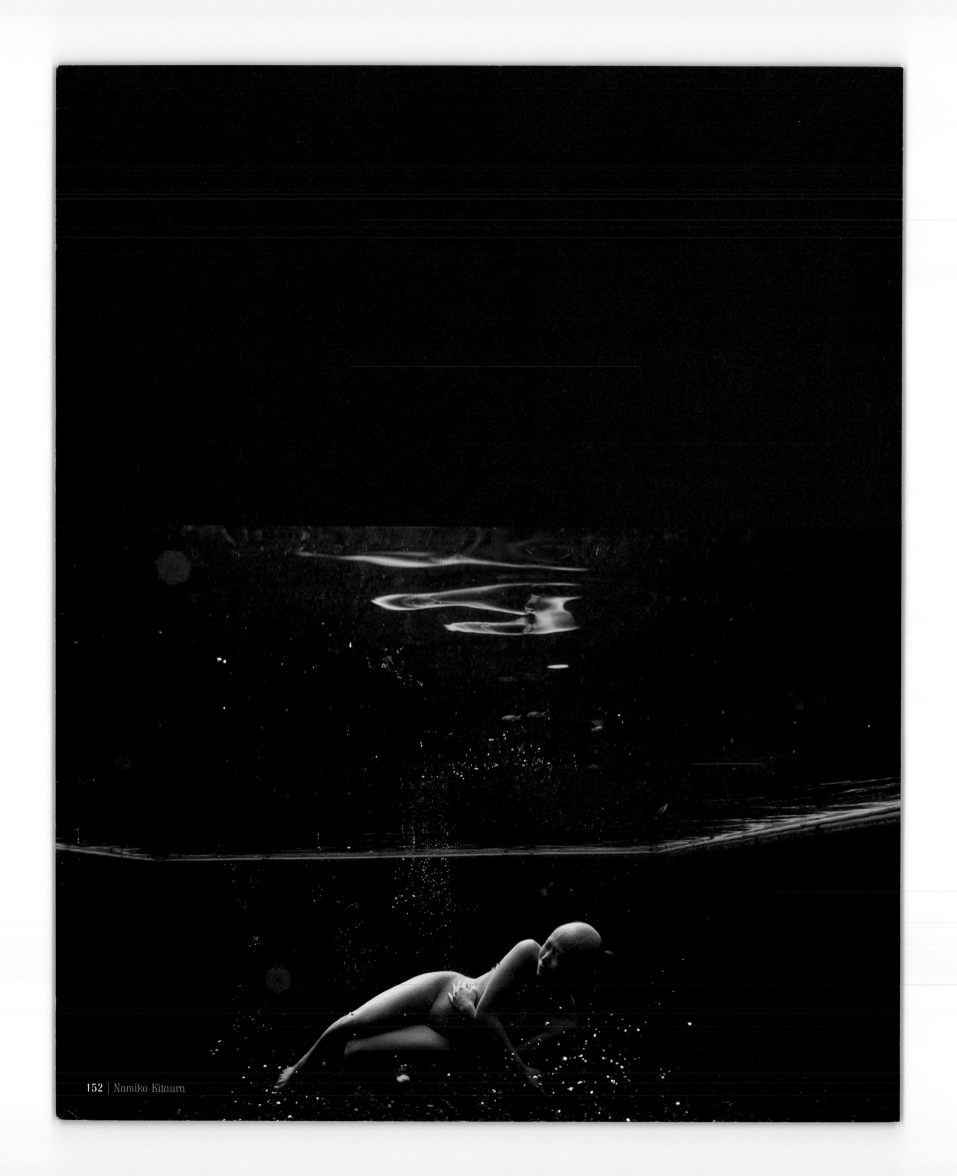

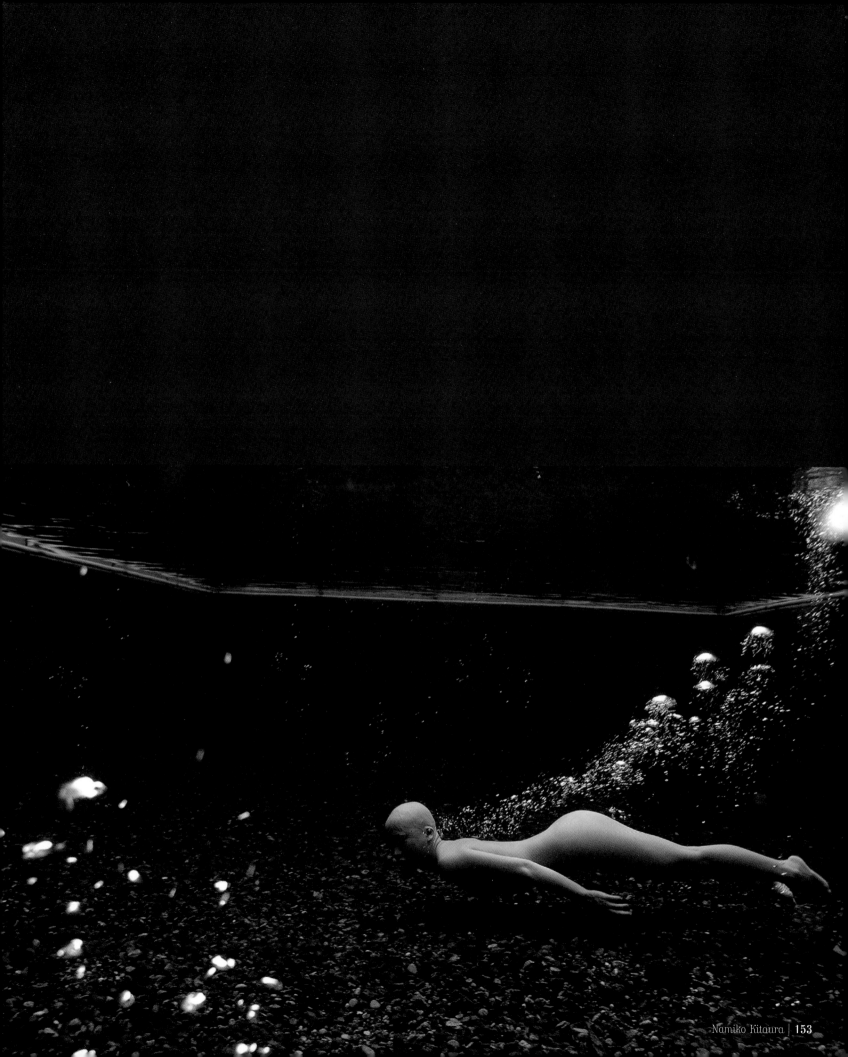

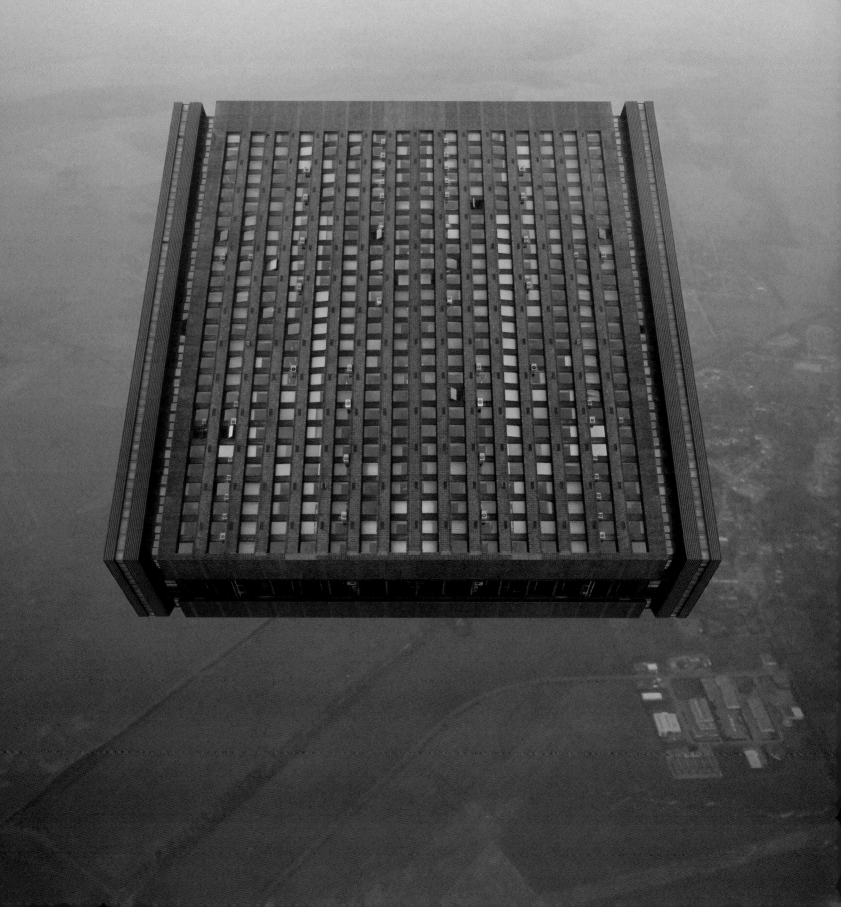

Index

Flag Design
Switzerland
www.flag.cc

Page 96

Nicholas Di Genova / mediumphobic
Canada
www.mediumphobic.com

Page 38, 39: 2004

Genovese Studios
USA
www.genovesestudios.com

Page 72, 73: Public Collaborative Installation
 Michael Genovese, Juan Angel Chavez,
 Cody Hudson, Chicago, 2004
Page 74, 75: Public Collaborative Murral,
 Mike Genovese, Juan Angel Chavez, Cody Hudson,
 Chris Uphues, Maya Hayuk, Chicago, 2005
Page 76, 77: "Hi:Fidelity",
 Public Collaborative Drawing, Michael Genovese,
 Cody Hudson, Sayre Gomez, 2005
Page 76: "Tragic Beauty",
 Public Collaborative Installation, Michael Genovese,
 Chris Silva, Juan Angel Chavez, Cody Hudson, 2005
Page 77: "Blacklist presents: The Live Festival",
 River East Arst Center, Chicago, Michael Genovese,
 Chris Silva, Juan Angel Chavez, Cody Hudson, 2004

Michael Gillette
USA
www.michaelgillette.com

Page 146: "Guitaron", self promotional piece, 2004
Page 147: Client: Mtv 2, promotional magazine advert,
 2005 / "Pimp my ride", Client: Mtv, magazine
 advert, 2005

Roya Hamburger
Netherlands
mail@royahamburger.nl
Represented by Xing:
www.xing.de

Page 16, 17: Client: Wellfit magazine Germany

Hort
Germany
www.hort.org.uk
HORT - Visual Systems: art direction and graphic design
for culture, fashion, music, magazines and everything
that we are connected with.

Page 36, 37
Page 134, 135

I'm JAC / Irene Jacobs
Netherlands
www.im-jac.com
Represented by Unit:
www.unit.nl

Page 24, 25: Client: IYF&W Magazine, 2004/2005

Kosuke Ikeda
Japan
www15.ocn.ne.jp/~worksbox/

Page 30, 31: © 2004 Kosuke Ikeda, all rights reserved,
 2004

Manabu Ikeda
Japan
Represented by Mizuma Art Gallery:
http://mizuma-art.co.jp

Page 54, 55

Illdesigners
USA
www.illdesigners.com
multi disciplinary illustration design team

Page 70, 71: Client: Our Demand Magazine,
 Sweden, 2004, Secret Doorway project
Page 92, 93: Client: Antipodium Shop,
 London, 2003, for London Fashion Week

Karen Ingram
USA
www.kareningram.com

Page 96: 2004

Carlos Irijalba
Spain
carlosirijalba@hotmail.com

Page 154: Environment VII, 2004
Page 155: Environment IV, 2004

JeSu / Jette Tosti & Sus Borgbjerg
Denmark
www.gulstue.dk

Page 99: JeSu / Gul Stue, 2005

Namiko Kitaura
Japan
www.namikokitaura.com
Represented by Studio G (Paris/Milan/NYC)
and Signo Management:
www.studiog.fr, www.signo-tokyo.co.jp
Freelance photographer in London and Tokyo. Artist in re-
sidence at Fabrica / Benetton research centre, Italy (www.
fabrica.it). Aims to visualize the almost invisible aspects of
the human condition that lie below the physical, and their
juxtaposition: passion in depression, comfort in sadness,
tranquility in chaos and beauty in ugliness.

Page 120: Make-up by Masayo Tsuda,
 hair styling by Yuki, © Namiko Kitaura, 2003
Page 121: Styling by Ryo Araki,
 hair styling by Kazuya Matsumoto,
 © Namiko Kitaura, 2004
Page 124,125: © Namiko Kitaura, 2005
Page 152,153: © Namiko Kitaura, 2005

Index

Brendan Monroe
USA
www.brendanmonroe.com

Page 56: "Carried Through", 2005
Page 57: "Daytime Drifters", 2005
Page 58: "Murkish", 2005 / "Bamboo Deer", 2005
Page 59: "Girl in Green", 2005 / "Sleeping With Trees",
 2005 / "Dotted Words", 2005
Page 60: At Junc. Gallery, Los Angeles, CA, 2005
Page 61: Paper Face Sculptures, 2005

Misato Nagare
USA
www.calarts.edu/~mnagare

Page 97: "Sweet Panties", 2003

Keren Richter
USA
www.notkeren.com and
www.bloodistheneroblack.com
Freelance illustrator and painter, creative director for
"Blood is the new black".

Page 42: "What's so good about goodbye",
 silkscreen on wood / "Psych out", digital, 2005 /
 "Heaven", acrylic on wood, 2003
Page 43: "Killing moon", silkscreen on wood, 2004 /
 "Silver apples", digital, 2003 / "Coast to coast",
 silkscreen on wood, 2004

Rachel Salomon
USA
www.rachelsalomon.com

Page 62: "Another Time", 2004 /
 "Thinking of You", 2004
Page 63: "Black Blossoms", 2004 / "(for) B", 2004

Supermundane
www.supermundane.com

Page 32, 33: 2004

Yoshi Tajima
Japan
www.radiographics.jp
Tokyo based graphic designer/illustrator, loving cats,
curry and house music. Using collage, photography,
drawing and painting.

Page 84: drawing, 2005
Page 85: drawing, collage, 2005
Page 86: collage, drawing, 2005
Page 87: collage, 2005

Tomoko Tsuneda
Japan
www12.ocn.ne.jp/~tsune/
Illustrator

Page 69: ILA_TsutomuMoriya, 2005

Jessica Williams / Paperheart
USA
www.paperheart.org

Page 67: 2005

Paul Willoughby
United Kingdom
www.paulwilloughby.com

Page 78: "Sunset Wave", 2004
Page 79: "The Day After Tomorrow", 2004
Page 80: "Duke Kahanamoku", 2004
Page 81: "Rwanda", 2004

Steve Wilson
United Kingdom
Represented by PearceStoner:
www.pearcestoner.com
Photographic and creative artist management.

Page 18: Image for Produced by Revolver Films, 2005
Page 22: "The Living Things", commissioned through
 Zomba, 2005
Page 23: T-shirt design for Tanktheory.com, 2004
Page 108: Client: Jalouse magazine (France),
 Illustrator:Steve Wilson, Photographer: Lacey @
 www.pearcestoner.com, Stylist: Charles Davis,
 Model: Madja @ ICM, Hair: Duffy @ Premier,
 Make-up: Shinobu, 2004

Akira Yamaguchi
Japan
Represented by Mizuma Art Gallery
http://mizuma-art.co.jp

Page 51: "Department Store", Nihonbashi Mitsukoshi,
 pen, watercolor on paper, 84.1 x 59.4 cm
 Courtesy: Mitsukoshi Ltd. / Mizuma Art Gallery,
 2004
Page 52: "Existence", ink, acrylic ink, paper on board;
 145 x 205 cm, Courtesy of the artist and Mizuma Art
 Gallery, 2004

Ytje
Netherlands
www.ytje.com
Illustrator

Page 82: "The D train", 2005
Page 83: "El Morocco", 2004

The Great Escape

Edited by Robert Klanten, Sven Ehmann, Matthias Hübner, Hendrik Hellige
Layout and Design by Matthias Hübner, Hendrik Hellige

Production Management by Janni Milstrey, Vinzenz Geppert
Cover photo by Kevin Mackintosh / PearceStoner.com

Bibliographic information published by Die Deutsche Bibliothek.
Die Deutsche Bibliothek lists this publication in the Deutsche Nationalbibliografie;
detailed bibliographic data is available in the Internet at http://dnb.ddb.de.

ISBN 3 89955 096 X
Printed by Fischer Medien GmbH, Aichelberg
Made in Europe

Respect copyright, encourage creativity!
For more information please check www.die-gestalten.de